Art History's History

VERNON HYDE MINOR

University of Colorado at Boulder

Prentice Hall, Englewood Cliffs, New Jersey 07632

Library of Congress Cataloging-in-Publication Data

Minor, Vernon Hyde.
 Art history's history / Vernon Hyde Minor.
 p. cm.
 Includes bibliographical references and index.
 ISBN 0–13–194606–4 (Prentice-Hall). — ISBN 0–8109–1944–3
(Abrams)
 1. Art—Historiography. I. Title.
N380.M556 1994
707'.2—dc20 93–28088
 CIP

Acquisitions editor: Norwell Therien
Editorial/production supervision, page layout,
 and interior design: Jenny Moss
Cover design: Tommy Boy
Production coordinator: Robert Anderson

Acknowledgments appear on page 206, which constitutes
a continuation of the copyright page.

© 1994 by Prentice-Hall, Inc.
A Paramount Communications Company
Englewood Cliffs, New Jersey 07632

Printed in the United States of America
10 9 8 7 6 5 4 3

ISBN 0-13-194606-4

Prentice-Hall International (UK) Limited, *London*
Prentice-Hall of Australia Pty. Limited, *Sydney*
Prentice-Hall Canada Inc., *Toronto*
Prentice-Hall Hispanoamericana, S.A., *Mexico*
Prentice-Hall of India Private Limited, *New Delhi*
Prentice-Hall of Japan, Inc., *Tokyo*
Simon & Schuster Asia Pte. Ltd., *Singapore*
Editora Prentice-Hall do Brasil, Ltda., *Rio de Janeiro*

Contents

◆

PART TWO: WHAT IS ART? ANSWERS FROM ANTIQUITY TO THE EIGHTEENTH CENTURY 29

◆

PART THREE: THE EMERGENCE OF METHOD AND MODERNISM IN ART HISTORY 85

Foreword

The history of art is a comparatively young discipline, at least in relation to other humanistic studies. Critical approaches to biography, to classics, to literature, and to philosophy preceded serious and integrative investigations of the style and meaning of a work of art once it had already been created. Prescriptions for ideal works of art were not uncommon during antiquity or the Renaissance, but fifteenth-century treatises like Alberti's *The Art of Painting* took little interest in the study of pre-existing works, preferring pure theory to critical reflection. When in the next century Giorgio Vasari (who has been called the grandfather of art history) wrote his *Lives of the Painters, Sculptors, and Architects,* he established the pattern of presenting the history of art as a sequence of historical biographies. Vasari, however, had little interest in relating the work of art to the larger religious and political issues of his time, and his biases toward the art of his own region (Tuscany) and of his own day (the middle of the sixteenth century) hardly conform to the qualitative criteria that subsequently would guide critics and historians into the modern era. Yet even as later generations of critics would soften one set of aesthetic prejudices they would congeal another, and in most instances ideal preconceptions continued to take priority over attempts to evaluate a work of art on its own terms.

Erwin Panofsky once said that that the best way to make an art historical point was not to illustrate it. Before photographic book illustrations or lantern slides became widely available in the twentieth century, most discussions of art went unillustrated and were thus by nature freer to discourse in a manner that could be both more opinionated and more offhanded. The densely illustrated book and the phantasmagoric slide lecture have changed all of that, reuniting the practice of simultaneously looking at and thinking about art. What could seem more natural? Since the 1950s enrollments in introductory art history courses have grown and publishers' profits have swelled, whether the course and the book are engendering art appreciation

and coffee table etiquette or aspiring to provide their audience with something more.

In recent years, something very strange has occurred. As book and lecture hall illustrations have become more numerous and color film technologies more refined, an increasingly large number of art historians have turned away from the work of art as the primary object of their study. Although this may not yet be evident from the titles of courses offered in college and university curriculums, it is the only conclusion to be drawn from the topics listed on the program of annual meetings of the College Art Association of America or on the table of contents of even the most moderately progressive professional journals. Theoretical issues have come again to the fore while an obsession with methodology has led many to adopt disciplinary perspectives borrowed from other fields like literary criticism, social history, and women's studies. The political and social context of a work of art is no longer seen as merely being reflected in an image, but issues of class and gender are now believed to be densely interwoven into that image. Accordingly, the role of the artist who created the work is diminished in importance. As more of the "New Art History," as it is called, filters down to undergraduate course levels and into texts read by the general public, the more perplexed will be those who hold the traditional expectations for formal analysis and connoisseurship, conventional iconography, and a little history. The casual museum-goer with little or no academic training in art history and a high regard for artistic genius will regrettably be the most disaffected of all.

It is for this audience—students, those that teach students, and the museum-going general public—that Vernon Hyde Minor's book will be of the greatest value. Clearly written in refreshingly plain language, the author traces the entire history of art criticism and theory. His intention, as he states in the Introduction, is "to attempt to describe . . . what art history is, where it came from, what ideas, institutions, and practices form its background, how it achieved its present shape, and what critical methods it uses." Not since Lionello Venturi's *History of Art Criticism* was published in 1936 has so ambitious a task been addressed. Venturi's effort to be complete at times led him to be too encyclopedic, and his coverage of contemporary criticism ends with the theories of Walter Gropius and Frank Lloyd Wright. Minor's text is more selective, more focused, and more readable. More importantly, it takes us up to the present with insightful and incisive treatments of the most current approaches to the study of art. The last third of the book explains, with patience and sympathy, the new perspectives of art taken by Marxist, feminist, deconstructionist, semiotic, and psychoanalytic critics, while the final chapter, "Culture and Art History," offers a brilliant summary of the challenges today's student of art history faces in our multicultural society.

Whether one agrees or disagrees with any of the arguments reviewed in this text is less important, I think, than whether one understands them and is able to see how in the past or the present they can affect the study of art. As

terms like theory and methodology, ideology and revisionism replace ones like style and quality, originality and genius in art historical discourse, the educated person of today needs to be better informed about critical theory than he or she did only a decade or two ago. For Americans especially, whose cultural background may make them wary of both the power of images and theoretical speculations in general, this book will make that task a great deal easier.

JOHN VARRIANO

Preface

When I set out to write a text on the critical theories of art history, I realized that my archeological investigation of this discipline would cross quite a few boundaries. Art history results from so many different forms of academic discourse that it hardly qualifies as a unique field of study. The histories of criticism, aesthetics, and philosophy count for much in the study of art history. History itself is a complex field of inquiry in the modern university and can have the appearance of either a social science or a humanistic discipline. It can make sense to teach art history within an independent university department, a traditional history department, a humanities department, or a department of fine arts. Art history, it seems to me, is a hybrid and sometimes a handmaiden of other disciplines. I realized that writing about art history as a form of inquiry (which is something very different from the "history of art") would result in a text of mixed but perhaps not blended parts. And so this book is about the study and teaching of art and art history, about the histories of philosophy, religion, and aesthetics, and the currents of contemporary criticism in art history and other humanistic disciplines. I hope that the breadth of this text makes up for its lack of homogeneity.

One of my concerns was to make the book as widely accessible as possible, which meant that I would have to avoid jargon, become a generalist rather than a specialist (and thereby disclaim a high degree of authority), and assume relatively little art historical background on the part of the reader. This survey, therefore, is only an introduction to the nearly limitless number of issues in art history and should not be taken as anything like the final word. I certainly do not expect agreement upon all points touched upon in the text; rather, I'm anticipating that interested readers will use their objections or demurrals to launch them into further study. This prefatory

apology, however, does not absolve the author from errors of fact and substance. For these, I assume full responsibility.

And finally there are those whom I wish to thank. Bud Therien, editor of art and music for Prentice Hall, has helped me, talked with me, and reassured me from the inception of the text to its printing. Prentice Hall's reviewers, Michael Camille of the University of Chicago, Howard Risatti of Virginia Commonwealth University, and David G. Wilkins of the University of Pittsburgh, shared their wealth of knowledge of art history and its literature and helped to lead me in some fruitful directions. And there have been my teachers. Morris Weitz taught a course on aesthetics at The Ohio State University that, nearly thirty years ago, caught my interest in the very questions that I bring up in the text. Marilyn Stokstad encouraged me as a graduate student and continues as a valued colleague to share her knowledge, good humor, and advice. To my mentor Robert Enggass I owe an enormous debt of gratitude and inspiration. My mother, Eleanor Minor, made a point of leaving art books around for me to peruse and dream over when I was very young and forever impressionable. And of course there are friends and colleagues too numerous to mention who have assisted my learning. I wish to thank specifically Paul Gordon and Claire Farago for reading and commenting on parts of my text. My sons remained endlessly tolerant (and largely unaware) of my writing of this book, for which I must thank them. And then, of course, there is my muse.

Introduction

When I was an undergraduate and took my first art history course, I encountered an almost legendary text. H. W. Janson's *History of Art* has led generations of eager undergraduates through the history of art from the Old Stone Age to the present. Janson's name has become synonymous with the title "Survey" in an art history course. What impressed my fellow students and me back in 1963 was the sheer quality of the book: solid, beautifully bound, a handsome layout, and probably the best art reproductions any of us had ever seen. The black and white illustrations were sharply detailed, with a full tonal range from dark to light, and always in perfect "register" (no blurriness of detail). And the color plates, bound in separate sheaves, were—and this is the word I remember we used—breathtaking. Most of my friends were studio majors, which made them, I believe, especially keen on the quality of the text. And as we sat down to do the assigned reading, we found Janson's prose, on the whole, clear, precise, careful, explanatory, but sometimes difficult or too evocative. In the colloquialism of the day, we couldn't tell quite where he was "coming from." For instance, in comparing Cimabue's *Madonna Enthroned* (fig. 1), with earlier Byzantine icons, he writes: "His huge altar panel, *Madonna Enthroned*, rivals the finest Byzantine icons or mosaics; what distinguishes it from them is mainly a greater severity of design and expression, which befits its huge size." Now, there's certainly nothing wrong here, but much seems unsaid or implied. And as a freshman art history student, I wasn't too sure what to make of so short a characterization of such a large and, according to my professor, very important painting. Even though Janson wrote several more sentences on the panel, it just didn't seem enough to us. What were we supposed to make of Cimabue's "rivalry" with Byzantine icons and mosaics (fig. 2)? Was there some sort of competition for grandeur? Perhaps. And "the greater severity of design and expression"—what, exactly, does that mean? More square, more solemn? Janson never told us; we hoped our professor would explain things. We assumed

1

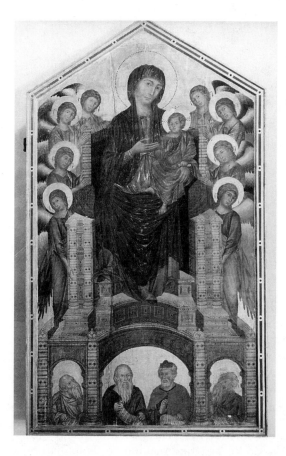

Figure 1. Cimabue, *Madonna Enthroned*, c. 1280. Uffizi Gallery, Florence. Photo: Alinari, Florence.

that the textbook was written in a kind of shorthand that was best deciphered by listening to further lectures and looking at slides. But often we heard more of the same in lectures: professors characterizing works of art rather than analyzing them. Such phrases as "note the subtle modulation from plane to plane" were not uncommon in describing Greek sculpture, for instance. And here's another quotation from Janson, this time on Jean-Antoine Fragonard's *The Bathers*: "A franker 'Rubéniste' than Watteau, Fragonard paints with a fluid breadth and spontaneity reminiscent of Rubens' oil sketches. His figures move with a floating grace that also links him with Tiepolo, whose work he had admired in Italy." All right, so his paintings look like those of Tiepolo and Rubens. What does that tell a student? Fragonard's art has fluidity, breadth, grace, and spontaneity. So does a well-played baseball game. I do not wish to diminish the enormous contributions to the discipline of art history made by Janson and other eminent art historians, such as Gombrich, Gardner, and Hartt, but as was pointed out in a review that appeared in the *Art Journal*, there are problems with the texts by these authors because they emphasize the idea of appreciation at the expense of

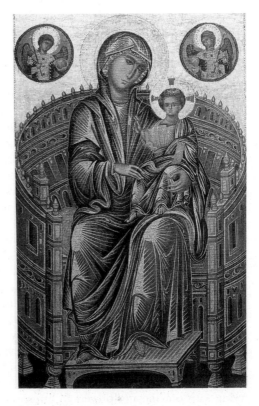

Figure 2. *Madonna Enthroned*, late 13th century; pane $32\frac{1}{2} \times 19\frac{1}{8}$". Andrew W. Mellon Collection, National Gallery of Art, Washington, D.C. Photo: © 1993, National Gallery of Art, Washington, D.C.

other methodologies and forms of criticism. I believe readers are aware, just as I was as an undergraduate, that courses in history, literature, philosophy, chemistry, and physics do not proceed this way. The methods in these disciplines seem more geared toward a conception or version of "truth," or a process that leads toward "understanding." Art history, we thought, was about "appreciation," although we weren't entirely sure what that word meant either. "Appreciation" seemed to be some skill developed by experts and sophisticates.

And to develop that skill, one needed a certain vocabulary. Students try their best to imitate their teachers and their textbooks, often with unnerving results. Now as a teacher, well remembering my many frustrations as an art history major, I tell my students that I do not want their papers to adopt the pseudo-anonymous and authoritative voice of a textbook. And when looking at works and attempting verbal analyses, I expect them to go beyond such catch words as "fluid," "buoyant," "graceful." But of course, we as professionals are ultimately to blame for language that is frequently strange, unnecessarily inflated, overly decorous, and sometimes frivolous. I

think our problem arises from an unclear sense of the purposes, nature, origins, and assumptions of the discipline of art history.

So it is my intention to attempt to describe in this book what art history is, where it came from, what ideas, institutions, and practices form its background, how it achieved its present shape, and what critical methods it uses. The audience I hope to reach consists of those who are encountering art history for the first or nearly the first time, who are curious not just about the art, but why we say the things we do about it. I would like to convince the reader who believes that there is only one way to talk about art—the text's way—that this point of view is simply too reductive and authoritarian. At the the other extreme, I wish to persuade the resistant and laconic reader how invalid is the belief that all art is merely personal, and that everyone's opinion is equally valid. Along the way, the reader will become aware, I hope, of what makes art history humanistic.

The humanities study not only discrete works of art and literature, but also concern themselves with process as well: how one reads, looks at, understands, and enjoys art. Literary theory, for example, has blossomed in academic circles over the past fifty years, to the point where there are many now who fear that theories of criticism are of equal or greater interest to graduate students and professors than the original texts. Murray Krieger has written that a piece of literary criticism is "a fully autonomous literary object" (*Arts on the Level: The Fall of the Elite Object*, Knoxville: University of Tennessee Press, 1981, p. 40). In this intentionally provoking statement, Krieger wants to challenge the notion that critics and teachers serve the artist and his or her work, trying with our meager powers to interpret things for those less enlightened than we, and at the same time teaching the skills of interpretation. But there never used to be any question about who has priority, who's the boss: the artist and the work of art have been in charge. Krieger of course says no. The critic is equal to the artist; the criticism is equal to the work of art (although, in the visual arts at least, it probably wouldn't sell for quite so much).

Until recently, the scenario in art history has not been anything like that of its sister disciplines. We take seriously the original painting, statue, craft work, performance, or building, sometimes preferring to contemplate it in silence. John Keats addressed a Grecian urn, "Thou foster child of silence and slow time." This constitutes an aesthetic condition and experience we sometimes can feel when moving through the still halls of a great museum looking at mute works of art. But we as teachers and students tend toward loquacity, just like the literary critics. We talk and write about art. So serious is this desire that it has been appropriated, for better or worse, by the "academy" (the universities, museums, galleries, and the art world), institutionalized and turned into a discipline. The "New Art History" is more theoretical than ever before. Times have changed. Perhaps not even the works of art have stayed the same.

What follows are chapters, or more properly speaking essays, on this dis-

cipline of art history. Much of the first part of the book will be historical, for "history" is in fact half of our name. History is remembering, and through this act of "anamnesia" we can come to have some understanding of why things are the way they are.

The modern academy, as a place for studying art, begins in later sixteenth-century Italy as a professional forum for artists. It often encouraged theoretical discourse on the arts, sometimes to less-than-enthusiastic artists. But as a cultural and ideological phenomenon, its influence has been keenly felt; it is experienced today perhaps more strongly than ever. The nature of the academy, whether an independent artistic organization under the protection of the papacy—Rome's *Accademia di San Luca*—or a royal academy controlled by Louis XIV's lieutenants, or the modern university, creates agendas and influences artists and art historians in one manner or another. These and related matters will be explored in more detail in the first part of my text.

History meets aesthetics in the chapters on theories of art from Plato to the nineteenth century; history backs off somewhat in my treatments of theories of criticism in the twentieth century. Ways of doing art history, what we call methodology, have become very complex in the twentieth century, especially since the 1960s. The College Art Association's annual meetings, where artists get together with other artists and debate contemporary issues, and where art historians give talks or participate on panels, have changed substantially in character since the mid-1980s, all in an effort to come to terms with shifting methodologies, ideologies, and practices. We art historians are the self-appointed keepers of the sacred flame of understanding art. And how we do it is very interesting, especially at the turning of this new century. Just the richness of the variety of recent art historical approaches with which this text deals gives some suggestion of how involved our project is: semiotics, deconstruction, Marxism, psychoanalytic approaches to art history, feminist critiques, multiculturalism—to name only the better known. As I write about each of these approaches, I'll try to show how they apply to individual works of art.

◆

Bibliography

BELTING, HANS, *The End of the History of Art?* (trans. C. S. Wood). Chicago: University of Chicago Press, 1987.

GARDNER, HELEN, *Gardner's Art Through the Ages*, 9th. ed. (eds. Horst de la Croix, Richard G. Tansey, and Diane Kirkpatrick). San Diego, Calif.: Harcourt Brace Jovanovich, 1991.

HARTT, FREDERICK, *Art: A History of Painting, Sculpture, Architecture*, 4th. ed. Englewood Cliffs, N.J. and New York: Prentice Hall/Abrams, 1993.

HAUSER, ARNOLD, *The Philosophy of Art History*. New York: Knopf, 1959.

JANSON, H. W., *History of Art*, 4th ed. (revised and expanded by Anthony F. Janson). Englewood Cliffs, N.J. and New York: Prentice Hall/Abrams, 1991.

JOHNSON, W. MCALLISTER, *Art History: Its Use and Abuse*. Toronto: University of Toronto Press, 1988.

KLEINBAUER, W. EUGENE, *Modern Perspectives in Western Art History*. New York: Holt, Rinehart & Winston, 1971.

PANOFSKY, ERWIN, *Meaning in the Visual Arts*. Garden City, N. Y.: Doubleday, 1955.

PREZIOSI, DONALD, *Rethinking Art History: Meditations on a Coy Science*. New Haven, Conn.: Yale University Press, 1989.

ROSKILL, MARK W., *What Is Art History*, 2nd. ed. Amherst: University of Massachusetts Press, 1989.

REES, A. L., and F. BORZELLO, eds., *The New Art History*. Atlantic Highlands, N.J.: Humanities Press International, 1988.

Part One

THE ACADEMY

A man named Cimon once owned a beautiful pleasure garden in the suburbs of Athens. This walled-in grove had walks and fountains, as well as a storied past: according to legend, an Attic hero named Akademus originally held this plot. His fame derived from an encounter with the Dioscuri—Castor and Pollux—on a quest to find their sister Helen, only recently abducted by Theseus. Akademus told the great twins of Helen's secret location. Because the Lacedomenians so revered the Dioscuri, they always spared the Academy—as the pleasure garden had then come to be known—when invading Attica. As a result of the help given by a hero, therefore, the Academy survived because it was protected and charmed. When Plato took possession of the pleasure garden, around the year 400 B.C., he founded his school, which took the name of the garden: the Academy.

The Academy is an important idea in Western culture: here the honor and dignity of philosophy flourishes; young men and women learn to think, to act, to become human. Out of the garden—which carries with it an enchanted and pastoral heritage—came the idea of learning. The fruit of the tree of knowledge in the academic tradition is certainly to be eaten. This knowledge gained by the metaphorical "eating" does not constitute a fall from grace; rather, it can redeem us, make us free. At least that is the academic belief and custom.

Of course academies do not transmit pure, changeless wisdom from some omniscient source to wholly receptive students. Academies have lives and agendas of their own: they, like most other human products, have histories. So Plato's Academy, which lasted almost a thousand years (from approximately 400 B.C. until it was closed by Justinian in A.D. 529), had a long career, with changes in character and with distinct "schools."

It is the nature of the schools or programs of art academies that concerns us within the context of this book, because the curricula and points of

view represented by academies—including the modern university—have much to do with how the art historian and student confront, reckon with, and understand art.

Following the historical threads of academicism is not easy. Particularly from our vantage point, in which we investigate the study (rather than the making) of art before the Renaissance, there is not a great deal to go on. There is little or no instruction on interpreting art—at least in the academic setting. On the other hand, one does find an extensive literature from the Roman Catholic Church on how one should read images, and this has academic implications.

Christian Readings of Art

The Church's position has been that the visual arts illustrate or, in more Christian terminology, "illuminate" the sacred text. Probably the most famous statement of the Church's position in relation to images came from Pope Gregory the Great (reigned 590–604), who wrote:

> Pictures are used in churches so that those who are ignorant of letters may at least read by seeing on the walls what they cannot read in books. What writing does for the literate, a picture does for the illiterate looking at it, because the ignorant see in it what they ought to do; those who do not know letters read in it. Thus, especially for the nations, a picture takes the place of reading. . . . Therefore you ought not to have broken that which was placed in the church in order not to be adored but solely in order to instruct the minds of the ignorant.

The Church has pretty much stuck to this position through modern times. Gregory was, first of all, responding to iconoclasts, those who were attacking icons because of God's commandment that no one is to worship before graven images. Gregory makes clear that pictures are effective manuals, visual texts, not idols. If one were mistakenly to believe that some divine spirit dwelt within the works of art, that would be idolatry. Works should merely point to the other, true reality: that of the sacred realm. Since few people could read in the Middle Ages, images were necessary. There is remarkable common sense here, but an odd sort of naiveté as well. Naturally the church wished to promulgate its doctrines and beliefs, and if visual art can do that, then it should be employed. But certainly, the Church was aware of the long tradition of art as something that delights as well as instructs. The Church was also aware that many would naturally see some indwelling spirit in images, whether that animation or energy were magical or beautiful. Miraculous images continue to thrive in many Catholic countries—images that are thought either to have come alive or to have provided some divine and providential intervention in the affairs of the world. And there is Gregory's assumption

that one could, if illiterate, "read" a picture. Why is reading a picture so easy, so natural? How would anyone read Christian art if he or she had not already received a very thorough grounding in this tradition by being told about it in words? If one already knows the narratives and images, then are pictures primarily mnemonic devices: aids to the faltering memory? Is that how Gregory believes instruction works? Perhaps he did not wish to investigate this issue too deeply. At any rate, the Roman Catholic Church has been responsible for the creation and preservation of an enormous amount of art, as well as certain discourses, mostly deriving from Gregory, on its meaning.

Guilds

One of the first appearances of institutions having some relation to our present idea of an art academy came about in the Middle Ages. Craft guilds became prominent in Europe by the twelfth century. Like other fraternal organizations, guilds were based upon mutuality and cooperation, with strong bonds of Christian brotherhood. Nonetheless, they concerned themselves with the process of making, building, and merchandizing; they were, in other words, largely commercial operations, and although they protected their members, the guilds also made constituents dependent upon the organization. Each member would take an oath, pay his dues, and support his brothers in times of need. The communal nature of the guilds must have encouraged the sense of belonging and commonality that is so at odds with our modern notion of the struggling, independent artist working in spite of or at odds with mainstream interests. In the Middle Ages, from the twelfth to the fifteenth century, craft and merchant guilds were municipal organizations—therefore having a strongly urban character—and were regulated monopolies. Some guilds sold their crafts at public market and fairs. Parallel to the craft guilds, there appeared in the fourteenth century journeymen and yeomen, masters who set up their own organizations sometimes in competition with the older guilds.

The training of artists within the guild system generally followed a common pattern. The aspiring artist began at about the age of twelve as an apprentice or assistant in the shop of a master and remained there for approximately seven years. Following this training, he became a master who took on tasks or contracts for a short period, such as a day, rather than making longer-term commitments. The word journeyman results from the idea of day labor: *journee* meaning "day's work" in Old French. Once an artist became successful, he would employ assistants.

The guild system can cause a modicum of uncertainty for the art historian. If a particular master were successful, had a thriving shop, and numerous patrons, he then would set up an industry of art. A certain devotional image (say of the Virgin and Child), theme, or narrative could become popu-

lar and much in demand. A number of versions or direct copies would be made. The master himself might prepare the replicas, but it was more likely to be a job handed on to an assistant. One of the chores of connoisseurship is to decide upon originality and authenticity. Whose hand made the painting? It sometimes can be very difficult to make that judgment about late medieval paintings, especially those made in Flanders, where shops often were efficient and staffed by highly skilled assistants. Originality, evidence of the presence of the master, authenticity: these are concerns of much importance since the romantic era. It's likely that the guild system—although recognizing the role of authenticity—gave less credence to the "master's hand" than the modern art historian, dealer, or curator does. A painting made entirely by the master's hand would command a higher price than one executed by an assistant, but the importance of originality was less an issue than it is now. An original Van Gogh can be worth tens of millions of dollars; a fake, or one done by an assistant (if he had had one) would be practically worthless. And a present-day museum curator would rather have a painting by Jan van Eyck than one by his assistant Petrus Christus, and would certainly pay more for an original.

On a level beyond the pecuniary—a place where money doesn't count—the historian/critic often seeks certainty and authenticity. Why? There is a fairly involved philosophy connected to the idea of certainty. Neither Plato nor John Locke, for instance, would admit the merely probable into the sphere of knowledge. Saying a painting is "probably" by Rogier van der Weyden carries less impact than saying that it is "unquestionably" by the master. Knowing and certainty are connected, but, as we will see in the chapters on deconstruction especially, our search for certainty is difficult, "uncertain," and perhaps even suspect. So what was probably not a major issue in the workshops of the fourteenth and fifteenth centuries has become one to the modern art historian.

Although not much is known about shop practices and how assistants were instructed in the purposes and nature of painting or sculpture, we do have Cennino Cennini's *Il Libro dell'Arte* (usually translated as "The Craftsman's Handbook," but literally meaning "The Book of Art"), which in fact tells us something of the craftsman and his procedures at the end of the fourteenth and beginning of the fifteenth centuries (the manuscript was completed in 1437). Cennini opens his text with statements that reveal his and his culture's attitudes toward art and artists:

> Here begins the craftsman's handbook, made and composed by Cennino of Colle, in the reverence of God, and of The Virgin Mary, and of Saint Eustace, and of Saint Francis, and of Saint John Baptist, and of Saint Anthony of Padua, and, in general, of all the Saints of God; and in the reverence of Giotto, of Taddeo and of Agnolo, Cennino's master; and for the use and good and profit of anyone who wants to enter this profession.

THE FIRST CHAPTER OF THE FIRST SECTION OF THIS BOOK
In the beginning, when Almighty God created heaven and earth, above all animals and foods he created man and woman in his own image, endowing them with every virtue. Then, because of the misfortune which fell upon Adam, through envy, from Lucifer, who by his malice and cunning beguiled him—or rather, Eve, and then Eve, Adam—into sin against the Lord's command: because of this, therefore, God became angry with Adam, and had him driven, him and his companion, forth out of Paradise, saying to them: 'Inasmuch as you have disobeyed the command which God gave you, by your struggles and exertions you shall carry on your lives.' And so Adam, recognizing the error which he had committed, after being so royally endowed by God as the source, beginning, and father of us all, realized theoretically that some means of living by labor had to be found. And so he started with the spade, and Eve, with spinning. Man afterward pursued many useful occupations differing from each other; and some were, and are, more theoretical than otherwise; they could not all be alike, since theory is the most worthy. Close to that, man pursued some related to the one which calls for a basis of that, coupled with skill of hand: and this is an occupation known as painting, which calls for imagination, and skill of hand, in order to discover things not seen, hiding themselves under the shadow of natural objects, and to fix them with the hand, presenting to plain sight what does not actually exist. And it just deserves to be enthroned next to theory crowned with poetry. The justice lies in this: that the poet, with his theory, though he have but one, it makes him worthy, is free to compose and bind together, or not, as he please according to his inclination.

And there's more. But what I have quoted tells us much of the self-conception of the artist in the late Middle Ages. Cennini's text certainly documents theory as well as the "academy" (or tradition of training—the academy not having been yet invented). Cennini places the artist below God and the saints, but connected to them by reverence—which is adoration and homage, as well as by subservience. We know our place. Cennini also sees that he inherited his art from Giotto and then Taddeo and Agnolo Gaddi. So he in a sense creates a short history of art, with him as "epigone," the one who follows or inherits, but who perhaps is not as great as the original Giotto, whom Cennini reveres. Many in the Renaissance believed in the idea of progress, but they sensed the loss from one generation to the next: "we are dwarfs on the shoulders of giants." Others, such as Giorgio Vasari, saw progress as ever ascending, with the present marking the pinnacle of accomplishment. This straight line of connection is a lot like modern art history, which concerns itself with influence and linkage. Cennini also mentions utility, profit, and the well-being of the artist.

Then, Cennini continues his contextualizing by telling us about Adam, Eve, sin, loss of Paradise, and the beginning of "work." Painting is work, part of the "wages" of sin, how we continue to pay for the behavior of our first fa-

ther and mother. But there is something redeeming about this work, because it—art—sits on the throne next to theory, and endows the artist with a degree of freedom and the ability to "bind together" things that had not been there, to reveal and uncover the invisible, to be like the poet. These are "worthy" projects. Together with the humility of the craftsman, Cennini finds worth and dignity, the potential for the individual to create something new. This is the dawn of the Renaissance.

It is, as well, a part of the Middle Ages. Manual or hand labor is what gets most of the attention in the book. Cennini thinks of knowledge in the following terms: "how to work up or grind, how to apply size, to put on cloth, to gesso, to scrape the gessos and smooth them down, to model with gesso, to lay bole, to gild, to burnish; to temper, to lay in; to pounce, to scrape through, to stamp or punch; to mark out, to paint, to embellish, and to varnish, on panel or ancona." And so on, for the rest of the book.

The Renaissance Academy

The idea of an academy in the modern sense, as an organization of free men and women dedicated to learning, revived in the West in Florence in the fifteenth century. Greek scholars, accompanying a delegation from the Eastern Orthodox Church to Florence in the later 1430s to discuss the reunification of the Greek and Roman Churches, reintroduced Plato's writings to Europe. One of the Medici, Lorenzo—known as "the Magnificent"—assisted Marsilio Ficino, a writer and the translator of Plato, in the founding of an academy. Cosimo de' Medici gave Ficino his villa near Puteoli, and in fact it was this house with its gardens that constituted the name "academy." Here intellectuals met informally and discussed Greek philosophy.

But the idea of an academy for painters, sculptors, and architects only appeared in the sixteenth century and is based upon social and intellectual changes in the status of artists and the understanding of art. Leonardo da Vinci never founded an academy, yet he established certain ideas about art that seem to have a lot to do with academic traditions as they have developed over the centuries since the Renaissance. Leonardo saw that there are two conflicting views of the artist's identity: either one can conceive of the artist as a craftsperson whose talent is mechanical, or see him or her as one who works with the mind—what corresponds roughly to our notion of the scientist. In fact, Leonardo made the distinction between *scientia* and *arte meccanicissima*. We might say that in the Renaissance view, the human hand and the human mind occupied different spheres of importance. The mind obviously was more important because it is one's most spiritual and humanizing faculty, and it therefore grants much more prestige to the artist. Much of the

role of the academy has had to do with the artist's social status. The artists of the High Renaissance (c. 1500–1530) made their careers outside the medieval guild system: Leonardo, Michelangelo, and Raphael worked for popes, kings, and princes. And Michelangelo asserted that he sculpted with his mind rather than his hand. So the educational system of the academy implies both humanizing and socializing forces. And the idea that one can teach rather than merely train an artist is also an invention of the Renaissance in the West. In fact, Leonardo suggested a system of teaching that had a "core" curriculum: perspective, the theory and practice of proportion, and the making of drawings from nature as well as those based upon the work of the teacher.

The first formally organized academy for artists, one that corresponds roughly to a modern school of art or a university's department of fine arts, came about through the collaborative efforts of Giorgio Vasari, artist and first art historian, and the Grand Duke of Tuscany, Cosimo I. It is interesting that here state and culture come together. In the middle of the sixteenth century in Italy there were numerous organizations for artists, mostly vestiges of the medieval guild system, based loosely upon which materials the artists used. The academy sought to bring artists together not on the basis of stuff—like paint, fabric, stone—but surrounding an idea: the idea of art, or more specifically *disegno*. It was called the *Accademia del Disegno. Disegno* is related to our word "design," with some important overtones. *Disegno* means both "design" and "drawing"; further, it signals "creativity," although there is not much common understanding about what that means even today. In addition it comes from the Latin *de + signum*, which means "representation by signs"—like language. Vasari's basic desire seems to have been to free the artist from his dependent position in the medieval guild. In that he undoubtedly succeeded, but in the intellectual training of the artist he seems not to have attained all his goals.

There is a similar story to the academy founded in Rome at the end of the sixteenth century. The *Accademia di San Luca* was established on many of the same grounds as the Florentine institute: The founders hoped to improve the rank of artists in society, to free them from the constraints of the guild system, and to provide them with an intellectual background for the creation of art. We know that certain of the early lectures were canceled, suggesting that the artists perhaps were not all that interested in hearing theory. The *Accademia* (dedicated to St. Luke as the patron saint of artists—he was thought to have painted a portrait of Mary and the Infant Jesus) remained little more than a club for the artists. One of the interesting sidelights, however, for the Roman academy is that they admitted nonartists, noblemen, and lovers of art, who were called *accademici d'onore e di grazia*. One wonders if these were not people with an interest in understanding and appreciating art, a lot like the modern art history student?

The French Academy

The most important academic phenomenon in the seventeenth century was the founding in 1648 of the *Académie Royale de Peinture et de Sculpture* by Jean-Baptiste Colbert, as part of King Louis XIV's imperialistic ambitions. The King wanted to control culture, just as he wanted to control everything else. There is a distinct connection between the program of the *Académie* and Louis's political ambitions: he hoped for an art that would propagate and perpetuate his role as the grand monarch. The organization and curriculum of the *Académie* were complex; there were, however, salient features to which I'll restrict myself, as there is not the space to go into a detailed history. The important elements are the following: the emphasis upon convention; the positing of a hierarchy of genres; the role of nature in the concept of the ideal; and the "expression of the passions." All of these bear upon the way we "read" a work of art, how art historians and others search for the literary narrative.

First of all, the idea of convention. This means that the artist does not try to be unique or creative; art springs from previous examples. "The best rules, the best masters" sums up the *Académie*'s attitude toward convention. The student is exhorted to look to the artists of antiquity, to look to the art of Raphael, to look to the art of Poussin. Even though it is somewhat at odds with modernist ideas about originality and creativity, adherence to convention is not a license for copying or plagiarizing. If artists work in a customary style, especially one that is symmetrical, clear, and direct, then they succeed. Artists and amateurs—lovers of art who were not themselves artists—listened to lectures on literature and history, so as to be better informed about their culture and its traditions. The connoisseurs, amateurs, and the interested lay public gathered near the artists to hear presentations (*conférences*, as the *Académie* called them), similar to the way nonstudio art history students come to art history classes today. All of this in the French *Académie*— students drawing from casts, imitating great masters of the past, attending lectures on Western culture—led to a very determined (we might say "overly" determined) style known as French Classicism. Some resisted the stifling aspects of such rigorous training. In the eighteenth century, Denis Diderot advised students to avoid the academic tradition of experiencing life through the screen of culture and convention and to "look in the streets, gardens, markets, houses, for that is where you will get the right idea of the true movement and action of life." This desire to free oneself from the constraints of training, so as to be free, fresh, and open to new experiences, turns up quite often as a hostile reaction to the *Académies*. The Impressionists, especially Degas, were to say much the same thing in the nineteenth century. And it certainly is not unusual to find an art history or studio student today complaining about the shackles of training and the suspect values of the culture being foisted upon them: "I

won't take another boring art history lecture!'' or ''What makes these people think they can teach me creativity?'' The debate between freedom and discipline has been going on for some time.

As one might expect, the reliance upon training in convention led to high quality and to an emphasis upon history painting as the most prestigious form of art. History paintings are works composed of a relatively large number of figures acting out a scene from legend, history, or the Bible. The human images, as in Poussin's *Last Supper* (fig. 3), are carefully placed on stage, with the most important figure ''centered,'' that is, positioned in the middle, a location that in our culture confers dignity and authority. The fact that history painting ranks so high shows how much intellectuals in the seventeenth century loved to make lists in ascending and descending order, so that it was always clear what was more important and what was less.

In 1667, an academician named Félibien published a hierarchy of types of painting. Now there had been since antiquity hierarchies of modes or styles in oration: some speeches, because of the inner significance of their subject matter, were grander than others. But this academic hierarchy of the

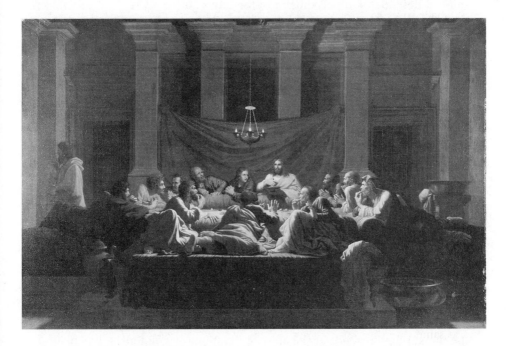

Figure 3. Nicolas Poussin, *The Last Supper*, 1647. The Duke of Southerland (on loan to the National Gallery of Scotland, Edinburgh). Photo: National Gallery of Scotland, Edinburgh.

seventeenth century was based not upon style but upon subject matter. The subjects portrayed either conferred upon or withheld dignity from the picture. The lowest subject was that of immobile objects, what the French call *natures mortes* (literally, "dead natures"), and what the English call the still life. These objects can be shells, fruits, or flowers, for instance. Next up the hierarchical scale are landscapes and paintings of animals. The human figure occupies the higher categories. Low-life or daily scenes are the least significant of these, followed by portraits, historical scenes—contemporary and ancient—and finally at the pinnacle are pictures dealing with the mysteries of the Roman Catholic Church: the Sacraments.

The importance of these distinctions for the art historian is how the tradition of training, and to a certain extent the practice of indoctrinating, establishes a value system that can have political overtones. The social-political historian notes how the academy represents authority and control. The academy attempts to establish a power relationship among the culture, the ruling class, the artist, the public, and the patron. The academy in this and many instances defends the interests of the established institutions: the monarchy, the Church, and the educated elite. By imposing control, through artistic ideology, from above, the academy attempts to establish for itself a secure position as defender and perpetuator of the status quo.

Two other important elements in the makeup of the *Académie,* as formulated in France during the later seventeenth century, are the so-called ideal and the new psychology. We probably all have some general notion of what "ideal" means: it has to do with the perfect, the ultimate, the desirable. And we realize that it is not usually attainable; in fact, our turn-of-the century culture harbors some suspicions about the ideal. To call someone an idealist (often "starry-eyed") is not a compliment. We contrast the ideal with the real, and so did the *Académie.* As many thinkers had done since the days of Plato and Aristotle, those who wrote about the ideal in the seventeenth century believed that there was a realm of the perfect, the unchanging, and the true—in other words, the ideal—somewhere out there beyond the moon. But the reality of the world is messy, cluttered, changing, decaying, imperfect, and oftentimes ugly. The job for the artist is to fix the world, make it perfect again, restore the ideal—and put it in a picture. Nature is raw and amorphous, like the clay of a sculptor, and must be reformed. This allows the artist to be almost godlike.

Besides subjecting nature to the method of the artist (the *Académie* believed that art was *nature mise en methode*), which imposes the artist's conception upon unthinking substance, there is another approach that begins not with a preconception but with an investigation of reality: psychology. Because the human figure stands at the apex of the hierarchy of genres, it is natural that a certain kind of psychology would be developed for investigating the mind. Indeed, there is an old tradition among artists that one should show not just the appearance of the human body, but also the operation of its soul

(Xenophon quoted Socrates as saying that it is the business of the artist to show not only the movements of the body, but the intentions of the soul.) Now the soul (or spirit or mind) is not visible, so how does the artist reveal it? Through the placement of the figure and its gestures. But the academicians of the seventeenth century felt that more than action or motion was necessary to understand our emotions (note that "motion," "emotion," and "motivation" are linguistically linked words) or our inner workings. The human face as a location for understanding human nature received little attention in art before the Renaissance. A face gives identity and appearance, much like a fingerprint, but in the visual arts there was only the occasional demonstration of emotion in the face, such as with a devotional work of art like the *Pietà*. This was to change in the Baroque period.

Charles le Brun of the French *Académie* gave a lecture in 1668 on the human face and how it can display many feelings. The English philosopher John Hobbes believed the passions or emotions of the human soul are best expressed by the motions of the body and changes "in the countenance." René Descartes also wrote on these passions. Charles Le Brun made the practical application of these thoughts to the visual arts. He systematized and categorized the passions, providing students with drawings of stock emotions. The tendency to rationalize and categorize, to see human feelings not as part of the flux and continuity of human experience, but rather as finite cases of clearly determined feelings, is typical of that age. Admiration, boldness, esteem, veneration, ecstasy, disdain, horror, dread, simple love, desire, hope, fear, jealousy, hate, sadness, physical pain, joy, laughter, crying, anger, extreme despair, rage—these were the repertory of human expression. It is interesting that present-day research psychologist Silvan Tomkins claims there are in fact nine basic emotions. Six are the primary emotions of interest, enjoyment, surprise, distress, fear, and anger, followed by shame, disgust, and "dissmell"—the revulsion at something that stinks. These emotions are expressed on the face and are recognizable to all cultures, regardless of language or tradition. These are, as Le Brun probably would have agreed, innate (*Affect, Imagery, Consciousness*, New York: Springer, 1962).

Such concerns have moved out of the academic context for the study of art into mainstream popular culture. We all are relatively expert at reading facial expressions, even those beyond the "top nine," and body language as well. To me, the most common adaptation of the academic study of the ideal, of gestures, and of expressions is to be found on television soap operas. The actors invariably have faces and bodies most would consider ideal; they move with stock arrogance, seductiveness, self-assuredness, or meekness that we all can interpret, and the directors favor many tight shots of their faces, where the few emotions of love, anger, betrayal, and so forth are instantly recognized. Television acting derives rather directly from the Renaissance and academic conventions of painting.

Two other academic issues that spring from the late seventeenth- and

early eighteenth-century traditions concern contemporary art history and art education: first, the interest in debates, or "quarrels," as they were then termed, and second, the beginning of public exhibitions and the defining of a larger art public outside the academy.

The quarrel that surfaced in the *Académie* at the end of the seventeenth century centered around a struggle over authority. From whom do we learn, the "ancients" or the "moderns"? The defenders of the "ancient" position were the more traditional academicians, who believed that *le beau idéal* ("the beautiful ideal") was already discovered and expressed in antiquity, sanctioned by tradition, and confirmed by the High Renaissance and Raphael. For these "ancients," "line" or *disegno* was the essence of art because of its origin in the rational intellect of the artist. The "moderns" believed that contemporary artists and intellectuals could contribute as much as the traditional *beau idéal* to our understanding of the nature of art, and that contemporary artists and rulers (they cited Louis XIV) were every bit as grand as those of the past. For them, "color" was the primary concept in the visual arts, because color, which does not at first appeal to the rational intellect, excites the eye and therefore strikes us more directly, immediately, and deeply. We are more likely to accept a direct visual sensation (color) than we are an intellectual proposition (*disegno*). And we are more easily deceived (although it's a welcomed and desired deception) by color than by line. Color is more concrete; line more abstract. Color is more natural; line more artificial.

But as is usual with such debates, the real terms, the real issues at stake, were only proximately about color and line. More generally they were about the desire to free oneself from an imposed authority; in fact, it had to do with seizing the power, rebelling against the tradition, realizing one's own generation's validity, asserting the aesthetic as well as social autonomy of the artist. As so often happens, no one really won the debate. The *Académie* did not lose its monopoly on art instruction; the insurgents did not create a new, liberated, aesthetic order. The styles of Poussin (cited by the followers of line) and Rubens (by those of color) continued to exist more or less side by side in the eclectic atmosphere of eighteenth-century France.

The artists of the academic tradition knew that their audience was relatively small: the royal court, some wealthy patrons who purchased paintings for their small collections and to decorate their homes, and a sprinkling of connoisseurs and amateurs. This was not a particularly large public.

Beginning in 1737, the *Académie* began holding regular Salons (so called because the first was held in the *Salon Carré* of the Louvre), which lasted about three weeks each. This is the beginning of the modern art exhibition. The public—and it seems to have been a rather amorphous or mixed, rather than elite, public—flocked to these exhibitions, where the paintings were hung floor to ceiling. Viewers eagerly purchased the small guides (*livrets*) that explained what one was seeing. As many as 20,000 of these guides would be sold for a single Salon—sounds like these were blockbuster

exhibitions! Here the modern critic was born. Since it was a public event, writers could not resist making their comments, often haughty and dismissive, equally as often sensitive and engaging. Artists discovered that there existed a large public or market for their art and that one could figure out which section of that market to target. The modern demography of broadcast and print advertising owes something to the discoveries of the eighteenth-century *Académie* and its Salons.

These then are the basic premises and contours of the academic tradition, what we inherit in modern times and incorporate into the teaching of art history as a discipline. Let me here outline some of the other famous academies of the last two centuries, keeping in mind that in their institutional conservatism they have essentially continued the programs of the earlier organizations.

Later Academies

The *Académie Royale* eventually succumbed to the democratic intentions of the French Revolution and was suppressed (1795); finally it was reconstituted as the *Ecole des Beaux-Arts* (School of Fine Arts), a famous school in nineteenth-century France. The Royal Academy in London boasts a long tradition, one that begins under George III in the mid-eighteenth century, and continues today. It was known to be very well regulated in terms of "patronage, protection, and support." The two most important American academies in the nineteenth century, emerging from the European tradition, are the National Academy of Design in New York and the Pennsylvania Academy of the Fine Arts, the oldest continuous academy in the United States and our first art museum.

Probably because of the influence of the Protestant Reformation, early educational policies in the United States were not sympathetic to instruction in art. Colonial schools derived from the Latin grammar schools of England, which taught students how to read and write and to understand the foundations of religion and the laws of their own land. Benjamin Franklin, following some of the progressive ideas of John Locke, believed that drawing should also be introduced into the school curriculum. He wrote, "All should be taught to write a fair hand, and swift, as that is useful to all. And with it may be learnt something of drawing, by imitation of prints, and some of the first principles of perspective" (Efland, p. 45). But generally, instruction in art did not gain an important place in American education for quite some time.

In the nineteenth century, several academies dedicated to the training of artists were established in the United States. As mentioned previously, Philadelphia was the site of an early academy. Already in 1794 an academy existed there, which sponsored exhibitions at Independence Hall; however, because of internal squabbling, it soon failed. The present Pennsylvania

Academy of Fine Arts was constituted in 1807 and held its first public exhibition in 1811. Dissent also accompanied the opening of the National Academy of Design, which in 1826 grew out of the New York Academy. Further disagreements within this organization led to the founding in 1875 of the Art Students League, the first really independent art school in the United States. Most disputes had to do with the availability of life-drawing classes, books, and the accessibility of art collections: some of the same concerns of art history and studio art students today.

The Movement to the University

Until fairly recently, the university tradition in the West, since the Middle Ages, had virtually no concern for the artist or the art historian. By the end of the eighteenth century in Germany, owing mostly to new interests in archeology and antiquities, the study of art history in a form more or less recognizable to us today took hold. The phrase "history of art" as a title first appeared in Johan Winckelmann's *Geschichte der Kunst des Altertums* of 1764, and an early attempt at determining the principles of art history was Karl Friedrich von Rumohr's *Italienische Forschungen* of 1827. Full professorships of art history were established in 1813 at Göttingen, and afterward chairs of art history appeared in universities in Germany, Austria, and Switzerland. Nikolaus Pevsner, who has written the best work on the tradition of the academy, claims that "the first man whom we can call an art historian, and who was Professor of the History of Art, was Franz Kugler at the Academy of Art in Berlin. He was appointed in 1833 and wrote a *History of Painting* in 1837 and a *Handbook of the History of Art* in 1841–1842. At that time Jakob Burckhardt was a student of history at Berlin, under [Leopold von] Ranke; and with Burckhardt the history of art, in our sense, begins." German-speaking countries were the leaders in art history until the exodus of Jewish scholars in the 1930s. And many of them came to America.

The German universities, however, were not interested in teaching the practice of art, which they left to the academies or conservatories, such as those at Düsseldorf, Dresden, and Munich. The first instances of university art courses in the English-speaking world were at Oxford, Cambridge, and University College, London, where the collector and patron Felix Slade established professorships in art in 1868. Some of the most distinguished of modern British art historians have held the Slade chair in modern times: the first was John Ruskin, an interesting writer and art historian who was to have some influence upon the development of art history in the United States.

As one might expect, the establishing of art and art history in U.S. colleges owes much to our prestigious institutions: Harvard, Yale, and Princeton. But in addition to the Ivy League schools, there were lectureships in art

history established at the University of Michigan in 1852, the University of Vermont in 1853, and the College of the City of New York in 1856.

The moving force behind the creation of an art history curriculum at Harvard was Charles Eliot Norton, a man whose reputation continues to impress itself upon the scholarly and educational aims of art history (there is an important lecture series dedicated to him at Harvard). We might say that Norton represents the gentlemanly art of art history. Harvard educated, a writer for *The Atlantic Monthly* and *The Nation*, he spent a considerable amount of time in Europe during the middle years of the nineteenth century. There he came in contact with European culture and the ideas of John Ruskin. Ruskin was violently opposed to the then popular idea of "art for art's sake," an aesthetic point of view that threatens to isolate art from other human activities. Like many modern art historians, the British writer believed that the art of a particular period reflects its society, but in a manner entirely different from how Karl Marx would have construed the connection. For Ruskin, art reflects the ethical concerns of the cultured elite of a society; Marx, of course, saw art, like other cultural products, as inevitably tied to the economic basis of life, to the means of production and the resulting conflicting relations among the classes. But Norton, like Ruskin (with whom he became friends), discovered something ennobling in the study of art and its connections to culture and literature. His sense of the rawness and barrenness of American life contrasted with the European tradition of beauty. The old idea of "Truth is Beauty and Beauty Truth," with its vagueness and its insistence upon the self-evident, probably impressed Norton. When in 1874 he was invited by the president of Harvard to become a professor of fine arts, he eagerly took up the position, as if it were a cause, and asserted in one of his letters to Ruskin "there cannot be . . . good painting or sculpture, or architecture, unless men have something to express which is the result of long training of soul and sense in the ways of high living and true thought." This, it seems to me, is one of the most hallowed (and perhaps banal) traditions in art history: that by studying art, one becomes more civilized, discovers his or her potential, spirit, and ideal. A larger percentage of women's than men's colleges, by the way, offered art history and studio training in the early years of the twentieth century. Professor Norton believed that training in the practice of art should accompany his art history lectures—enormously popular at Harvard—and this was done, but with far fewer participants than in his regular course. The canon, or privileged list of art objects, formed the core of Norton's list of works to be discussed: the works of ancient Greece, medieval Venice (a love he learned from Ruskin, who had written *The Stones of Venice*), and the Italian Renaissance. He felt that very little art of any consequence had been produced since about 1550.

Yale actually built a school of fine arts in 1864, but art history was not emphasized in these early years; nor was it at Syracuse University, which also opened an art school in the last quarter of the nineteenth century. Princeton

on the other hand attempted to define the discipline of art history as distinct from archeology and classics, the only departments in the early nineteenth century that dealt with works of art in a historical manner. In 1882 the university appointed two professors, one for classical studies, the other for post-classical art. Interestingly enough, the Fine Arts Department of Princeton did not believe itself capable of teaching "appreciation"—that was a talent one either had or not—but relied instead upon facts: names, dates, schools.

There was a strong sense of the "impracticality" of art history in these early years, an issue that continues to bother students today. I often hear a student ask, "But what can I do with art history?" F. F. Frederick in his study of the fine arts in American higher education at the turning of the last century commented on the particular nature of art historical studies for the undergraduate: "It is the aim of students . . . to know about fine art, and to know it systematically and fully, without thought of its immediate application. And it is the aim of these universities to encourage in the student this high form of thinking—this study of pure fine art, if we may use the term as in speaking of pure mathematics—as far removed as possible from the affairs of practical life." This of course reflects both Kantian "disinterestedness" and the "art-for-art's-sake movement." To a certain extent, Frederick's attitude reflects the connoisseur's and antiquarian's notion that there is something about taste—the *je ne sais quoi*—in the appreciation of fine art. Either you get it or you don't.

At the turn of the twentieth century, art history courses were given at a large number of American universities, both public and private. There were basically two kinds of offerings: the introductory survey, which generally met three times a week for an hour per meeting, and which proceeded chronologically; and the nonchronological format that covered great works of art in terms of style, important ideas, or typical artistic problems. These more thematic courses were for the nonmajor. The colleges apparently were aware that students received little or no instruction in the history of art in secondary schools, so their beginning art history courses were more foundational and introductory than, say, courses in the sciences or mathematics. As evidence of the marginal importance given to art history at this time, it was extremely rare to require it as part of the general college curriculum.

A survey by the College Art Association of offerings in a representative sampling of fifty American colleges and universities spread throughout the United States showed that in 1940 there were more than 800 art history courses listed, which marks a dramatic increase over the offerings in 1900. Harvard had the largest list, with sixty-one courses. Because art history, especially in the United States, had its beginnings in departments of classics and classical archeology, most of the courses offered in the early part of the twentieth century were in ancient art. All subsequent periods diminished in popularity, with perhaps the least emphasis being given, in the early part of the

century, to American art. The general tendency was away from classics and toward what we now see as the traditional courses in art history: ancient, medieval, renaissance, baroque, modern, and American art. And it became less common for art history to be taught outside of its own department, as it had been included in classics, history, German, studio art, and other subjects. By the middle of the twentieth century, university offerings in art history were fairly well stabilized and remained so into the 1980s, when new changes began.

One of the most important impetuses to art history in the United States occurred in the 1930s as the result of the migration of German art historians to America. National Socialism, or Nazism as it is better known, was both anti-intellectual and anti-Semitic. The promulgation of the Nuremberg articles in 1933 purged German universities of Jewish, radical, and "decadent" artists and scholars. Within the space of a week in April of that year, many hundreds of scholars in the scientific, sociological, and humanistic disciplines suddenly found themselves without work, without a future. The United States and Great Britain profited enormously by Hitler's freezing out of Germany's intellectuals. Walter W. S. Cook of the Institute of Fine Arts in New York City said that he really believed Hitler was his friend, because the Führer shook the tree and Cook gathered the apples. He got the best art historians.

These German-trained, Jewish art historians brought a remarkable range of methodological backgrounds with them to the United States. American art history has been known for its highly developed techniques in establishing facts: the who, the what, the when, the where, and the how. But the why . . . well, there's a traditional American suspicion of asking questions that sound metaphysical or mystical. Why ask why? German art history—*Kunstgeschichte*—had been long established and was largely interdisciplinary. Therefore there was great interest in the question of why things look, function, and mean the way they do as works of art. It can be argued—and indeed has been many times—that art history is really the fruit of many disciplines, although itself may not be one. In Germany, ideas in sociology and economics, psychology, linguistics and philology, history, and especially philosophy had informed art history thinking. The study of literature, literary history, and theory were known and taught in the United States, but didn't have much effect on art history. Similarly, history and philosophy were considered separate disciplines from art history and, in the tradition of the American university, went their separate ways. The immigration of German and Jewish refugee art historians to the United States changed things significantly.

Kunstgeschichte American Style, as Colin Eisler has dubbed it, was characterized by new perspectives in Marxism, psychoanalysis, *Weltanschauung* (worldview), *Kunstwollen* (the will to create art), *Geistesgeschichte* (intellectual history), philosophy, and iconography. These various points of view greatly intellectualized the study of the history of art in America.

The American tradition of objectivity and practicality met the German penchant for theory. Here's how one of the best known German immigrant art historians, Erwin Panofsky, described the meeting of cultures:

> To be immediately and permanently exposed to an art history without provincial limitations in time and space, and to take part in the development of a discipline still animated by a spirit of youthful adventurousness, brought perhaps the most essential gains which the immigrant scholar could reap from his transmigration. But in addition it was a blessing for him to come into contact—and occasionally into conflict—with an Anglo-Saxon positivism which is, in principle, distrustful of abstract speculation. . . .

And of his need to write in English now, rather than in his native language, Panofsky writes, ". . . every German-educated art historian endeavoring to make himself understood in English had to make up his own dictionary. In doing so he realized that his native terminology was often either unnecessarily recondite or downright imprecise. . . ." The philosophical and the practical joined together to form a new art history in the 1930s and 1940s. The effects are still with us.

James Ackerman, then the editor of the *Art Bulletin*, commented to the nation's artists and art historians at a convention in 1958 that art history was flourishing as never before: "The practice of art, history, and aesthetics have become integral to higher education, and are respected disciplines where they were once peripheral recreations." Along with the growth of art history, he noted a remarkable precision and objectivity in the American style of art history. He commented on the practice, still fairly common, of teaching "surveys" of art history in which "one slices the pie of history into large or small helpings of period and area and then one eats it chronologically." The danger in doing this—and presumably the hazard continues—is that we are training future art historians rather than addressing the larger public who perhaps are more interested in ideas, themes, appreciation, or some form of philosophical understanding. Ackerman found a theoretical innocence in the teaching of art history in the United States: we simply weren't—and probably still aren't—all that aware of our assumptions and conventions, of the basis from which we teach. Despite the influence of the immigrant art historians on the writing and teaching of art history, "Anglo-Saxon positivism" still had enormous authority. As a report by the College Art Association commented in the mid-1960s: "American art history has maintained a markedly cautious tone and conservative temper. Soundness rather than daring or brilliance, is its chief quality." The report goes on to say that our essential conservatism flourishes in the groves of academe:

> The preoccupation with soundness, the overemphasis on method, the caution and conservatism of American art history are university-bred qualities. They are academic qualities. Like the eclectic campus architecture which

surrounds him, the American student and scholar in the humanities is profoundly conditioned by the economics of the academic marketplace and the bureaucratic patterns of university administration. From his student years onward, he passes through a succession of tests and ordeals which are designed to weed out the unsound and unacademic. The acceptance procedures of graduate programs and the hiring policies of departments, the world of committee action and deanly decree—all these are designed to smooth out irregularity and to minimize eccentricity.

Although art history looked like a strong and growing academic discipline back in the late 1950s, Ackerman worried that it didn't quite know its direction or purpose. That problematical situation seems to exist today. Perhaps there's been a degree of parochialism in the graduate training of art historians. At least into the early 1970s, five schools—all in the Northeast—produced most of the Ph.D.'s in art history: Harvard, New York University's Institute of Fine Arts, Princeton, Yale, and Columbia. Since then, the major state universities in the Midwest, South, and West have been training art historians in larger numbers. This greater geographical diversity is probably having some effect on the acceptance and promotion of new theories and methods in the writing about and teaching of art history, although there has been no comprehensive survey as yet to prove this point.

Art history is well established in American colleges and universities as part of the general study of the liberal arts and humanities, and yet its precise role in the curriculum is not very clear. Looking through university catalogues, one is apt to find in the sections that seek to justify the school's requirements and course offerings some reference to how important the appreciation of art is in the civilizing process. Can you imagine anyone saying this about physics or biology?

Art history's nature, function, purpose, and justification: These are the complex issues that I am trying to approach in a variety of ways in this text. I've written about theories of art and art history from antiquity to the present and also about the complexities of contemporary critical discourse within the humanities and art history. Before summarizing the chapter on the academy and art, I want to discuss generally and briefly the way art history has been taught in the last several generations. These procedures are undergoing rapid change.

The British-Austrian art historian E. H. Gombrich writes about the fascinating, almost mesmerizing, lectures given by Heinrich Wölfflin at the University of Berlin. Wölfflin would simultaneously project two photographic slide images of works of art before the students and then discuss their stylistic similarities and differences. The development of the projector and the diapositive (slide) image revolutionized the study of art. Now one could bring together paintings, sculpture, architecture from throughout the world and show them next to one another. The classroom had become an instant, personal, and ever-changing museum. Gombrich, however, sensed a certain dan-

ger in this art history theater: perhaps false and facile analogies were being drawn. The world of art was being seen in binary oppositions that were almost too symmetrical (such as Wölfflin's pitting of the Renaissance against the baroque; see the subsequent section on Wölfflin). Still the comparative method has dominated the teaching of art history in the American university throughout much of the twentieth century. Many art historians would have a difficult time lecturing in a well-lighted room without visual aids.

It isn't easy to characterize the way all art historians teach, but there are certain patterns or styles of teaching that have more or less predominated over the past forty years. Students enter a room, which may vary in size from a 500-seat auditorium to a small room with perhaps twenty seats. The lights go down and the slides come up. The professor, except in the more specialized or thematically oriented courses, proceeds to tell a story about art from one point in time to another, usually organized in terms of historical periods: antiquity, Middle Ages, Renaissance, baroque, rococo, romantic, and so on until the present time. Each period is supposed to have a recognizable style to its art; students are expected to know what the stylistic elements of each period are. Usually the survey unfolds according to a fairly common formula. The professor begins with the earlier works and moves forward in time, pointing out the changes and evolutions in style, the personal styles of individual artists, and how the artist alters his or her style with time. Form and content are wrestled with, explained, distinguished. The iconography (content) generally is alien to the contemporary student, so the professor needs to give some background on subject matter and its meaning. Then commences the subtle work of attaching style (form) to subject matter to reveal an even deeper level of meaning. This is the tricky part, and often leaves students—especially those who do not have a good "eye"—confused. But the work continues. Come test time, students often are expected to know the name of the artist (where applicable), title of the work of art, and date. The student also, if writing an essay, has to demonstrate historical, stylistic, and iconographic skills.

Although I've greatly condensed and simplified a complex procedure, I believe I've given an accurate sketch of the contemporary academic model of art history as taught at the introductory, undergraduate level. From this kind of training students should develop a fairly clear picture of the contours of world art—although with an emphasis still upon the Western tradition—and a sense of who did what, when, where, how, and (but rarely) why. If a student comes to love art, to be moved by it in some deep and inexplicable way, so that it turns out to be his or her vocation, then something nearly magical has happened. But this often depends more upon the character of the student than the quality of the professor, and probably has no bearing on the critical theory of art history.

There are many suppositions underlying the way we teach art history, why we art historians do the things we do. And there certainly is more varia-

tion on the basic model than I've suggested here. The new approaches as well as the philosophical and ideological underpinnings of the standard model will be addressed in the later chapters of this text. And the role of the academy will once again come into play: for some of the most difficult and obscure theories of interpretation have been nurtured in the university.

Conclusion

The academy is the setting and location for learning: it is the surroundings, the furnishings, the physical framework for discussion and instruction. The origin of the idea in the West is found in the garden, which is a piece of arranged or composed landscape cut off from the larger environment, much like the campus (which comes from the Latin *campus*, meaning "field") of an American university. The procedures and interests of the academy range from the practical, to the cognitive, the social, and the authoritarian.

There are "pre-academic" institutions, such as the Roman Catholic Church and the medieval craft guilds. Neither of these had as its primary concern the intellectual development of the artist or the connoisseur (what I'm thinking of as a precursor to the modern art historian or student of art history). The Church wanted art to teach. There is the common belief that a picture is worth a thousand words; whether there is any sense to such a pronouncement, it has been widely held. And as we've seen, the Church promoted such a view. The guilds existed primarily for practical reasons: to train the artist and to protect him. In the Middle Ages one thought of the artist as a worker, one whose hands were more important than his mind, but in our look backward we have seen that this split between hand and mind, although not resolved, reversed itself. With the founding of the academy in Renaissance Italy, the artist's social status and intellectual ambitions increased. The cognitive ability of the artist, not just some relatively insignificant knack, received attention; in fact, this ability was nurtured in the academy. As with most institutions, academies, as they increased in numbers, came to have fairly complex agendas. The French *Académie*, for instance, served the state and the ruling classes as well as the artist. Both outside and inside the *Académie*, a definable public, one beyond connoisseurs and collectors, formed in the eighteenth century. Museums became alternative academies in the nineteenth century. Perhaps the most significant change in the twentieth century was the mass movement of artistic training from conservatories or academies to the universities; this has been especially true in the United States. And the worthy, old tradition of connoisseurship and dilettantism has become a particular discipline in the university: art history. A collateral development in the academy that has occasioned a lot of discussion and antagonism is the development of what has been called "critical theory." Although departments of linguistics, languages, literature, and philosophy

first championed the new theories of criticism, they have breached the walls of the citadel of art history, upsetting many, encouraging and stimulating others.

◆

Bibliography

BARASCH, MOSHE, "Classicism and Academy," *Theories of Art from Plato to Winckelmann.* New York: New York University Press, 1985, pp. 310–377.

BOSCHLOO, A. W. A., et al., eds., *Academies of Art: Between Renaissance and Romanticism.* The Hague: SDU Vitgeverij, 1989.

CENNINI, CENNINO, *The Craftsman's Handbook: The Italian "Il Libro Dell'Arte"* (trans. Daniel V. Thompson, Jr.). New York: Dover, 1954.

EISLER, COLIN, "Kunstgeschichte American Style: A Study in Migration," *The Intellectual Migration : Europe and America, 1930–1960* (eds. Donald Fleming and Bernard Bailyn). Cambridge, Mass.: Harvard University Press, 1969.

EFLAND, ARTHUR, *A History of Art Education.* New York: Teachers College Press, 1990.

GOLDWATER, ROBERT J., "The Teaching of Art in the Colleges of the United States," *College Art Journal* (May 1943).

HISS, PRISCILLA, and ROBERT FANSLER, *Research in Fine Arts at the Colleges and Universities of the United States.* New York, Carnegie Corporation, 1934.

PANOFSKY, ERWIN, "Three Decades of Art History in the United States: Impressions of a Transplanted European," *Meaning in the Visual Arts.* New York: Doubleday, 1955, pp. 321–346.

PEVSNER, NIKOLAUS, *Academies of Art, Past and Present.* New York: Da Capo Press, 1973.

RITCHIE, ANDREW, *The Visual Arts in Higher Education.* New York: College Art Association of America, 1966.

Part Two

WHAT IS ART? ANSWERS FROM ANTIQUITY TO THE EIGHTEENTH CENTURY

What if someone were to ask you, "What is art?" Chances are you wouldn't have much of an answer. We seem reasonably sure about what a car mechanic does . . . but an artist? Art may have been a straightforward activity at one time, but no longer. The making and displaying of art and the writing about art have been especially problematical over the past century. Beginning students in art history courses that deal with modern and contemporary art are invariably perplexed by abstract art, pop art, hyperrealism, conceptual art, postmodernism—to name just a few examples of difficult styles and approaches. Occasionally students can't find any evidence of talent—something they believe should be demonstrated—or the subject matter may seem so bizarre (or so silly) that they are at a loss to explain it. Then, on the other hand, students often believe that art is such a subjective and eccentric thing that there really can be no agreement about what it means or why it's made. "Your opinion is as good as mine" is a fairly common response.

In fact, definitions of "art" and its sometime companion, "beauty," have never been simple matters. Yet, throughout history, thinkers and artists have attempted to describe and assess art and beauty. The modern student of art history will discover that there have been some fairly consistent approaches to the problem of definition and that these attempts at understanding have a bearing on what goes on in the current practice of teaching and writing about art history.

1

Ancient Theory

Plato

As most historians do, we begin with Plato. We have to rummage a bit through his philosophy to find those elements that can go toward formulating a theory of art. Plato reveals that he knows about the visual arts (there is even a tradition that he was trained as an artist), but he never really addresses the question "What is art?" It's likely that this query concerned him less than it does us. Remember, at that time art was considered a craft rather than something more noble; its status was not high, and even its procedures were suspect to Plato.

Plato, like his contemporaries, really had no word to correspond to our understanding of "art." The nearest word in Greek is *techne*, comparable to our idea of "technique." *Techne* is treated by Plato as a deliberate, conscious, intended action, something very different from that which occurs in nature (*physis*), where things arise without a driving, conscious force—where things just happen.

Rather than constructing artistic notions around *techne*, however, Plato prefers the term *mimesis*. *Mimesis* means "imitation," in the fairly direct sense of copying from nature; but, for Plato, things as they appear in nature are mere reflections of their true identity. He believes that there are universal essences, what he calls the True, the Good, and the Beautiful. These, although immaterial, are the ultimate reality, against which other phenomena must be gauged. Because Plato's scheme of things is hierarchical, everything is arranged in an ascending or descending order, depending upon its proximity to the realm of forms: the True, the Good, the Beautiful. *Mimesis*, which results in an image, reflects but barely participates in the final realm. Therefore, a work of representation derives but is distanced from absolute existence: It is a suggestion, elicitation, evocation, shadowing. This kind of language, especially the use of the word "shadow," will turn up in later art theory. There's virtually no reality in a work of art.

Plato discusses the meaning of this separation of painting or sculpture from the original in Book X of the *Republic*, his treatise on the concerns of the ideal state. In Plato's time there were new ideas being put forth by the so-called Sophists that honored poets and painters over philosophers. Plato disagrees with such a notion and wants to set things straight. According to Plato, only the philosopher, not the poet or the artist, can interpret the divine forms through the method of "dialectic," a process of reasoning that uses questions and answers to lead one to the truth.

To demonstrate this, Plato uses the humble, common example of the bed. First of all, there is the general idea of "bed," a kind of perfect bed existing in the realm of forms. A particular craftsperson makes a particular bed, one that may be functional but that is imperfect: It is subject to change, error, discomfort, decay; it can be rumpled and broken. Nonetheless, the craftsperson participates, however meagerly, in the original idea, because he knows what a bed is and how to make one. The painter, on the other hand, may know how to paint, but he or she does not necessarily know how to construct a bed. The two-dimensional representation of the bed is merely a copy of something that already is a copy of the true "bed" existing in the realm of forms. Therefore, the artist is at two removes from reality. That displacement from the true puts the artist below the craftsperson, makes him or her a somewhat dangerous purveyor of illusion and deceit. Because of their "dishonest" behavior, Plato bans artists from the Republic.

For us, beauty and art are, if not synonymous, at least related. Plato sees no connection. Just the same, he develops a philosophy of beauty that comes to inform various theories of art, so we need briefly to consider it.

Because Plato believes that ultimate reality is beyond the physical, his language is abstract. "Beauty" is an idea: It is being, unrelated to space and time, part of the great trinity of the True, the Good, and the Beautiful. Beauty can appear in this world in the guise of a beautiful young beloved (usually a boy or young man; Plato's imagery is frankly homosexual), who is godlike, or it can appear in some other thing (rarely an art object) that displays harmony, symmetry, and measure: what in antiquity generally is called *symmetria*.

Plato owes much to Pythagoras here, who associated number with the nature of the cosmos. Pythagoras (sixth century B.C.) noted that a taut, vibrating cord held firmly at certain points along its length created ratios in the frequency of vibration. If one holds the cord in the middle, the number of vibrations doubles, for instance. Certain intervals of the musical scale can be expressed in ratios of 6:8, 9:12, and so on. Pythagoras then took these ratios and applied them to the universe: He asserted that the harmony of music expresses the harmony of the cosmos. This is a remarkable leap of imagination and has had much to do with subsequent theories of beauty.

According to Plato, our souls before they entered the body had a vision of beauty. When something in our experience excites that sensation, we draw upon our spiritual memory. Those of us who had souls with the clearest vi-

sion in pre-life (philosophers, as you might expect, have the keenest pre-life sight; artists are relatively blind in this regard) recapture the experience, the vision, of beauty through memory. Our recollection can give rise to an almost divine madness. In *Phaedrus*, Plato writes of a "kind of madness which is imputed to him, who, when he sees the beauty of the earth is transported with the recollection of the true beauty." The power of beauty results from an intense yearning to return to something better and more true than this fallen existence on earth.

But finding earthly beauty is not an end in itself, rather it signals the beginning of an ascent, just like going up a ladder. In fact, the metaphor of the ladder is the one Plato employs in the *Symposium*. The lover (it is the erotic impulse that begins the contemplation of beauty) who has excited within him a pre-life vision of beauty moves, as if from one rung to another, from the contemplation of physical beauty to an awareness of the true and everlasting beauty that exists in the realm of ideas. Here Plato shows himself to be a mystic: Experiencing earthly beauty is but the beginning of an ascending journey. He writes in the *Symposium* that "the true order of going is to use the beauties of earth as steps along which [a human] mounts upwards . . . for the sake of that other beauty."

I don't think this is an alien experience to us; it's not that unusual for someone to be transported by a work of art or some other aesthetic moment. The abstract expressionist painter Mark Rothko claimed that he wished to take us all on a journey into the unknown. For Plato it's a journey into the remembered rather than the unseen, but a trip just the same. The purpose of such a pilgrimage for Plato is not the creation of something new but the knowing of something that already was there. Reality is complete; humans cannot add to it, they can only discover it. Beauty is independent of someone trying to perceive it.

Aristotle

Aristotle follows Plato and posits a different "epistemology" (system of truth or philosophy of knowing). Raphael's *School of Athens* (fig. 4) depicts Plato and Aristotle in opposing terms, with Plato pointing upward toward the realm of forms, and Aristotle gesturing in the direction of the world, because his knowledge came from objects, the physical phenomena of experience. As Leonardo was later to paraphrase Aristotle, "all our knowledge has its origin in our perceptions." (It is somewhat ironic that, in the painting, Raphael would depict Plato rather than Aristotle in the guise of the aging Leonardo). Of course a single painting cannot explicate complex philosophical discourses, but it can give us a forceful image of them.

As with Plato, we have to piece together remarks from various sources to get a sense of Aristotle's aesthetics, especially as they relate to the visual arts. He wrote *Rhetoric* and *Poetics,* and we know—although these writings do

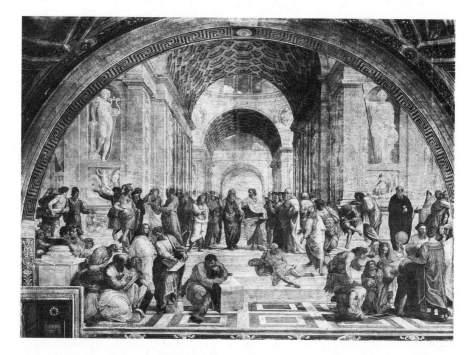

Figure 4. Raphael, *The School of Athens*, 1510–1511; fresco. Stanza della Segnatura, Vatican Palace, Rome. Photo: Alinari, Florence.

not survive—that there were texts on literature and music. But apparently he never composed anything specifically dedicated to the visual arts.

Perhaps the most telling difference between Aristotle and Plato concerns imitation (*mimesis*). In Aristotle's view, the artist or tragedian has the freedom to represent things as they are, as they ought to be, or as they might be. Men and women can be depicted who are like the rest of us, or better, or worse. But the artist's freedom is moderated by the need to keep to the general, the typical, and the essential. Aristotle has quite a bit to say about tragedy, but we're limiting ourselves here to those comments that have enough generality to apply to the visual arts as well. For instance, Aristotle believes that imitation involves human action, and that conception makes sense for painting and sculpture and some of the other issues arising from his *Rhetoric* and *Poetics*. Things such as pity and fear, catharsis, and the unity of form—with a beginning, a middle, and an end—are salient points in his aesthetic philosophy. I'll discuss these elements in more detail in the subsequent section on architecture.

Aristotle tries to explain art in terms of its causes; in fact, his philosophy builds upon his causal structure. There are four causes for any phenomenon: the efficient, the material, the formal, and the final. If we use a statue as an example, we can demonstrate this scheme. The efficient cause of a statue is

the sculptor and his or her procedure. The material cause addresses the medium: what is it made of, and what does the stuff of the statue have to do with the work's nature? The formal cause is the statue's shape, its literal form. And the final cause results from intentions and consequences. For whom was the statue made? Why? These questions for Aristotle are forms of general explanation, ways of understanding.

The art historian finds particular interest in the efficient cause of a work of art because it has to do with the artist, his or her personality, his or her delight in making, and the context of his or her life (there are efficient causes for efficient causes). The art historian wants to understand how the artist's impulse to create is rooted in culture and biology—in both nurture and nature.

For Aristotle, the final cause of a work of art arises from our need to know. But how does one "know" from a work of art? Aristotle is not clear on this.

And, like Plato, Aristotle concerns himself with beauty, but he does not relate it necessarily to the visual arts. Beauty is a function of form, more or less. He writes in the *Poetics* that

> Beauty is a matter of size and order. What is a matter of art is the limit set by the very nature of the action, namely, that the longer is always the more beautiful, provided that the unity of the whole is clearly perceived. A simple and sufficient definition is: such length as will allow a sequence of events to result in a change from bad to good fortune or from good fortune to bad in accordance with what is probable or inevitable.

Beauty is not abstract for Aristotle; it is grounded in an object, a thing. It is context-bound: beauty requires an object, a place. By itself the notion of beauty means nothing. Aristotle makes no claim for an abstract good or an abstract beautiful.

Treatises by Ancient Artists

We know from surviving sources that a number of art treatises existed in antiquity, although most have been lost. Such a famous painter as Parrhasius wrote *On Painting*, but the text no longer exists. Iktinos, the architect of the Parthenon, explicated an architectural theory, but his writings do not survive. Polykleitos, the sculptor of the *Spear-Bearer*, wrote the *Canon*, in which he set out the rules for making sculpture. Again, this text is lost, but we can draw some inferences from other ancient sources and get an idea of Polykleitos' theory and practice.

The *Doryphoros* or *Spear-Bearer* (fig. 5), made to illustrate the *Canon*, does not survive in the original; we know it only through Roman copies, literary descriptions, and a bronze reconstruction made in the 1930s (illustrated

here). When in the course of their history Greek artists began investing ratio-
nal values in sculpture, Polykleitos created a theory of art and made this
statue to illustrate it. The *Spear-Bearer* is at once a text and an image, a highly
contrived idea and a seemingly poised, relaxed, natural youth. Artists and
writers of antiquity referred to this statue as a paradigm of art. If we had the
original figure, we probably could understand better the extraordinary signif-
icance it once had.

Pliny the Elder, a Roman writer of the first century A.D., describes the
Spear-Bearer by Polykleitos as "a boy of manly form bearing a lance, called 'the
Canon' by artists, who draw from it the rudiments of art as from a code (so
that Polykleitos is held to be the only man who has embodied art itself in a
work of art)." He also mentions that Polykleitos' statues characteristically
"step forward with one leg." So we have given to us the significance of the
statue along with its essential and typical aspect.

The appearance, with one leg forward, is that contrived stance known
as counter-poise, or *contrapposto*, often deployed in ancient (and Renais-
sance) sculpture. As an arrangement for a figure, counter-poise demon-
strates the potential of the human body: It stands at rest, but shows an ability
to move. Weight is distributed to engage the supporting members, as well as
to those that are relaxed. The "mind" too is employed. Often we impute hu-
man character and sensibility to a work of art; this one, especially, rewards
that desire for identification and empathy. By assuming the *contrapposto* posi-

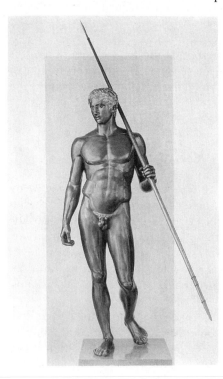

Figure 5. Polykleitos, *Doryphoros* (*Spear-
Bearer*), c. 450–440 B.C.; bronze recon-
struction. Universität, Munich. Photo:
Studio Koppermann, Gauting, Germany.

tion, the *Spear-Bearer* adjusts himself to interact with surrounding space in an emotional and physical manner. His head turns from the central axis of his figure, suggesting attention and the potential decision to move on. Although the head of the *Spear-Bearer*, like so many faces in the classical period of Greek sculpture, has a dreamy and abstracted expression, he retains mental presence. We sense a mood there, even if we can't be sure precisely what it is.

Notwithstanding the absence of the original statue and its accompanying text, we can surmise Polykleitos' intentions. Classicist and art historian Gisela Richter suggests that the *Canon*, the imbedded idea of "art" within art, was about proportions, either arithmetical or geometrical. Arithmetical proportions are based on certain measurements, like the interval between the two knuckles of the thumb, from which every other measurement in the body is worked out in multiples of this basic module. The ancient writer Galen states that beauty consists "in the proportions not only of the elements but of the parts, that is to say, of finger to finger and of all the fingers to the palm and wrist, and of these to the forearm, and of the forearm to the upper arm, and of all the parts to each others, as they are set forth in the Canon of Polykleitos." This interrelation of parts suggests something beyond linear measurement; that is, the ratio of part to part is geometrical because volumes, not just lines, compare to one another.

This is an example, as J. J. Pollitt remarks, of *symmetria*, "the commensurability of parts," which has a philosophical underpinning. Deriving ultimately from the Pythagoreans, a belief that numbers underlie both physical and abstract phenomena served to anchor human experience and action in a stable and comprehensible universe. Numbers reveal divine presence in the human sphere. The *Spear-Bearer* becomes an instance of the perfect, the beautiful, the ideal.

Architecture and Order

So far we have looked to the philosophers Plato and Aristotle for their comments on art, and we have been able to find theoretical attitudes and designs, if not comprehensive philosophies, on the arts. One also can reconstruct in part a famous treatise from antiquity: the *Canon* of Polykleitos. But none of this applies with any great precision to architecture, clearly one of the significant contributions of ancient Western civilization. To write about architecture as an art form requires that we survey ancient literature so as to construe attitudes and ideas on how writers and critics looked upon and conceived architecture as an expression of their culture and values. Actually, the results of this activity can be quite rich, as witnessed by several important studies of classical architecture and its humanistic principles.

There are certain categories of sources for architectural theory in antiquity. The first that I'll consider involves the ancient traditions of poetics and

rhetoric, already referred to in my discussions of Plato and Aristotle; the second is the more specific formulations put forth by Vitruvius, an architect in the early years of the Roman Empire.

The ancient texts on poetics and rhetoric were so fundamental that they can be seen to inform all the humanistic pursuits, such as poetry, tragedy, literature in general, the visual arts, and architecture. Both poetics and rhetoric in the Greek world are founded upon the idea of order.

The word *poeisis* comes from the Greek and means basically "making," in a constructive and methodical fashion. In Aristotle's *Poetics* he seeks to draw distinctions and set up categories within literature. For instance, he differentiates on the basis of medium, object imitated, and the manner of imitation or point of view in narration. A work of art, be it literature or by extension architecture (keeping in mind of course that Aristotle probably did not think of building as an art form and, therefore, the proper subject of poetics), can move the spectator either through pity and fear (as with tragedy) or through awe, which is a wonderment at something beyond our comprehension. A work of art can arouse feelings of great intensity. What is the attraction, the pleasure of such a sensation? When we fear an event in tragedy or pity the hero, we get little or no satisfaction from that emotion. Similarly, a well-wrought building in and of itself probably does little to shake us down to our toes. But if one identifies with the work of art by knowing something about it—and this seems to happen quite often—then the beginning of the aesthetic experience is possible. The end, for Aristotle and others, is purgation or catharsis.

Aristotle observed that "those who are liable to pity and fear and in general persons of emotional temperament pass through a like experience . . . they all undergo a catharsis of some kind and feel a pleasurable experience." Even though we identify with the work, we recall our distance, our safety, our nonannihilation by the object. This results in a release of pleasurable energy. So catharsis is not just edifying, it is purging and purifying. It is almost medicinal: Both the body and soul are relieved and somehow cleansed. Notice what the art historian Rudolf Wittkower writes about the cathartic effect of Christian architecture in his discussion of a Renaissance treatise on architecture (which of course is based upon classical ideas): A Christian church "should be the noblest ornament of a city and its beauty should surpass imagination. It is this staggering beauty which awakens sublime sensations and arouses piety in the people. It has a purifying effect and produces the state of innocence which is pleasing to God." And Tzonis and Lefaivre in their study of classical architecture comment that anyone creating a work of art participates in what they call "worldmaking," which means that the artist creates something new and separate, although analogous to the so-called real world. Plato referred to the "demiurge," the original creator who, by extension into this world, could be identified with the artist. Tzonis and Lefaivre write that

the purpose of this worldmaking . . . is to "instruct and persuade" according to the classical rhetoricians, to "purge," that is carry out a "catharsis" of the emotions [what Wittkower referred to as the sense of piety and innocence]. The work should affect the minds of the audience for the sake of public good. It should edify wisely, consult and comment judiciously, defend and praise, rouse consciousness, and criticize. (p. 5)

Tzonis and Lefaivre bring together both the ideas of rhetoric (which, in its most basic, oratorical form has to do with the art of persuasion) and the elements of poetics.

We also know that ancient architects frequently wrote commentaries on their buildings; however, the texts if not the temples all are lost. We can, just the same, infer some of their concerns by reading the *Ten Books of Architecture* by the Roman architect Vitruvius, who claims to have known earlier treatises.

Like the rhetorician, Vitruvius sets up formal categories for architecture, establishing those forms—that conscious sense of arrangement—that are necessary to make the building expressive and coherent. He calls these the fundamental principles of architecture.

1. Order: "Order gives due measure to the members of a work considered separately, and symmetrical agreement to the proportions of the whole."
2. Arrangement: ". . . includes the putting of things in their proper places. . . ."
3. Eurythmy: ". . . is beauty and fitness in the adjustments of the members. This is found when the members of a work are of a height suited to their breadth, of a breadth suited to their length, and, in a word, when they all correspond symmetrically."
4. Symmetry: ". . . is a proper agreement between the members of the work itself, and the relation between the different parts and the whole general scheme, in accordance with a certain part selected as standard."
5. Propriety: ". . . is that perfection of style which comes when a work is authoritatively constructed on approved principles. It arises from prescription, from usage, or from nature."

In a sense, buildings talk. Tzonis and Lefaivre write that "indeed, all classical works, buildings included, have an oratorical or conversational, humanlike tone. . . ." Apparently, this metaphor of the building, and all the visual arts, as rhetoric—as that which speaks—has meant a great deal to commentators on art throughout the ages. The identification of language and the visual arts has a long tradition. The Roman writer Plutarch quotes Simonides as saying that painting is mute poetry and poetry painting that

speaks; and Horace, also a Roman critic and writer, formulates the more succinct notion of *ut pictura poesis*, meaning "as is painting so is poetry." Perhaps we can extend this identification and say that as is rhetoric, so is art criticism.

Ancient rhetoric established a threefold division of the speech:

1. **Invention**: which proofs or demonstrations were chosen to explicate the particular topic under consideration.
2. **Disposition**: how the oration or argument is ordered.
3. **Elocution**: how eloquent is the speech, how well chosen the words, how many and in what manner literary devices are employed.

Numerous writers on art have adopted this tripartite division for other artistic activities. The sixteenth-century Italian art theoretician Dolce, for instance, took the ancient arrangement and adapted it to the visual arts: he saw art in terms of *inventione, disegno,* and *colorito. Inventione* has to do with the creation of the elements of the work of art; *disegno* is the design or construction of the painting (see previous chapter on the Academy, p. 13); and *colorito,* of course, concerns color, the ornamentation of the painting. The adaptation may not be perfectly symmetrical, but it is close.

Tzonis and Lefaivre shape the rhetorical model to architecture and come up with the following formulation, a simpler scheme than Vitruvius's: "taxis, which divides architectural works into parts; genera, the individual elements that populate the parts as divided by taxis; and symmetry, the relations between individual elements."

We can use the Parthenon (fig. 6) by Iktinos and Kallikrates to show how this schema can be used to analyze a building. What results is not an assessment of the temple's "final cause," its essential meaning or fundamental purpose, so much as it is an informed description demonstrating how the Greeks may have responded to the building's beauty and physical presence (which of course could initiate the process of catharsis). I will keep the analysis short; the reader should have little difficulty in extending it.

Taxis: This has to do with dividing the building into its elements. One of the usual ways of dividing up a building like the Parthenon is to view it in plan and elevation. Figure 7 shows the general schema of a Greek temple, as well as the particular format of the Parthenon. The aesthetics of antiquity often relates the general to the particular and vice versa: There are particular instances but general rules. The ground plan of the typical Greek temple shows first of all how the temple is isolated or cut off (*templum* means "to mark off space") from its surroundings by the base (substructure or stereobate), which forms the outside perimeter. There then is an inner perimeter called the peristyle or colonnade. The enclosed section of the temple is constituted by the naos (or cella) and pronaos. The elevation (fig. 8) demonstrates the three-part division of a building in profile. We begin again with the base, which isolates the temple from the earth by providing a pedestal; then comes the column, followed by the superstructure or entablature. These then are subdivided into discrete elements.

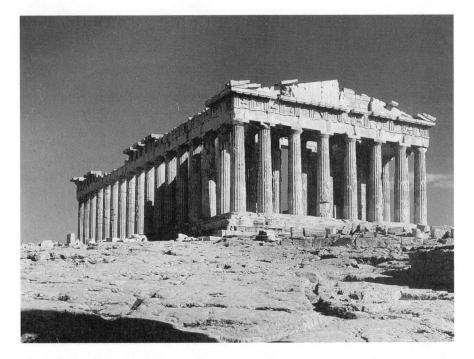

Figure 6. Iktinos and Kallikrates, The Parthenon, c. 447–438 B.C. Acropolis, Athens. Photo: Alison Frantz.

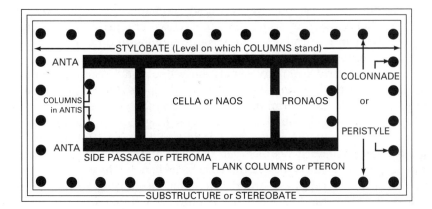

Figure 7. Plan of a typical Greek temple, after I. H. Grinnell.

Which leads us to the next category, that of genera: the individual elements. Let's look more closely at the column, an architectural part that the Greeks treated as a work of art in its own right. There are two "orders" in the Parthenon: the Ionic, inside the temple, and the Doric on the outside. The Doric column is the most severe type, with little ornamentation or intricate detail. In later times, it was associated with masculine qualities, in contrast to the more feminine Ionic. However, there is no evidence the Greeks made such gender-related associations. Nonetheless, this rather plain column divides up into distinct details that create subtle transitions. As organic forms swell and subside, so does the shaft alter in form: it thickens at the bottom, bulges slightly in the middle like a muscle (*entasis*), and tapers toward the capital. Before reaching the capital, the column passes through the "necking," or band, marking a zone immediately beneath the echinus. The echinus squares the circle, so to speak, providing a transition from the cylindrical shaft to the square abacus. The circle of the echinus is inscribed within the square of the abacus.

What is the purpose of discussing the formal nature of these architectural elements? Is it a matter of appreciation? Perhaps. But there's more to it than that. Finding correlations between the built environment and the unconstructed landscape, between culture and nature, is humanistic. As the Greeks and so many after them believed, the arts speak like orators: what they say changes in syntax and vocabulary depending upon the form. But utterance is important. Here the forms bespeak an interest in the beauty not just of harmony and accord, but of transition and change. The twenty arrises (edges) of a column to the flutes (grooves or channels) model the sunlight so as to form shadows of differing lengths around the column—another transitional device. Purgation, purification, catharsis (and with Plato a kind of transportation and madness)—these are the things that accompany the aesthetic experience of an intense human and architectural event. Admittedly, it is not easy for any of us to explain this almost physical response to a thing of beauty; Aristotle, in fact, never really clarified the matter. According to the testimony of multitudes, it exists just the same. This is not the place to examine further the nature of catharsis, but it has something to do with the genera, the details of the parts of the whole.

Finally, symmetry. Symmetry signals the proportional relations of the larger segments of the building. As J. J. Pollitt has reported in his analysis of the Parthenon, the ratio determining the symmetry of the temple is 4:9. This 4:9 ratio describes the relation of the width to the length of the building, the height of the order up to the cornice to the width of the facade, the diameter of each column to the distance between the axes of neighboring columns, and the proportion of the width of the cella to its length. Here, as with the *Spear-Bearer*, symmetry calls forth order, exactitude, relationship: those things that mirror the nature and harmony of the universe and that are inherently beautiful.

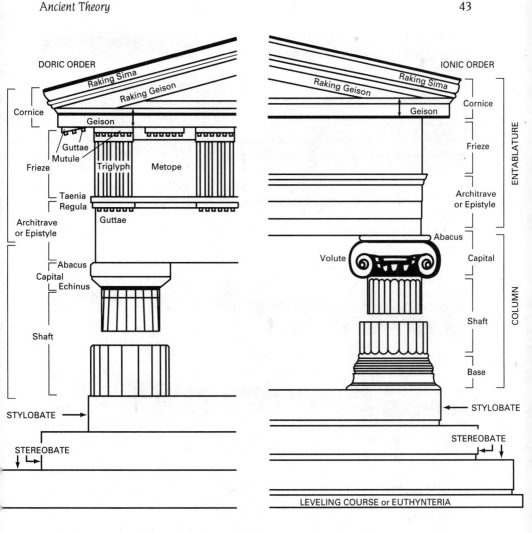

Figure 8. The Doric and Ionic orders, after I. H. Grinnell.

Plotinus and Artistic Creativity

lover of beauty

Plotinus (A.D. 204–270) fills the double role of the last aesthetician of anti-
quity and the first of the Middle Ages. He inherits the tradition of Plato, but
spiritualizes it in a way that made him quite accessible to the Christianized
West. Most likely born in Egypt, he studied in Alexandria for more than a
decade. In his forties he came to Rome and lectured extensively on meta-
physical and spiritual matters. After the age of fifty, persuaded by his pupils

to publish his lectures and assisted by his biographer, Porphyry, he composed his philosophy into six sections, each with nine parts. These he called the *Enneads.*

Plotinus is generally credited with founding Neoplatonism, the form of philosophy that derives ultimately from Plato, but which differs in some important ways from what the Athenian of the classical age formulated. The importance of Plotinus' writings for the history of art is his insistence upon the philosophical role of the visual arts, their connection to beauty, and their dependence upon artistic creativity. By drawing our attention to the creative act, Plotinus tells us that there is something other than the object to consider: the birth of the artistic idea in the mind or soul of the artist. We will see in the Renaissance, especially during the Mannerist period, the *disegno interno* (the internal design or artistic idea) as a pivotal idea in artistic theory.

Plotinus' ideas, like those of Plato, originate in some nonmaterial, perfect "trans-celestial" realm: the level of the One, the Absolute. Here, like a cup always spilling over, the ultimately real overflows or emanates outward through the realm of forms (comparable to Plato's level of Idea), the level of the Soul, and finally into matter. We can grasp, in matter, the original truth, but "as through a glass darkly." Matter resists truth; it has a degree of opacity.

The artist functions effectively as an illustration for and purveyor of Plotinus' system. The artist can help us see the spirit world by injecting beauty into matter: he or she does this through creativity. In the following passage, Plotinus describes the difference between matter (in this case a stone) that has not received the artist's attention, and matter that has:

> Suppose two blocks of stone were lying next to each other, one unformed and untouched by art, the other artfully worked into a statue of a god or a man—if of a god, perhaps into the likeness of a Muse or a Grace; if of a man, into the image not of just anyone, but of such a one as only art has composed from all beautiful people. Then the block of stone formed by art into an image of the beautiful will appear beautiful not because it is a block of stone (for then the other one would be just as beautiful) but because of the shape art has lent to it. The material did not possess this shape, but it was in the mind of him who envisaged it before it came into the stone. And it resided in the artist's mind, not insofar as he had eyes and hands, but only insofar as he partook of art. This beauty, then, was much greater in art. For the beauty inherent in art does not itself enter into the stone, but it remains unto itself, and that which enters into the stone is only a lesser beauty derived from it; and even this does not remain pure unto itself and such as the artist desired it, but is revealed only insofar as the stone was obedient to art.

As with Plato's formulation, there is distance between earthly beauty and absolute beauty. Art does not body forth or incarnate beauty; rather, it reflects, mirrors, or suggests real beauty. But that in itself is important. And art does communicate with real beauty; the artist has what Plotinus refers to as a living vision. It's the real thing. Virtually no one would admit this before Plotinus did.

However real the vision may be, the art object does not deserve attention for its own sake. Plotinus advises that "he who looks at physical beauty should not lose himself in it, but should realize that it is only an image, a hint and a shadow, and should flee to that which it is a reflection." But whither do we flee? Apparently it's a spiritual journey back through the artist's mind and then, treading against the current of the emanation, on to the absolute One. This "fleeing" from the physical object results in "ecstasy, self-surrender," and "flight yonder, of the alone to the Alone." Plotinus is a mystic.

It remains for us to consider briefly Plotinus' notion of beauty, because it differs from earlier formulations. The standard of beauty in antiquity is *symmetria*, by which is meant the harmony and accord of parts. *Symmetria* is mechanical, relational, physical. Plato is reported to have said that "everywhere measure and commensurability are associated with the excellent and the beautiful." But Plotinus finds *symmetria* to be only an external manifestation of an internal idea; beauty itself is nonphysical. Soul and spirit have unity and can "illuminate" matter, but matter itself can have no unity, no real beauty. Further, there are qualities, like sunlight or the expression on someone's face, which are beautiful even if they have no relation to symmetry: these are the nonquantifiable elements of the world, those things which have to do with mood rather than measure. We contemplate the sunshine or some other instance of natural beauty in an inarticulate, free reverie.

And lastly there is the matter of *mimesis*. Art, according to Plotinus, does not just imitate the external appearance of things, it imitates principles. He explains: "The arts do not simply copy visible objects, but reach out to principles of nature; the arts provide much themselves, for they can add where there is deficiency; they can do so since they themselves possess beauty." He gives the example of Phidias' Zeus, which is not based upon what the sculptor saw; rather, it shows what Zeus would look like if he chose to manifest himself to us. The artist, through his or her inner eye and creative ability (*logos*), knows what that appearance would be.

By reformulating imitation (*mimesis*), beauty, and creativity, Plotinus unites aesthetics and the philosophy of art. Those salient elements of artistic theory—imitation, beauty, rhetoric, poetics—that had grounded our discussions of art in antiquity, come now to form a cohesive philosophy of art, and are the basis of modern aesthetics.

♦

Bibliography

BUTCHER, SAMUEL HENRY, *Aristotle's Theory of Poetry and Fine Art, with a Critical Text and Translation of the Poetics.* New York: Dover, 1951.

KEULS, EVA, *Plato and Greek Painting.* Leiden: E.J. Brill, 1978.

LEE, RENSSELAER W., *Ut Picura Poesis: The Humanstic Theory of Painting* . New York: W. W. Norton, 1967.

LODGE, RUPERT, *Plato's Theory of Art.* New York: Russell & Russell, 1975.

MURDOCH, IRIS, *The Fire and the Sun: Why Plato Banished the Artists.* Oxford: Clarendon Press, 1977.

PANOFSKY, ERWIN, *Idea: A Concept in Art Theory* (trans. Joseph J. S. Peake). New York: Icon Editions, Harper & Row, 1968.

POLLITT, J. J., *The Ancient View of Greek Art.* New Haven, Conn.: Yale University Press, 1974.

RICHTER, GISELA, *The Sculpture and Sculptors of the Greeks* (new rev. ed.). New Haven, Conn.: Yale University Press, 1950.

TATARKIEWICZ, WLADYSLAW, *History of Aesthetics: Vol. 1, Ancient Aesthetics.* The Hague: Mouton, 1970.

TZONIS, ALEXANDER, and LIANE LEFAIVRE, *Classical Architecture: The Poetics of Order.* Cambridge, Mass.: MIT Press, 1986.

VERDENIUS, W. J., *Mimesis: Plato's Doctrine of Artistic Imitation and Its Meaning to Us.* Leiden: E. J. Brill, 1949.

VITRUVIUS POLLIO, *The Ten Books on Architecture* (trans. Morris Hicky Morgan). Cambridge, Mass.: Harvard University Press, 1914.

WITTKOWER, RUDOLF, *Architectural Principles in the Age of Humanism.* London: Warburg Institute, University of London, 1949.

2

Medieval Theory: Christianity, the Human, the Divine

When you walk into the Basilica of St. Peter's in Rome (fig. 9), your immediate response might be one of awe, followed by unease or confusion. This is a majestic, stunningly ornamented church: Think of the money lavished on this, the (nearly) largest church in Christendom! Is such "glitz" proper in the House of the Lord? What about the starving and the homeless; shouldn't the money be spent on them? Why are there so many images of popes and so few of Christ and God? And isn't there something idolatrous about having so much art in the House of God? For some, the experience of St. Peter's can be oppressive, as if the Church concerned itself too much with the things of the world, as if it were too conspicuous in its opulence. This uneasy mixture of wealth, art, and beauty in support of the divine has been a concern of the Church since earliest Christian times. Beauty is vanity; beauty is a manifestation of God. Images are dangerous idols; images instruct the faithful. These antagonistic concepts are at the core of Christian aesthetics.

In fact, the very idea of a medieval, Christian theory of art is problematical. Only in the last fifty years have any extensive studies appeared on medieval aesthetics. This is because Christianity deals with moral law, faith, love, and eternal life, but not in any strict sense with art. Nonetheless, art plays an important role in the history of Christianity.

Let us begin with Holy Scripture. When the Book of Genesis describes creation, when the Book of Wisdom reports that God arranged "everything according to measure, number, and weight," the writers of scripture draw on traditional concepts of beauty. The Song of Solomon tells of many lovely things: "Let me see thy countenance, and let me hear thy voice, for sweet is thy voice and thy countenance is comely" (2:14). The representational arts, nonetheless, were often forbidden. At least a half dozen times in the Old Tes-

Figure 9. Interior, St. Peter's. Vatican City, Rome. Photo: Alinari, Florence.

tament, one finds reference to Moses' ban on graven images, on idols. Proverbs say that "Favor is deceitful, and beauty is vain" (21:30). In addition, there are in the Old Testament somewhat traditional ideas of beauty. Scripture says that it is part of creation: "And God saw everything that he had made, and behold, it was very beautiful" (Genesis 2:31). It states that beauty is determined by measure, as can be seen in the the Book of Wisdom and, earlier, in the Pythagorean theorem. And the Bible states that beauty can be empty (the sin of vanity), if not perilous: "Thou shalt not make unto thee any graven image nor any likeness of any thing that is in heaven above or that is in the earth beneath or that is in the water under the earth" (Exodus 20:5).

The Christian attitude toward art differs from the Hebrew tradition. The art historian Ernst Kitzinger stated in very strong terms that "in the entire history of European art it is difficult to name any one fact more momentous than the admission of the graven image by the Christian Church." Because the human is made in the image of God, and Christ is the divine made human, physical images of the saints, Christ, God, the Blessed Virgin Mary, and the narrative sequences from the Bible are permitted. Gerhart B. Ladner published a small in book in 1965 called *Ad Imaginem Dei: The Image of Man in Me-*

diaeval Art in which he develops the argument that God's incarnation in human form justifies religious art. He writes, ". . . it was possible for all men to be represented in art, for man was not only created in the image and likeness of God, but also renewed, reformed in the image-likeness of Christ, who as the perfect image of God had nevertheless assumed a human body."

Given this sanction for image making, artists had several choices, as Ladner makes clear. In the earliest Christian tradition (c. third and fourth century A.D.), artists relied on antique prototypes, the classicizing images favored by Greek and Roman artists. This naturalistic style Ladner calls the "incarnational" image of Christ. Later, with the splitting of the Christian world in two (Rome and Constantinople), there came to be a greater spiritualization of human images, emphasizing the less corporeal image-relation of the human to God.

There is another justification for Christian art, and it has to do with instruction. Elsewhere I quote from Pope Gregory the Great (who reigned 590–604) that paintings are for the illiterate. They can "read" in a picture what they cannot in a book. Can one read a picture in the same manner as one reads Holy Writ? Words finally are not pictures, nor are pictures precisely the same thing as words. But the two connect in many ways, even if it is difficult to find the clearest philosophical understanding of how they connect. This justification of images as "Bibles for the illiterate" has a fairly consistent tradition throughout the Middle Ages. St. Augustine wrote that one reads in a picture as one reads in a book, but the possibility of misreading is greater in works of art. This is a warning; one not often heeded.

The Synod of Arras in 1025 declared that "the simple and illiterate in church who cannot gaze upon this [the Crucifixion] through the Scriptures may contemplate it through certain features of a picture." And perhaps the two most succinct statements along these lines come from theologians who lived at the same time: St. Bonaventure (1221–1274) and St. Thomas Aquinas (1225–1274). Bonaventure wrote:

1. They [images] were made for the simplicity of the ignorant, so that the uneducated who are unable to read Scripture can, through statues and paintings of this kind, read about the sacraments of our faith in, as it were, more open scriptures.
2. They were introduced because of the sluggishness of the affections, so that men who are not aroused to devotion when they hear with the ear about those things which Christ has done for us will at the least be inspired when they see the same things in figures present, as it were, to their bodily eyes. For our emotion is aroused more by what is seen than by what is heard.
3. They were introduced on account of the transitory nature of memory, because those things which are only heard fall into oblivion more easily than those things which are seen.

And in a similar vein, St. Thomas declared:

> There were three reasons for the institution of images in churches. First, for the instruction of simple people, because they are instructed by them as if by books. Second, so that the mystery of the Incarnation and the examples of the saints may be the more active in our memory through being represented daily to our eyes. Third, to excite feelings of devotion, these being aroused more effectively by things seen than by things heard.

What the theologians are emphasizing is veneration, instruction, and recollection. We don't learn anything new from images, but we review what already has been taught to us, and that is healthy and enlightening. Making much the same point, the art historian E. H. Gombrich commented that a holy image can only be "read" in terms of "context, caption, and code."

However, there is also a tradition that says images are not for the unlearned. Petrarch wrote in his will about a painting by Giotto that he was bequeathing: He referred to the painter "whose beauty amazes the masters of the art, though the ignorant cannot understand it." And Boccaccio also wrote about Giotto that he "brought back to life that art which for many centuries had been buried under the errors of those who in painting had sought to give pleasure to the eyes of the ignorant rather than to delight the minds of the wise." These latter comments, however, belong to Renaissance art theory, when art was becoming much more intellectualized.

Other justifications for images existed in the early Christian era. There was the tradition, for instance, of miraculous images painted by no hands (*acheropoietoi*), usually depicting Mary and the Christ Child. These just painted themselves, although there must have been some divine assistance. How could there be anything idolatrous about that? Other miraculous images were the indentation left by the body of Christ when He was bound to the column and scourged; the image of Christ's face that appeared on Veronica's veil after she wiped the sweat from His brow as He struggled up Golgotha; and, according to ancient legend, the portraits by St. Luke of Mary and the Christ Child—these last not exactly miraculous, but with a sense of divine intention. All of these images had a certain wonderous potency. Icons were used, for example, to drive Persians from the gates of Constantinople in 626 and fend off the Arabs in 717.

But this matter of potency was troubling. Does an icon actually contain some of the substance of that which it represents? Can there be an indwelling spirit; and, if so, does that make the image sometimes dangerous, other times beneficial? The Romans had *lauratrons*—images or other pictorial attributes of the emperor—which carried some of his authority. If an escaped convict, for instance, was found near the image of the emperor, he was granted a brief sanctuary. And, on the darker side, some of the early Christian Fathers believed that pagan statues were possessed by demons. Clement of Alexan-

dria wrote that these figures contained "unclean and loathsome spirits." According to Greek myth, the image of Medusa could turn men to stone if they gazed upon it; therefore, a shield with Medusa's head depicted upon it could be very helpful in battle. This sort of an image is called an *apotropaion*, a picture to ward off evil. Gargoyles on medieval churches provide much the same service.

And then there is the tradition of relics. An object or a body part can be efficacious—beneficial—if it was associated with or came from a saint. In the Middle Ages one could find reliquaries in most churches, and there was a veritable crush to have one's tomb placed as close as possible to saintly remains (*ad sanctos*), the purpose being to assist one's soul on its journey to Heaven. This is all very magical, of course, and depends upon a certain degree of superstition among the populace—a not uncommon quality.

Which brings us back to the question of symbol, a matter that concerned theologians deeply in the Middle Ages. In our time, the question often comes up in relation to the American flag. If it is "merely" a symbol of higher values, then someone burning it really commits no crime: The essential meaning remains unscorched. The other view—the more magical one—suggests that some of the dignity of our people and culture resides in that piece of cloth. Men and women have died for our freedom, and their spirit dwells in the flag. It would therefore be an abomination to burn it. These are the issues. And in the eighth century, these same issues in a different context helped to fan the flames of the struggle known as the "Iconoclastic Controversy."

The known or Western world split in two at the end of the fourth century. Constantine left Rome for Byzantium—soon to be renamed Constantinople—in 330. Afterward there were two churches: the Roman, or Western, and the Greek Orthodox, or Eastern. It was the Emperor of the East, Leo III (reigned 717–740), who banned sacred images. The debate quickly fell into two opposing ideologies: the iconodules (worshippers of images) and the iconoclasts (breakers of images). Again, the relation between an image and what it represents dominated the controversy. The iconoclasts believed that pictures of Christ could portray His physical nature but not His spiritual side. So long as only one of His natures could be shown, an incomplete and therefore sacriligious image resulted. It was a heresy—a serious one at this time—to assert visually or verbally that Christ had but one nature.

In another tactic that depended upon absolute distinctions, the iconoclasts insisted upon certain issues for representation. Either an image is identical to what it represents—coextensive, coessential—or it is totally separate from its subject. Either a picture of Christ is Christ or it is an abstract form composed of colors and lines on a flat surface with absolutely no connection to Him. In the first case—really an impossibility—the picture then is no longer a picture; in the second instance the picture is useless as a religious icon. In its uselessness it can, however, become an idol, something people

worship or value for its own sake. Moses' ban on images remained quite powerful in the minds of the iconoclasts.

The iconodules tried to find a middle ground. Denying the binary opposition—the either/or—the defenders of images came up with a compromise position. They took the old Platonic idea that an image somehow participates in the original. An image of St. John, for instance, reflects some of his presence: The picture is not identical with the man, but he or an aspect of him is there somehow or somewhere. As I mentioned previously, this is the magical element of art, its power. No one actually defined what this participation (*methexis*, in Greek) constitutes. To what magnitude, to what degree of certainty, in what precise manner is St. John present in an image of him? Not surprisingly, no one had an answer for those questions. St. John of Damascus, a leading iconodule, said that "Devils have feared the saints and have fled from their shadow. The shadow is an image, and I make an image that I may scare demons." As a shadow relates to a man, so an image relates to its subject. And both the shadow and the image carry some of the force of their originals: If properly used, they might frighten off a demon. Not a very clear analogy, but one that seemed useful enough.

The Iconoclastic Controversy boiled for more than a century; finally, the iconodules prevailed. Images survived. Those who feared, hated, and destroyed images lost, but their antagonisms toward pictures never entirely died out. The power of art to stir up intense feelings, to offend some people, and to create confrontations over censorship is still with us.

In the West, the part of the world once dominated by the Roman Empire, there were not the same battles over the meaning, lawfulness, or appropriateness of images. In this part of the world we find basically a continuation of the Neoplatonic model. An aesthetician of some note, one who like Plotinus links the ancient with the medieval world, is Aurelius Augustinus, known to the Christian world as St. Augustine (354–430). St. Augustine is an endlessly fascinating man, whose contributions to theology are foundational to the Roman Church. And his role in the history of aesthetics is important as well. Raised in a milieu saturated with classical culture, he became a teacher of rhetoric, and exercised his calling in North Africa, Rome, and Milan. He felt at first a certain contempt for the Christian religion, but nonetheless made his conversion when he was in his early thirties. He later became a bishop and eventually was canonized by the Church. Thus he brings to us a profound understanding of Platonic and post-Platonic thought, a love of beauty in the physical world, and an acute self-awareness to an abiding religiosity.

Basically he returns to the Pythagorean and Platonic notion of beauty as something that relies upon measure, rhythm, and proportionality; further than this, however, Augustine understands that beauty has much to do with emotions and an internal sense of the divine. On the experience of pleasure he had several comments: "reason . . . perceived that it is pleased only by beauty; and in beauty, by shapes; in the shapes, by proportions; and in the

proportions, by numbers." Being concerned with pleasure—what we might call aesthetic experience—led him also to comment on the actual place of beauty. Is it out there in the world or is it a function of "the eye of the beholder," as certain relativists have said? Is a thing beautiful because it pleases, or does it please because it is beautiful? He settles a tricky aesthetic problem by declaring one point of view correct and the other in error: "It pleases because it is beautiful."

As a good Neoplatonist in the tradition of Plotinus (although he had a stronger sense of classical beauty than did Plotinus), Augustine knew that the beauty of this world—and that created by the artist—must lead us to something better: ". . . for all those beautiful things that here are conveyed through the souls into the artful hands come from that Beauty that is above the souls and for which my soul sighs day and night." Classic Christian Neoplatonism!

I think the reader will see that there are some common threads tying the controversies of the Byzantine East to the instructive, spiritualizing concerns of the West. What does a religious image do, and how does it do it? These are meant as practical, not philosophically posed questions: They are not intended to be exhaustive or definitive. Nonetheless, let's look at an icon from the sixth century A.D., the Icon of the Virgin and Child with Saints and Angels, from the Monastery of St. Catherine, Mount Sinai, Egypt (fig. 10), with these queries in mind. The panel is a little more than two feet high, composed of wood, with the images produced by suspending pigment in a waxy medium known as encaustic and applying it to the panel. There are six recognizable human figures, apparently five adults and a child. The pictorial space is limited, with the sides squeezing in the shoulders of the men on either end of the first row, and the top and bottom confining the heads and feet. It's a little like a club picture of some high school students taken by an indifferent photographer knowing that this would be used as a filler in the back pages of a yearbook. We have the necessary visual information of bodies, heads, and a hint of setting. In other words, the point of view is as neutral as possible, informative but not interpretive. And the figures have all the impassivity of mug shots. But these, of course, are neither club members nor criminals; in fact, they are godly, angelic, divine, saintly. The big wheel behind each head is the halo, ancient symbol of deity. So we have the elements of an icon: Mary and the Infant Christ (looking about forty years old!), two saints staring forward in their sacred states of being, and two angels scanning the skies. By giving us recognizable images while keeping them quite flat, the artist seems to be attempting to present the physical and spiritual simultaneously.

The icon is devotional rather than narrative: There is no story, only figures given to us for veneration and prayer. We are expected to look beyond their earthly presence to their divine natures: All the gold, flatness, poker-faced expressions, and immobility defeat any desire we might have to know them or get involved in some drama. They are extraordinarily reserved, denaturalized, but dignified agents of a divine system. They operate, you can

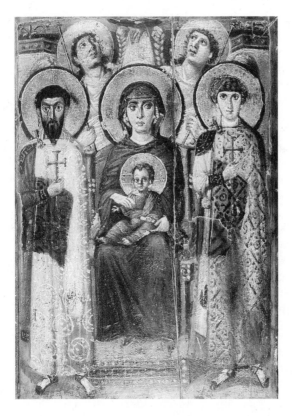

Figure 10. Icon of the Virgin and Child with Saints and Angels, sixth century A.D. Monastery of St. Catherine, Mount Sinai, Egypt. Photo: Reproduced through the courtesy of the Michigan-Princeton-Alexandria Expedition to Mount Sinai.

tell, as if by remote control. There seems to be no indwelling personality or character, no inner motive or vitality. This is how the artist comes to terms with the earthly as a reflection of the heavenly, with the two natures of Christ. Jesus is childlike in size, but with an adult's head; the large eyes, the halo, the priestly gesture of benediction (a *hieros* in Greek terms; that's why these figures are called hieratic) show him physically and spiritually. Imagine yourself looking at this in its original setting, with flickering candles on either side of the icon, incense in the air, the feeling of the cold, damp, stony hollowness typical of an early Christian church. You the worshipper probably would sense yourself transported to the disembodied idea of Christ, Mary, Saints, and Angels. In fact, these early icons worked so well as symbol and earthly image that their style changed little over the ensuing centuries.

◆

There are several other quotations, this time from the High Middle Ages, that reflect two opposing but nonetheless central concerns of the period. The first is from St. Bernard of Clairvaux and it echoes that iconophobia that appeared in the earlier Byzantine Middle Ages. Bernard, in what is called the *Apologia ad Willelmum*, asserts the primacy of texts over images, and

suggests the trifling and enervating quality of art. He, like St. Thomas Aquinas, understands that pleasure lies at the core of the aesthetic experience. When Aquinas wrote that "only man delights in the beauty of sensuous things as such," he was stating that we can take pleasure in something for its own sake. Not that Aquinas was advocating an early verison of "art for art's sake," but he was recognizing a certain human sensibility. And that worries St. Bernard. Bernard fears that too much art in the sacred context can distract the brethren from their more significant tasks. "And further," he observes, "in the cloisters, under the eyes of the brethren engaged in reading, what business has there that ridiculous monstrosity, that amazing misshapen shapeliness and shapely misshapenness? Those unclean monkeys? Those fierce lions? Those monstrous centaurs? Those semihuman beings? Those spotted tigers? Those fighting warriors? Those huntsmen blowing their horns? Here you behold several bodies beneath one head; there again several heads upon one body." And he goes on in this vein, describing with beautifully acute language the fantastic creatures populating medieval architecture. He concludes: "In fine, on all sides there appears so rich and so amazing a variety of forms that it is more delightful to read the marbles than the manuscripts, and to spend the whole day in admiring these things, piece by piece, rather than in meditating on the Law Divine." Entertainment can corrupt.

But there is a different point of view from another quarter. The Abbot Suger of St. Denis was a contemporary and acquaintance of St. Bernard. His attitude toward beauty and its role in the House of the Lord strikes a very different note:

> When—out of my delight in the beauty of the house of God—the loveliness of the many-colored stones has called me away from external cares, and worthy meditation has induced me to reflect, transferring that which is material to that which is immaterial, on the diversity of the sacred virtues: then it seems to me that I see myself dwelling, as it were, in some strange region of the universe which neither exists entirely in the slime of the earth nor entirely in the purity of Heaven; and that, by the grace of God, I can be transported from this inferior to that higher world in an anagogical manner.

The key term for the beauty-loving Suger is "anagogical," which means a religious, mystical ascent. Like Plato and the Neoplatonists long before him, Abbot Suger believes in hierarchy: Our earthly plane is inferior; something better lies beyond and above us. Through spiritual enlightenment we can have some sense of it. For Suger, the vehicle for ascent is the beauty of religious art. This is very different from Gregory the Great's defense of images as instructive to the ignorant. In the twelfth century, the director of the Royal Abbey of St. Denis—no illiterate layman—uses art and meditation to move from the material to the immaterial, from the muck of this world to some wonderful place not quite in Heaven, but close to it.

Summary of Medieval Aesthetics

Many of the writers of the Middle Ages who considered images usually did so without regard to beauty; those who wrote about beauty were not all that concerned with the problems and procedures of the artist. As mnemonic, devotional figures, images served the needs of morality, education, and religion. The aesthetics of this period, like the aesthetics of antiquity, was not the major concern of artists or art critics; indeed, what we know about the attitudes and values of the time comes mostly from theologians. On the whole they accepted the existence of images as necessary and salutary, even if they sensed a certain seductive danger (see the previous section on St. Bernard). Some, like the Abbot Suger, believed that art has an almost redemptive power. Many theologians asserted that beauty, although not necessarily associated with art, is something that is in the world because nature reflects the beauty of its creator, God. Various elements constitute beauty: harmony and measure on the one hand, clarity on the other. Clarity is not a quality discussed much in antiquity, but because light is associated with divinity, it forms an important element in medieval aesthetics. Brief references to three medieval theologians suggest the import of light in conjunction with proportion. Pseudo-Dionysius (c. sixth century A.D.) propounded the double system of *proportio et claritas*. Robert Grosseteste also believed in proportion, but said of light that "it is based not on number, not on measure, and not on weight or anything else like that, but on sight." Plotinus earlier had insisted on that element of beauty that is nonquantifiable. And finally St. Thomas Aquinas wrote that "beauty consists in a certain luster and proportion," and that "beauty demands the fulfilment of three conditions: the first is integrity, or perfection, of the thing, for what is defective is, in consequence, ugly; the second is proper proportion, or harmony; and the third is clarity—thus things which have glowing colour are said to be beautiful." Most writers of the Middle Ages would agree that *lumen rationis* is the light or brightness of virtue. It is but a small step from clarity to *perspective*, which in its original perspicuous sense means "to see clearly." Perspective, which turns vision into something measurable, was to play an important role in Renaissance art theory.

<div align="center">◆</div>

Bibliography

Duggan, Lawrence G., "Was Art Really the 'Book of the Illiterate'?", *Word and Image*, vol. 5, no. 3 (July–September 1989), pp. 227–251.

Eco, Umberto, *Art and Beauty in the Middle Ages* (trans. H. Bredin). New Haven: Yale University Press, 1986.

KITZINGER, E., "The Cult of Images in the Age Before Iconoclasm," *Dumbarton Oaks Papers*, 8 (1954), p. 85.

LADNER, GERHART B., *Ad Imaginem Dei: The Image of Man in Mediaeval Art, "Wimmer Lecturer, 1962."* Latrobe, Pa.: The Archabbey Press, 1965.

PANOFSKY, ERWIN, "Abbot Suger of St. Denis," *Meaning in the Visual Arts.* Garden City, N.Y.: Doubleday Anchor Books, 1955, pp. 108–145.

STOCKSTAD, MARILYN, *Medieval Art.* New York: Harper & Row, 1986.

TARTARKIEWICZ, WLADYSLAW, *History of Aesthetics, Vol II: Medieval Aesthetics.* The Hague: Mouton, 1970.

The Renaissance (1300–1600)

The philosophy of art in the Renaissance arises from certain fundamental texts, such as Alberti's trilogy *On Painting, On Sculpture,* and *On Architecture,* Ficino's *Commentary on Plato's Symposium,* Leonardo's *Treatise,* Michelangelo's literary remains, and Vasari's *Lives.* In addition to these texts—written now by artists as well as philosophers and humanists—there are certain key practices and expectations. Perspective, what we might call a technological development, is one of the important practices of the Renaissance; *istoria,* the idea that the picture must have an instructive narrative, is something inherited from the ancient tradition. Further, both the philosophies of Plato and Aristotle were revived. Let us begin with what the Renaissance derived from antiquity.

Marsilio Ficino

He met with the great intellectuals of his time, benefited from the patronage of the wealthy Medici, studied Greek and Latin, rediscovered texts by Plato, and founded the New Academy in Florence in 1462. His name is Marsilio Ficino, and he has a great deal to do with why the Renaissance is about rebirth: Like an archeologist, he attempted to reconstruct the ancient Mediterranean tradition of beauty and meaning. In his commentaries on Plato's *Symposium* and in his treatise the *Theologica Platonica,* Ficino summarized much of classical aesthetics and, in addition, emphasized the role of contemplation as first set forth in Plato's *Phaedrus.* The contemplative act is one of withdrawal from the world of experience so as better to ponder the world of forms. As a result of this process of inward consideration, one does not respond only to the proportional or quantitative aspect of beauty, but, like St. Thomas Aquinas and Plotinus had suggested, one finds something unitary and indivisible: "Some regard beauty as an arrangement of component parts, or to use their own words, commensurability and proportion. . . . We do not accept this view

because this kind of arrangement occurs only in composites and, therefore, no simple thing can be beautiful. However, pure colors, lights, separate sounds, the glitter of gold and silver, knowledge, the soul, are all called beautiful and are all pure and simple" (*Convivium* V:1). The shaft of divine light that enters the human soul is this irreducible stuff of beauty—the pure and the simple. Ficino's contemplative mode of apprehension, however, is not one of utter, abject passivity; rather, it is a dynamic action of human spirit and human love. The mind, the ear, and the eye are all engaged. This is more than self-knowledge: It is an awareness of how each of us shares in the universal, how we come to know our essential humanness as part of the divine order. Whether we know it or not, we participate in God. Coming to terms with this makes us fully human and spiritually aware.

Pico della Mirandola

Giovanni Pico della Mirandola, a member of Ficino's academy, wrote an oration entitled *On the Dignity of Man*, in which he had God speak to Adam. Here there is crystallized the Renaissance understanding of human nature: how it is that we can become great. God

> therefore accorded to Man the function of a form not set apart, and a place in the middle of the world, and addressed him thus: "I have given thee neither a fixed abode nor a form that is thine alone nor any function peculiar to thyself, Adam, to the end that, according to thy longing and according to thy judgment, thou mayest have and possess that abode, that form, and those functions which thou thyself shalt desire. The nature of all other things is limited and constrained within the bounds of laws prescribed by me: thou, coerced by no necessity, shalt ordain for thyself the limits of thy nature in accordance with thine own free will, in whose hand I have placed thee. I have set thee at the world's center, that thou mayest from thence more easily observe whatever is in the world. I have made thee neither of heaven nor of earth, neither mortal nor immortal, so that thou mayest with greater freedom of choice and with more honor, as though the maker and molder of thyself, fashion thyself in whatever shape thou shalt prefer. Thou shalt have the power to degenerate into the lower forms of life, which are animal; thou shalt have the power, out of thy soul's judgment, to be reborn into the higher forms of life, which are divine.

If we look at one of the most famous examples of God's and Adam's confrontation, Michelangelo's *Creation of Adam*, from the Sistine Chapel ceiling (fig. 11), we should be able to see how Pico's oration moves into visible form, how Ficino's inward deliberation can be depicted. What most commentators point out is that God the Father has yet to "create" Adam in the fullest sense: Their fingers are about to touch. Adam moves, his eyes are open, yet

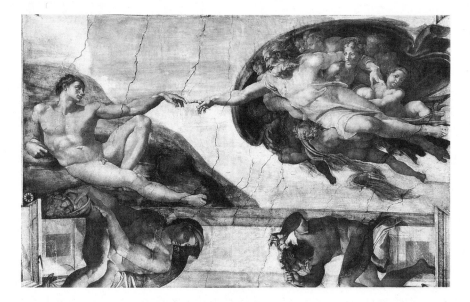

Figure 11. Michelangelo, *Creation of Adam*, detail of the Sistine Chapel ceiling, 1511–1512; fresco. Photo: Alinari, Florence.

he seems incapable of shaking off a dreamy lethargy. In Ficino's and Pico's terms, what Adam will receive is the gift of choice, of freedom, of self-discovery and self-realization. Being sentient is not being fully human. We have the potential to see what there is within us that can participate in the divine order, but we must learn how to bring that knowledge and that capacity into our lives.

Leon Battista Alberti

It is something of a relief to leave behind the Neoplatonic speculation of Marsilio Ficino or other Florentine humanists of the fifteenth century and encounter a real, live artist writing about what he knows best. Although Leon Battista Alberti's treatises, especially the one on painting, are informed by theoretical concerns, he himself was no philosopher; he had no system. Perhaps that's what makes him so accessible, even today.

Born in 1404, when his father was in exile from Florence, the young Battista received a humanist education first in Padua and later in Bologna. He became familiar with the antique tradition in literature and the arts through his university education. He studied philosophy and the natural sciences, and after the completion of his formal education, spent some time in Rome working for the Vatican Curia. When he entered Florence in 1434, the

first flush of the Renaissance was nearly finished. So, in effect, he saw the Florentine Renaissance at midstream: Masaccio was dead, Brunelleschi was building the dome to the Cathedral; much of the sculpture at Or San Michele was now in place; Ghiberti's sculptural style had changed to one of greater classicism and order. Leon Battista Alberti soon was at work on *Della Pittura* (published in 1436), to be followed by other treatises on the visual arts.

So much of Neoplatonic aesthetics deals with the invisible, the mystical, the ideational. Alberti believes in things seen. He is not so concerned with experiences on another plane of reality; in fact, this world pleases him: "No one would deny that the painter has nothing to do with things that are not visible. The painter is concerned solely with presenting what can be seen." Just the same, Alberti realizes that the world of sense perception can be deceiving and highly relative. He insists, therefore, upon a mathematical check for objects represented in paintings. Measurement is important because things must be fixed in space. On account of his desire for a secure location of objects, he emphasizes outline and the texture of surfaces—tactile phenomena. And, although not the first to use it, he is the first to write about linear perspective.

Alberti believes that a picture shows things that appear to be behind the surface of the picture itself. A picture, he writes, is like a "transparent window through which we look out into a section of the visible world." Alberti's visual system—based strongly on clear measurements, precise location, linear perspective, and the metaphor of the window—creates a system of absolutely determined visibility. In a sense, you can find the placement of every object in a painting created in terms of linear perspective; further, you can locate the position of the observer in relation to the space of the scene represented. That simply didn't occur before the Renaissance. Because the viewer now senses that the work of art is some kind of extension of his or her own space, the sense of identification with the scene is heightened. The painting is a microcosm—a self-contained "reality"—in which the observer participates.

But the system—that arrangement of lines, colors, and patterns on a flat surface—isn't in and of itself enough. Pure visibility and the sensuous attraction of forms provide only the beginning for a humanistic end. Alberti called this end or purpose *istoria*: "The greatest work of the painter is the *istoria*." Loosely speaking, we could say that *istoria* is subject matter, the story, narrative, or devotional image presented to the viewer. Literally *istoria* means "history," so that pictures employing traditional subject matter, especially multifigured compositions, are called "history paintings." Gregory the Great believed that religious subject matter appealed directly to the unlettered, informed them, and reminded them of the necessary lessons and personages of Holy Writ. Alberti would agree up to a point, but would have found Gregory's formulation impoverished.

Istoria refers to those themes and figures sanctioned by time and tradi-

tion. The artist does not so much invent subjects, but reinterprets those that are well known, and he does it in such a way as to elevate and touch the viewer. The mode of presentation must achieve The effect of monumentality. But Alberti does not mean absolute scale here: The monumental is that which impresses. It need not be physically big to do this. Grandeur of impact leads to pleasure and a certain spiritual current.

He wrote that "the istoria which merits both praise and admiration will be so agreeably and pleasantly attractive that it will capture the eye of whatever learned or unlearned person is looking at it and will move his soul." Gregory the Great would scarcely have understood the double appeal of art: Why would the learned need or desire pictures when they had the text? Alberti believed that art has a certain efficacious and spiritual impact. How is our innermost being stirred? No more than Aristotle is Alberti clear on this matter. As Kant later was to say, although we may not have an objective definition of beauty, we can agree on its presence. Similarly, although we can give no functional description of how a soul moves and what is the physiological or spiritual change that results, we can agree that great art stirs us deeply. This is vague language, but, even if not subject to epistemological criticism, it has been more or less accepted over the centuries.

One of the ways in which the spectator is engaged is through the "passions of the soul"—human emotion. Alberti has a sensitivity to the psychological: "The istoria will move the soul of the beholder when each man painted there clearly shows the movement of his own soul. . . . we weep with the weeping, laugh with the laughing, and grieve with the grieving."

We are often aided in our emotional as well as intellectual response by a speaking and gesturing figure within the work of art:

> . . . in an istoria I like to see someone who admonishes and points out to us what is happening there; or beckons with his hand to see, or menaces with an angry face and with flashing eyes, so that no one should come near; or shows some danger or marvellous thing there; or invites us to weep or to laugh together with them. Thus whatever the painted persons do among themselves or with the beholder, all is pointed towards ornamenting or teaching the istoria.

Alberti asserts that a composition should not have too many nor too few figures (between three and ten is best), that it should be neither too lavish nor too stark, and that it should be virile and dignified.

Painting is a noble pursuit, and the artist should be well educated. Art is not simply a craft, the artist not just a humble workman. Alberti defends the status of the artist: "The incredible esteem in which painted panels have been held has been recorded. Aristides the Theban sold a single picture for one hundred talents. They say that Rhodes was not burned by King Demetrius for fear that a painting of Protogenes should perish." He also observes that

. . . the Greeks . . . because they wished their sons to be well educated, taught them painting along with geometry and music. It is also an honor among women to know how to paint. Martia, daughter of Varro, is praised by the writers because she knew how to paint. Painting had such reputation and honour among the Greeks that laws and edicts were passed forbidding slaves to learn painting. It was certainly well that they did this, for the art of painting has always been most worthy of liberal minds and noble souls.

Alberti in his book on architecture, *De Re Aedificatoria*, makes clear his definition of beauty. Beauty is a "certain regular harmony of all the parts of a thing of such a kind that nothing could be added or taken away or altered without making it less pleasing." This definition, depending as it does upon ancient notions of *symmetria*, underscores Alberti's traditional beliefs and reveals the depth of his insistence upon system. The work of art must be methodical, so orderly in fact that disturbing any element will upset the entire balance.

As mentioned previously, Alberti returned to Florence after the ban on his family had been lifted. And, although his first treatise (*Della Pittura*) was not published in Italian until 1436, its ideas reflect both his own thought and to a certain extent the painting done in Florence before his arrival. The prime example of the new style in Florentine painting is Masaccio's *The Tribute Money*, part of his frescoes for the Brancacci Chapel in the church of Sta. Maria del Carmine (fig. 12).

The central scene of the fresco and the chapel is called *The Tribute Money*. We see several groups of figures: two men to the right, a man and a fish to the left, then in the center figures arranged like a circle in depth. The composition itself spreads to left and right, like a large movie screen. Our position as observers is elevated, as if we were floating several feet above the

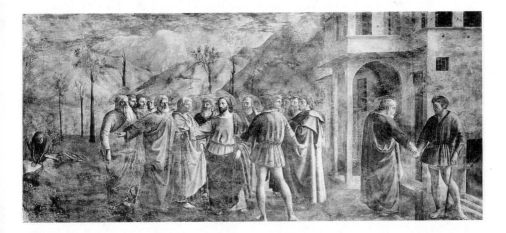

Figure 12. Masaccio, *The Tribute Money*, c. 1427; fresco. Brancacci Chapel, Sta. Maria del Carmine, Florence. Photo: Alinari, Florence.

floor of the chapel. In order to keep the composition arranged in an ideal fashion, so that it is parallel to the surface of the wall, Masaccio cannot take into account our actual point of view from the floor of the chapel, therefore our "hovering" position. The organizing system here, as in Alberti's treatise, is linear perspective. But, because the events of the painting take place largely in the country, we are not so aware of the perspectival system. Nature normally does not arrange itself according to some grid, but the architecture to our right does afford the possibility for artificial constructing. If your eye follows those lines or edges of architectural form that in reality would be parallel, you can see that as the building "recedes" in space the parallel lines converge. If this recession were to continue beyond the end of the building, you would find that the lines converge at approximately the location of Christ's head. The nonobtrusive linear perspective "shows" us the central or focal point of the composition, and this is not just an exercise in system or arrangement of parts. Christ is the center of the drama as well as of the pictorial space. Because, as Alberti admonishes us, the *istoria* or narrative is the purpose of the work of art.

Here we have illustrated a relatively obscure story from the Book of Matthew, which concerns one of Christ's teachings. As the group of Jesus and his followers comes to the gate of a city controlled by the Romans, they are approached by a tax collector: A toll will be exacted before they can enter. Some of the Twelve voice disapproval, disgruntlement. But Jesus reminds them to "render unto Caesar that which is Caesar's, and unto God that which is God's." In other words, pay your taxes; worship God. There will be no conflict. Peter, to our left, is directed by Christ to find a coin in the mouth of a fish; here is an ingenious way to pay the tribute. To the right, Peter hands the coin to the collector.

The composition (a *quadri storiati* in Alberti's sense, meaning "multifigured") is neither too spare nor too populated. There is an economy to the arrangement of elements: twelve disciples, Christ, and the tax collector (Peter is shown three times, the collector twice). This method of continuous narration allows Masaccio to show the two primary events of the story, and one secondary incident. Although Masaccio breaks with the unity of time (as Alberti points out in his treatise, unities should be visual, spatial, and temporal), he doesn't do so in a disruptive fashion: The scene remains coherent and, if one knows the story, quite legible. There is enough architecture represented to establish setting and the gate to a city. The scene relies upon the typical and general. And there are other elements—of light, outline, relief, facial and bodily expression, and so on—that Alberti discusses in a detailed manner in his treatise. Masaccio's *The Tribute Money* is an almost perfect illustration of Alberti's theories.

Leonardo da Vinci

If we consider Leon Battista Alberti to be the major theorist of the early Renaissance, then Leonardo fulfills that role for what we call the High Renaissance. He was born in 1452 and grew up in Florence where the Neoplatonist influence was strong. But he resisted it, just as he dismissed the authority of the medieval theologians known as Scholastics. He wrote that "any one who in an argument appeals to authority uses not his intelligence, but his memory." Memory has indeed played an important role in the uses and theories of art, from Plato through Gregory the Great to St. Thomas Aquinas. But what good is received opinion or an authority that descends from the Heavens, if one cannot go out and look at the world? Leonardo looked, and did so scientifically.

Although Leonardo da Vinci apparently had intended to write a comprehensive treatise on art, what we have surviving is more notes and marginalia than something philosophical and systematic. Yet a clear and unified view emerges, and it is based upon empiricism. The *Oxford English Dictionary* defines empiricism as "the doctrine which regards experience as the only source of knowledge." Leonardo raised the idea of experience to new heights. He made important contributions and discoveries in botany, zoology, biology, engineering, hydraulics, geology, optics, and anatomy, to name the most obvious. He studied in meticulous detail the world in all its fascinating parts: His drawings show the position of the fetus inside the womb, the structure of blood vessels, tissues, muscles, and skeleton. He was perhaps the most accomplished anatomist of his time. Vaselius' *Fabrica*, an important medical text published in 1543, owes a great deal to Leonardo's study. In fact, Leonardo called himself a *pittor anatomista*, meaning a "painter of anatomy." With great attention to detail he made drawings of plants, animals, and the characteristic movements of water. His drawings of visual phenomena were not done just to help train himself as an artist; in and of themselves, these details of the world captivated him. He was looking for and felt he had found the order of the physical world.

Although he was almost rapturous about the sense of sight ("O most excellent above all other things created by God," he addresses the human eye, "what praises are there to express your nobility? What peoples, what tongues can describe your scope?"), seeing by itself is not enough. He refers not just to the naked eye, the eye as mechanical lens opening upon the world; more than that, seeing is thinking, is intelligent, is informed. If you detach the eye from the brain, you'll end up with mere likeness. "The painter who paints only by practice and the use of his eyes but without understanding is like a mirror that imitates without understanding all that is placed in front of him." He makes his procedure clear when he writes that "this is the true rule how observers of natural effects must proceed: While nature begins with reasons and ends in experience, we must follow the opposite path, beginning with experience and with that investigating the reasons."

So his position on mimesis is really very different from the traditional one. Alberti and many others had suggested that the artist select the most beautiful details from nature and combine them to find something better than that which actually exists. Plato and the legion of Neoplatonists believed that inherent in mimesis is a distance or a falling away from reality. For Leonardo, mirroring nature is almost enough, but not quite. When he writes "that painting is the most to be praised which agrees most exactly with the thing imitated," he implies that the artist has not just shown us the surface of something but has captured the laws of nature (mathematics, anatomy, structure, optics, and color) and made them obvious in his depiction.

Like Alberti, Leonardo uses linear perspective as an important organizing device for visual experience, as an artistic equivalent to nature's "reasons." Although painting is an imitation of nature, it is a scientific imitation. Based upon mathematical perspective and the study of nature, painting renders the truth. Leonardo's truth is not beauty; in fact, beauty plays only a marginal role in Leonardo's thinking. When he does refer to beauty, he characterizes it as charm and grace: no transcendentalist, Neoplatonist he!

Leonardo inherited the Renaissance tradition of centered, clearly visible, symmetrical compositions with three-dimensional, anatomically accurate, and functional figures. And he subscribes to the doctrine of *istoria*. History painting is the highest form. Painting is noble and one must submit to a certain degree of decorum: "Observe decorum, that is to say the suitability of action, dress, setting and circumstances to the dignity or lowliness of the things which you wish to present."

Another way that Leonardo ties himself to tradition is in his psychological interests. He says that when one paints the figure, one must also be attentive to the soul: "The good painter must paint principally two things, which are man and the ideas in man's mind. The first is easy, the second difficult, because they can only be expressed by means of the gestures and the movements of the limbs." This is a call for the artist to make the invisible visible: The human soul should be exposed by the motion of the human body. Just as those scientific ideas about nature should be manifest in a landscape painting, so too should the vital center of human beings show forth through gesture and expression. Leonardo instructs the painter to study the speechless, because they communicate exclusively through gesture. We reveal ourselves, make ourselves known as human beings, not just through words but by way of the movement of our physical bodies. Leonardo would have understood what we mean today by "body language."

With an attitude that would have baffled medieval theologians, Leonardo values things seen over things read. He gives images priority over words—and not just because some observers are illiterate. Images inherently have more power than language: ". . . write up in one place the name of God, and put a figure representing him opposite, and see which will be the more

deeply reverenced." From the beginnings of the Christian Era, the text—the Bible—had been thought to carry the essential Christian meaning and message. Now, according to Leonardo at least, the image embodies significance more directly and more powerfully than the word. As he observed, the relation of painting to text is the relation of object to shadow. We know from the Neoplatonic tradition what this comparison means: The original object or idea has more substance, greater reality. Leonardo uses the traditional analogy, but turns it upside down. Now the idea is shadow; the painting or work of art is substance.

Michelangelo

Again, in Michelangelo, we have an artist who probably intended to write a treatise on art, but never did. Still, Michelangelo's thoughts on art are important because they reflect his times and have some originality. What we know about his ideas comes from his sonnets—he was an accomplished poet—and from his biographers.

Michelangelo had a powerful feeling for beauty. Ascanio Condivi, one of his pupils who later was to write a biography of the artist, explains that Michelangelo "loved not only human beauty but universally every beautiful thing . . . choosing the beauty in nature, as the bees gather honey from the flowers using it afterwards in their works, as all those have done who have ever made a noise in painting. That old master who had to paint a Venus was not content to see one virgin only, but studied many, and taking from each her most beautiful and perfect feature gave them to his Venus." This of course is the old-fashioned doctrine of selectivity, something to which virtually every artist (with the notable exception of Leonardo) for about 1,500 years subscribed.

Michelangelo grew up in the Renaissance tradition. He knew the writings of Alberti, and in matters of perspective and anatomy followed both him and Leonardo. And, although he derives some of his ideas of beauty from his contemporaries and immediate predecessors, there is something more spiritual about Michelangelo. He yearns for beauty. It represents the Divine.

He writes:

> He who made everything made every part,
> And then from everything He chose the fairest,
> To let us here look at His very greatest,
> And now has done so with His sacred art.

We recognize the Platonism here, the sense that the Divine is reflected on this earth and that we love that reflection because of what it represents.

But the one thing that Plato and many of his followers insisted upon—*symmetria*—isn't so important to Michelangelo. He believes that beauty is unmeasurable. Its power to attract us is what's significant.

> While toward the beauty that I saw at first
> I bring my soul, which sees it through my eyes,
> The inward image grows, and this withdraws,
> Almost abject and wholly in disgrace.

This passage shows how beauty creates in the heart of the observer a longing, a desire, a sense of being unfulfilled. We suffer from our aspiration and our need. But art offers some hope and consolation. There is something in the painting or sculpture that is pure, that embodies the eternal beauty. More than Plato believed possible, more even than Plotinus believed possible, art can contain the eternal. Beauty gets into an art object because the artist has it first in his head and then injects, or rather "discovers," it in the paint or stone. These are two differing processes—either putting something there or finding it there—but they both require the creative capacity of the artist. When one looks for beauty, one finds it in two places simultaneously.

> The best artist never has a concept
> A single marble block does not contain
> Inside its husk.

This concept (a *concetto* in art historical language) is something like an idea, but is different from it as well. Benedetto Varchi, a contemporary theorist, wrote, with Michelangelo's blessing, an explanation of his use of *concetto*: "In this place our Poet's *Concetto* denotes that which, as we said above, is called in Greek idea, in Latin exemplar, with us 'model'; that is, that form or image, called by some people the intention, that we have within our imagination, of everything that we intend to will or to make or to say; which, although spiritual . . . is for that reason the efficient cause of everything that can be said or made."

The *concetto* is the artist's intention. It can make it into the sculpture or the painting. In his later life, Michelangelo wearied of life's vanities and believed that art in its worldliness is not very important in light of the need for salvation. However, he never gave up the belief that art can, in fact, convey the beautiful, so long as the artist has an image of the beautiful in his mind and has the ability to "discover" it in the work of art. This is what we'd call creativity and talent.

Vasari's Lives

The first "modern" art historian was the sixteenth-century Italian artist and writer Giorgio Vasari. In his *Lives*, published first in 1550 and in a second edition in 1568, Vasari wrote biographies of noted artists from the fourteenth century until his time. But it is not biographies alone that establish him as an art historian; rather, it is his scheme of ordering and conceptualizing art as a historical phenomenon. In Vasari's scheme there was a *re nascere*, a "rebirth" (the origin of our word "Renaissance"), of art in Italy in the fourteenth century, beginning with Giotto and Cimabue (it is worth noting that most Renaissance art courses, following Vasari's model, begin with Florentine art at the end of the thirteenth and beginning of the fourteenth century). Vasari, like others before him, sees the "ancients" as having the first true vision in art. With a certain imperiousness he dismisses the whole of art in the Middle Ages, seeing the Gothic in particular as barbarous. From Vasari's point of view, art attains its value by its similarity to antiquity. And he notes that the "moderns" regained the ideal beauty and naturalism of antiquity, imperfectly at first (with Cimabue and Giotto), but with greater confidence in the fifteenth century and with perfect realization in the sixteenth-century art of Michelangelo and some of his contemporaries.

At the beginning of the third part of his *Lives*, Vasari writes a brief introduction that gives, in general terms, the foundations of his art historical methods. The first part of the *Lives* begins with Giotto and Cimabue and extends into the fifteenth century. According to Vasari, these early artists, while far better than anything in the preceding centuries, nonetheless are explorers, pioneers, and primitives—those whose vision is not satisfactorily developed. As Vasari points out at the beginning of the second part, with his historical method he has taken the reader and the three arts "from the nurse, and having passed the age of childhood, there follows the second period in which a notable improvement may be remarked in everything." His method is developmental, genetic in some ways, biological, and progressive. But the artists of the second part, roughly from the beginning of the fifteenth century up until the time of Leonardo da Vinci, are antecedents for the inevitable artists of perfection, those we still call the artists of the High Renaissance. Vasari explains the perfection of the High Renaissance in terms of rule, order, proportion, design, and style.

Vasari writes that

rule in architecture is the measurement of antiques, following the plans of ancient buildings in making modern ones. Order is the differentiation of one kind from another so that every body shall have its characteristic parts, and that the Doric, Ionic, Corinthian and Tuscan shall no longer be mingled indiscriminately. Proportion in sculpture, as in architecture, is the making of the bodies of figures upright, the members being properly

arranged, and the same in painting. Design is the imitation of the most beautiful things of nature in all figures whether painted or chiselled, and this requires a hand and genius to transfer everything which the eye sees, exactly and correctly, whether it be in drawings, on paper panel, or other surface, both in relief and sculpture. Style is improved by frequently copying the most beautiful things, and by combining the finest members, whether hands, heads, bodies or legs, to produce a perfect figure, which, being introduced in every work and in every figure, from what is known as a fine style.

We can look a little more closely at Vasari's assumptions and definitions. First of all, he associates rule with the measurement of antique buildings, and by doing this, he gives to antiquity an authority over the present. The rule of ancient buildings carries certain implications, which Vasari certainly understands. Rule in art reflects the composition, exactitude, and structure of the universe. Rule in art is therefore divinatory: The Divine or universal is reflected in the particular. The belief had long existed (beginning at least with Aristotle) that that which is most "real" in human nature and construction corresponds to an idea, the immutable principles of the superlunary realm, of the highest heavens beyond the moon. A human wishes to find the Mystic Way, the *itinerarium mentis in deum*—the mind's road to God, as St. Bonaventure phrased it. The desire to find this path, this transcendental connection, was important to Vasari and to the artists of the Renaissance.

Order for Vasari has to do with differentiation and classification. Separation creates clear categories, so that things are delimited, locatable, grounded, identifiable.

Proportion is treated rather simply by Vasari, being defined by the upright and the proper. But again there are traditional ideas behind proportion that Vasari accepted and invoked. Proportion has to do with commensurability and the relation of parts to one another, ideas important to the Greeks. As Plato said, "Everywhere commensurability and measure are associated with excellence and beauty."

Design for Vasari is the creative capacity to imitate that which is most beautiful in the world, usually following a system of selectivity. As Zeuxis was thought to have done in antiquity, the artist finds the most beautiful parts of the most beautiful women and recombines them into something that is more beautiful than any single woman and in which the whole is greater than the sum of the parts.

The word *disegno* means somewhat more in Italian than "design" does in English, for it is also the word for drawing and it refers to the compositional underpinning of a work of art. And as "creative capacity," (another definition of the term) *disegno* is the intellectual, rational part of a work.

The artists of Varsari's Second Period of the Renaissance (explicated in the second part of *Lives*) advanced over their predecessors, but they were not able to "attain the final stages of perfection" because they could not achieve

a freedom which, although beyond the rules, remained guided by their predecessors (a conservative rather than radical freedom); in the realm of order they lacked the capacity for good judgment, which does not so much require measurement as grace; and, similarly, in the way of design—*disegno*—they were not capable of grace and ease, but rather were stunted and crude. "Their draperies lacked beauty, their fancies variety, their coloring charm, their buildings diversity and their landscapes distance and variety." Some other things that Vasari found missing in the artists of the Second Period were finish, perfection, lightness, polish, assurance, vigor, and softness.

Vasari's story, like so many, has a beginning, a middle, and an end. The end is his own period. Leonardo da Vinci begins the Third Period and heralds the culmination and resolution of that which went before. He was "notable for the boldness of design, the subtlest imitation of Nature in trifling details, good rules, better order, correct proportion, perfect design and divine grace, prolific and diving to the depths of art, endowing his figures with motion and breadth."

Conjuring divine grace, Vasari brings the art of the High Renaissance to its proper summit. Grace is the love, beneficence, and care of God that makes the figures painted by Leonardo, Michelangelo, and Raphael more than graceful. The artists and their art participate in the Divine. The artists of the High Renaissance give to us a theophany, a vision of the miraculous and ineffable.

Such is the power of art, in Vasari's version. His study of art becomes the paradigm of art history. In the Third Period artists are "worldmakers." As Nelson Goodman explains, worldmaking is rhetorical, it seeks to persuade and instruct, to purge in the Aristotelian sense (see the section on "Architecture and Order") to bring about a catharsis. Art that participates in the Divine, that leads to the Mystic Way persuades with an unrivaled authority. The result edifies the public, raises its consciousness and awareness of the True, the Good, and the Beautiful.

Let us make an attempt to characterize and analyze a work that we could call quintessentially classical and canonical in the Vasarian sense. The *School of Athens* by Raphael (fig. 4, p. 34) can stand for many works of art in the context of High Renaissance art and art history. It was commissioned by the Pope for his public Papal Apartments, is a compendium of Renaissance imagery and thought, and reflects the "Divine" Raphael's experience of the *caput mundi* (capital of the world), Rome. The School of Athens resonates backward and forward in time.

We can look at the *School of Athens* first of all through Vasari's eyes, and then we can assess, from our own point of view, how the work reflects the Renaissance ideal. Although this work is an example of the Vasarian canon, his own discussion of it is, surprisingly, confused: He mixes it up with the *Disputation on the Holy Sacrament*, another painting by Raphael in the same room.

Vasari's descriptive vocabulary is primarily one of praise. For instance,

he mentions that the figure of Diogenes (lounging on the steps) is "admirable for its beauty." Other figures are "indescribably fine"; a youth has "remarkable beauty"; certain heads have a "beauty and excellence" that is "inexpressible."

So some of Vasari's key ideas are expressed in such words as the "excellent," the "indescribable," the "remarkable," the "inexpressible," and the "admirable." If a modern critic were to use this kind of language, he or she would be dismissed as uttering vague praise. But for Vasari these are words that describe the artistic qualities of the painting, those things that make the painting different from Nature. Vasari includes the "admirable" and "inexpressible" as part of the "marvelous" or *meraviglia*, as Vasari's friend Vincenzo Borghini described it. David Summers discusses *meraviglia* in his *Michelangelo and the Language of Art* as one of Borghini's three categories of art: *varietà* ("variety"), *imparare* ("learning"), and *meraviglia*. These three ideas correspond to the three aims of rhetoric: to teach, to delight, and to move. These, in turn, correspond to the three kinds of rhetoric: the simple, the middle, and the grand. *Meraviglia* is therefore associated with the highest form of discourse or oratory: the grand manner. Borghini states that "all things that cause *meraviglia* please you." And he goes on. "There is no doubt that extravagant things, never before seen or heard, or that have in themselves such a rare excellence, delight extraordinarily, and this extraordinary delight is called *meraviglia*." The marvelous is that part of a work of art that goes beyond expectations, beyond the first two aims of rhetoric.

Art historians treat the *School of Athens* as one of the central documents of the High Renaissance. "Central" and "High"—the terms themselves confer prominence and authority. Arranged in a circle, the students of the School converse with one another, gesture, reason, contemplate, and pose themselves for the enlightenment of the observer. This is not so much a narrative as a display of ideal types, historical and contemporary figures, and personifications of reason. But before considering the human element, the story or message, let's be "art historical" and consider the work in abstract terms. Although I will not be using Vasarian language to describe and analyze the *School of Athens*, I will be speaking as a modern art historian who is a direct descendent of Vasari.

This fresco organizes our visual experience through certain contrived devices. The work centers around two figures; it is large and in a lunette (windowlike) shape; classical architecture (along with the values it implies) dominates the space, which is perspectival; the figures are distributed evenly; light clarifies and reveals the position of every figure. The whole is ideal and universal, embracing time from the Athenian Golden Age until Raphael's present; embracing place from Athens to Rome (the architecture is similar to Bramante's plans for the rebuilding of St. Peter's Basilica). Raphael creates a world that is sufficient, logical, and legible.

For Raphael and his contemporaries, the aim of art is to please, to in-

struct, to use rhetorical elegance to educate the observer and to create, as mentioned previously, a sense of purification and renewal. His painting of all of philosophy, deriving either from Plato on the left or Aristotle on our right, should satisfy us with its completeness.

The educated observer would then, because of his interest in *istoria*, and will now, recognize to the left of Plato (a portrait of Leonardo?), Socrates demonstrating a syllogism on his fingers. The man in full armor and helmet who listens to Socrates is Alcibiades; Epicurus reads a book that is propped against the base of a column; the child to Epicurus' left is the little Federico Gonzaga. Just to the right of Gonzaga is Pythagoras, who writes in a book his theory of proportion; those around Pythagoras are Averroes, standing and wearing a turban, and Empedocles. The seated, meditative man in the act of writing on a marble slab is Michelangelo in the guise of Heraclitus. The group on the right side of the composition, in the foreground plane, consists of Euclid inscribing a design on a tablet (he is a portrait of Bramante), Ptolemy holding a terrestial globe, and Zoroaster with a celestial globe. Staring out at us are Raphael and Sodoma (Raphael to the left). Because of its universality, the human or narrative element fits the design. This entire "code," when deciphered as I have suggested, gives to us the idea of *virtus*: those qualities of dignity, worthiness, impressiveness, and nobility so favored by the Renaissance. Alberti also had emphasized those qualities of strength and steadfastness in the face of capricious fate that are also an important connotation of *virtus*.

Mannerism

Mannerism is not an easy term to pin down. In general, it describes a period in artistic production, especially in Italy, from about 1520 until 1600. As a style it signals something odd—odd, that is, by the standards of the earlier Renaissance.

There is a theme in artistic and art historical criticism that considers the relation of style to the thing represented. One school of thought favors what is sometimes called the "natural sign." This means that a painting of a tree can be nearly as natural as the tree itself, so that we judge a painting of a tree on how close it comes to the real tree. The opposite tradition, one which is very important in modern critical theory, says that everything in art is arbitrary, uncertain, variable: The picture of a tree is really a series of marks or signs arranged on a surface, and the only legitimate way of dealing with a painting is to consider it in abstract or semiological terms. Forget the so-called real tree.

In mannerism, this reference to *how* a painting occurs seems to gain some ground on what the supposed subject matter is. These kinds of critical

issues can seem elusive and almost precious to us, but they are important.
That is why I'm digressing some here. Jacques Derrida, one of the lions of
late twentieth century criticism, says that there is a tradition which states that
the imitated should have priority over the imitation (or imitator): "This is
not just one metaphysical gesture among others; it is the metaphysical exi-
gency, the most constant, profound, and potent procedure." What he means
by this is that in pre-modernist art theory, style serves meaning. Or should.
Don't let your style get in the way of painting a tree. But in mannerism there
seems to be a struggle between style and meaning. For instance, in Parmi-
gianino's *Madonna with the Long Neck* most of us will agree that stylishness is
more important than normality (fig. 13). The Madonna is too big. Her lap is
enormous, her head tiny, her child overgrown and maybe not alive (a prefig-
uration of His sacrifice). The space is discontinuous: The little man in the
background with the scroll may be a prophet, but he turns his head away
from what is written. And his spatial relation to the Madonna is ambiguous:

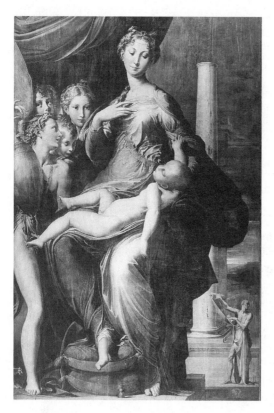

Figure 13. Parmigianino, *Madonna
with the Long Neck*, c. 1535. Uffizi
Gallery, Florence. Photo: Alinari,
Florence.

How far back is he? All but one of the columns next to him evaporate toward the top. They support nothing. The angels, with one wearing a "French-cut" robe, crowd into the corner, like a giggling group of school children, and look at the big baby. Mary seems pleased, but very affected. Even if we can explain some of the imagery and its symbolic meaning in terms of tradition, the overall appearance is new and disturbing. And that, it seems to many observers, is because the artificial and the stylish are emphasized. It is worth remembering that the word "mannerism" comes from the Italian *maniera*, which means, among other things, "style."

In antiquity, theories of beauty and the nature of the arts originated with philosophers. Although artists wrote about art, their ideas have survived only obliquely, through secondary sources. And the artists themselves were not highly theoretical. In the early through late Middle Ages, speculation on beauty came mostly from theologians. Art was understood almost exclusively in terms of its relation to religion. With the early Renaissance we have artists once again writing about art. They wrote manuals and about shop practices, the how-to of art. They mixed this with some theory and self-justification. Leonardo brought the practical and the scientific into a wonderfully harmonious balance. Michelangelo, like Ficino before him, returned us to Neoplatonic considerations of the origins of beauty and how it can manifest itself in the real world. For nearly a century and a half, artists had been given (or, more likely, had taken) the dais and had spoken to other artists about art. Now in the second half of the sixteenth century, philosophical speculation again asserted itself. Although some of the writers were artists, more were not. They were humanists, antiquarians, and *literati*—well-educated individuals with an interest in the arts and ancient history. And they spoke to people like themselves. They are the predecessors of today's art historians and critical theorists. In fact, one of these writers, Vincenzo Borghini, sounds a lot like a professor of art history speaking to a class. "You should know," he said to the artists of the Academy of Design in Florence, "that in every art there is a difference between operating in that art, and speaking or treating of it." Borghini believed that it was best to leave interpretation to the "philosophers and rhetoricians." One wonders if the artists responded with a degree of skepticism like they often do today.

Because so many of the writers at this time were only incidentally interested in technical matters such as the construction of perspectival space or the mixing of colors, more attention was given to speculation and to the nature of the artist and artistic creation. As Moshe Barasch has observed, this is the time when art theory comes of age. Theories of beauty, creativity, and the role of art are the direct focus of philosophical reasoning. We no longer have to infer from writings on something else what a particular opinion of art and beauty happens to be.

Much of mannerist art theory has to do with an overthrow of the rules and a consideration of artistic freedom and creativity. Leonardo had sug-

gested a mathematically based, scientific view of painting. Federico Zuccaro, a late sixteenth-century writer and artist, says about measurements that ". . . it is necessary to know them; but one must bear in mind that it is not always advisable to observe them." The artist has to make adjustments that are not, strictly speaking, mathematical. He also writes that ". . . the art of painting does not derive its principles from the mathematical sciences, indeed it need not even refer to them in order to learn any rules or manners of procedures, or even to be able to discuss them by way of speculation; for painting is not their daughter, but the daughter of Nature and Design. The first shows it form, the other teaches it to work." As we saw in the chapter on the academy, design—*disegno* in Italian—becomes a central element in sixteenth-century art theory. Nature perhaps is the source of the forms that turn up in paintings, but *disegno* is the style, the means of presentation, the structure, and—in a certain sense—the idea of a work. The idea comes from the artist.

Zuccaro said of the artist that his "intellect must be not only clear but also free, and his spirit unfettered, and not thus restrained in mechanical servitude to such rules, because this truly most noble profession wishes judgment and good practice to be the rule and norm of working well." So the liberation of the artist from exactitude, certitude, rules, and measurement gave him license to explore and experiment. This free-ranging approach engaged the artist's aesthetic capacity, the *disegno interno*, or "interior design." This interior design is the "imagination," as we might call it. But that doesn't really clarify things. What is the imagination? What is the *disegno interno?*

By getting rid of rules, by seeing nature as something imperfect, by giving the artist far more power than an accomplished imitator has, the theorists of this time painted themselves into a corner. They didn't want to say "anything goes," but they weren't sure what the limits were either. They speculated on the origin of ideas. Zuccaro claimed that before there can be a *disegno* in the work of art, it had first to exist in the mind of the creator. He said that the *disegno interno* is "a concept formed in our mind, that enables us explicitly and clearly to recognize any thing, whatever it may be, and to operate practically in conformance with the thing intended." Is this consciousness, intentionality, or a biologically based function of the relationship between the two hemispheres of the brain?

To answer these questions, theorists turned to the old model: Neoplatonism. The inner idea or *disegno interno* came originally from God; it is a spark of the Divine in the mind of man. According to Lomazzo, it also had first passed after emanating from the mind of God through the angels, then to the artist. So the artist is still something of a conduit for a higher power, but he seems to be active not passive. There is a shard, a piece of the divine *grazia*, of "graceful beauty," in the artist's mind, and he or she can make it appear in material form. How this happens is like describing beauty itself; it is

shrouded in mystery and something almost alchemical occurs. It is perhaps magical. Giordano Bruno (1548–1600) claimed that "beauty is of many kinds," and that "the essence of beauty, like the essence of pleasure and good, is undefinable and indescribable."

◆

Bibliography

ALBERTI, LEON BATTISTA, *On Painting* (trans. Cecil Grayson; Introduction and Notes by Martin Kemp). New York: Penguin Books, 1991.

BARASCH, MOSHE, *Theories of Art from Plato to Winckelmann.* New York: New York University Press, 1985, pp. 108–310.

BLUNT, ANTHONY, *Artistic Theory in Italy 1450–1600.* Oxford: Oxford University Press, 1962.

FARAGO, CLAIRE, *Leonardo da Vinci's Paragone: A Critical Interpretation with a New Edition of the Text in the Codex Urbinas.* Amsterdam: Leiden and New York: E. J. Brill, 1992.

GILBERT, CREIGHTON, ed., *Italian Art, 1400–1500: Sources and Documents.* Evanston, Ill.: Northwestern University Press, 1992.

KRISTELLER, PAULO O., *The Philosophy of Marsilio Ficino* (trans. Virginia Conant). New York: Columbia University Press, 1943.

PICO DELLA MIRANDOLA, GIOVANNI, "On the Dignity of Man" (trans. E. Forbes), *Journal of the History of Ideas,* 3 (1942).

SUMMERS, DAVID, *Michelangelo and the Language of Art.* Princeton, N.J.: Princeton University Press, 1981.

VASARI, GIORGIO, *Le vite de' piu eccellenti pittori: The Lives of the Painters, Sculptors, and Architects* (ed. William Gaun; trans. A. B. Hinds). London: Dent, 1963 (4 vols.).

4

Nature, the Ideal, and Rules in Seventeenth-Century Theory

Art theory in the seventeenth century pivoted on several key issues: naturalism, mannerism, idealism. Perhaps Caravaggio's *Basket of Fruit* (fig. 14) in the Ambrosiana can act as visual demonstration of nature, that always elusive and multilayered concept that lies behind the three major issues. Nature stood in the minds of the seventeenth-century artists and theoreticians as an inescapable artistic question. Caravaggio pushes a basket of fruit into the viewer's face. "Here is nature, over the edge," he might be saying. Look at the worm-eaten holes in the leaves and the fruit. Through decay, Caravaggio's fruit basket shows the passage of time, underscores the impermanence of this sublunar, imperfect world. Nature appears to be, for Caravaggio, not so much an animating as a destroying force: It is the force that through the green fuse (to paraphrase Dylan Thomas) drives the flower—and us—to death. I believe we can view Caravaggio's *Basket of Fruit* as an ironic visual comment or critique on the role of nature in art. Critics and historiographers of the seventeenth century remark on Caravaggio's insistent if unidealized "return" to nature.

In a contrary approach, mannerism, as we have seen, detaches itself from nature, the "world out there," with such determination that it is grounded in custom and practice, caprice and artistic invention. So it too was rejected by the middle-of-the-road theorists of the seventeenth century.

Bellori reconciled art and nature by developing an aesthetic position that called for purification of nature. By beginning with nature but ending in the ideal, Bellori's procedure is, to a large extent, methodical and normative (that is, following rules).

Figure 14. Caravaggio, *Basket of Fruit*, 1596. Ambrosiana, Milan. Photo: Art Resource.

His essay "The Idea of the Painter, Sculptor and Architect" has been called the "most authoritative statement of classical artistic theory that the seventeenth century produced." In it Bellori brings forth a Neo-Aristotelian cosmology and an attitude toward art that is based partly in theory, partly in practice. His cosmology divides the universe into two areas: the first, above the moon, where all remains perfect, immutable, cosmically unruffled; and the second, the sublunar world, characterized by decay, deformation, imperfect nature. Nature tries to produce excellent things, but disarrangement is inevitable. Nature is beset by clutter, confusion, and jumble. Artists imitate the first creator by first forming the right idea in their minds. They emend nature—correct her errors—by selecting the most beautiful from nature and submitting that gathered data to the "compass of the intellect."

Avoiding the intellect results in un-idealized naturalism, which is the crime of being "too natural." According to Bellori, the painter Dionysius was called an *anthropographos,* a (mere) painter of men. A similar error involves imitating the ugly or the vile, because that places one in league with the Devil.

The best procedure, according to Bellori, involves selecting the most beautiful things that already exist in nature. Here one must recapture those fleeting remains of beauty that briefly survive in this world of experience. As found in Cicero and Pliny, there is that story we have come across already several times: It tells of how Zeuxis fashioned the likeness of Helen from five virgins. The resulting image was so beautiful, according to Bellori, that a statue

of Helen rather than the woman herself was carried off to Troy. And suppos-
edly Raphael wrote to Castiglione about his *Galatea* (fig. 18, p. 116) that "in
order to paint a beauty I would have to see several beauties, but since there is
a scarcity of beautiful women, I use a certain Idea that comes to my mind."
The question once again is: Where does this idea come from? Whatever the
source—and it does not necessarily come from a synthesis of empirical obser-
vations—the result is what the Italians called a *disegno interno*, an idea in the
mind of the artist.

When suggesting to the artist how best to render the passions of the
soul, Bellori does say that the idea maintained in the artist's mind should de-
rive from a melding of observations. He writes that

> we must consider that Painting being at the same time the representation
> of human action, the Painter must keep in mind the types of effects which
> correspond to these actions, in the same way that the Poet conserves the
> Idea of the angry, the timid, the sad, the happy, as well as of the laughing
> and crying, the fearful and the bold. These emotions must remain more
> firmly fixed in the Artist's mind through a continual contemplation of na-
> ture, since it would be impossible for him to draw them in his imagination;
> and for this the greatest care is necessary, since the emotions are only seen
> fleetingly in a sudden passing moment.

In the act of posing, the model who stands before the artist's eyes re-
mains immobile, so therefore cannot perform an action or display an appro-
priate emotion. But, it seems to me, Bellori is only suggesting one kind of
idea here, the idea of imputing to a static figure an active motivation. The
idea of beauty is of another order: It identifies with truth. Bellori quotes
Guido Reni as saying, in regard to his painting of St. Michael for the Ca-
puchin Church in Rome, "I would have liked to have had the brush of an an-
gel, or forms from Paradise, to fashion the archangel and to see him in
Heaven, but I could not ascend that high, and I searched for him in vain on
earth. So I looked at the form whose Idea I myself established." Did he form
this idea only through observation? Like Raphael, Reni senses that there
must be some superfluity, an excess of inspiration—or whatever is the stuff of
the artistic Idea—beyond the moments of experience. The denseness of Idea
always exceeds syntheses of separate observations. It's more than the sum of
individual instances of beauty or truth. The Idea does not originate with the
angels, but neither has nature the capacity to yield it up to the human mind.
Maybe it is something in between. More than the recombinative capacity of
the human mind is at issue here.

Critiquing the Roman Catholic Church's use of visual art as a text for
the illiterate, Bellori notes that "yet the common people refer everything
they see to the visual sense. They praise things painted naturally, being used
to such things; appreciate beautiful colors, not beautiful forms, which they
do not understand; tire of elegance and approve of novelty; disdain reason,

follow opinion, and walk away from the truth in art, on which, as on its own base, the most noble monument of the Idea is built.'' But as we have seen in the discussion of medieval theory, reading art as an instructive text is not so simple a thing as the Church Fathers maintained. Ideal art is not for the vulgar; in fact, art is not all that good at engendering propositions for the illiterate, or—for that matter—for the educated. The idealist conceptions of the seventeenth century have little room for an uncomplicated "reading" of art, because at the level of naturalism, where images and ideas are supposedly transparently conveyed, there really is little of value. The uneducated may be pleased in a trivial sort of way, but the real meaning of visual art—its beauty— cannot be understood by the simple minded.

Art theory in the seventeenth century generally followed the traditional tenets of rhetoric: to instruct, to move, to delight. And in order for one to be properly instructed, one had to be well educated, or at least artistically literate. Although the observation is quite common that the baroque style appeals to the masses in order to bring them back into the fold of the Mother Church (one thinks of Bernini's "arms" in the Piazza of St. Peter's), we find in the theory of this period much to suggest that art of the best kind, High Art, has limited appeal and a select audience.

The seventeenth century is notable for incorporating psychology into artistic imagery. Motion in the human body was seen as an indicator of sensation and meaning. Although sight is a mediated sensation—what we see is not natural, immediate, direct—it can nonetheless reveal to us, through art, truths about the human condition. As the British writer Thomas Hobbes observed, all motion results from motivation, and all motivation results from desire for approach or need for avoidance: joy, hope, fear, anger arise from successful or unsuccessful approach or avoidance, desire or aversion.

Psychology in art derives from its mission to instruct, move, and delight that observer educated into the same system of values as the artist and the dominant culture he or she represents. Bellori notes Poussin's adherence to the oratorical principle: Move the audience through action and diction. Lines and colors are inadequate without "action." Both Poussin and such an early psychologist as Hobbes believed that action results from a psycho-physical coordination. The mind and body act together. The placement or arrangement of the body, gestures, and "countenance" (Hobbes's term) reveal a moment in the interior chain of thoughts.

Charles le Brun as director of the *Académie Royale de Peinture et de Sculpture* brought such concerns with human psychology into the realm of artistic interest. Of course, since antiquity artists had been advised to show the movements of the soul within the body, and Leonardo had stated that a figure in a painting must demonstrate the mind; if it does not, it will be judged "twice dead." It remained for Le Brun to categorize and institutionalize the study of human emotion in art.

Although I have already written about Le Brun in the chapter on acade-

mies, I will repeat here a summary both of his contributions to seventeenth-century art theory and of the subsequent contributions—as well as subversions—of Roger de Piles.

Charles le Brun first spoke on physiognomics ("physio," meaning "body"; "gnomic," meaning "to judge") to the French Royal Academy of Painting and Sculpture in 1671. Because of Le Brun's efforts, expression became part of the curriculum. In general, the psychological concerns of the Renaissance and of earlier periods had more to do with the body, governed by principles of proportion established in antiquity, than it did with the face. When the sixteenth-century writer Giovanni della Porta considered the human countenance in his study of physiognomy, he understood the face to reveal permanent character rather than fleeting emotion.

The seventeenth century, with such writers as Hobbes, Le Brun, Descartes, and to a certain extent Bellori, conceived of the passions in nonmetaphysical, mechanistic, rationalistic, deterministic, and positivistic terms. In other words, they were more practical than theoretical, more psychological than Neoplatonical. These writers understood the expressive importance of the human face. But how does one record emotions on this human surface? While Leonardo suggested that the artist always have a sketchpad handy so as to record those expressions that pass quickly, and while Bellori referred the artist to one's own ever-resourceful Idea for the passions, Le Brun instructed the artist to study the face, to examine its structure, and to discover which muscles create what feelings. An inner understanding serves one better than external observation. Further, as an instructional aid, Le Brun provided drawings as models for the expression of passion on the human face.

Among Le Brun's other implementations at the *Académie* were rules. In Moshe Barasch's discussion of Le Brun and his curriculum (upon which I am relying for much of this discussion), he quotes René Rapin's definition of poetics as "la nature mise en méthode," meaning "nature made methodical." In a manner somewhat similar to Bellori's, the *Académie* saw nature as modified and mediated by rules. Although the laws of nature may guide science, the laws of art must guide nature: Students must learn how these laws of art operate. Rules are precepts rather than absolute laws; they assist learning. Henri Testelin's *Opinions of the Most Skilled Painters on the Practice of Painting and Sculpture Put into a Table of Rules*, published in 1680, is based upon notes that Testelin made at the *Académie*. The academic system is divided into four parts: composition, line, color, and the expression of the passions. (It is worth noting that "scientific construction," anatomy, and perspective—so important to Renaissance practice and theory—are now left out of the rules of art.) These rules become not only guides for artists but also guides for judging artists. Roger de Piles, for instance, published a ranking of artists according to the four academic categories. A further implication of Le Brun's academic rules was Félibien's publication in 1667 of the hierarchy of painting genres, based now upon subject matter, not just upon mode or style. Ancient

rhetoric had categories and hierarchies of styles, but none so extensive as that promoted by academic practice in the seventeenth century.

What to the Renaissance was *istoria* becomes in academic theory *grand goût*. This involves taste, which as Barasch points out, grew from a tradition of subjectivity; nonetheless, a custom of normative taste exists at least from the end of the sixteenth century.

Grand goût as related to the ideal departs from our experience of reality, exceeding reality in such a way as to be universalizing, generalizing, and anonymous. But these rules finally could not maintain the assurances about art that they once had. By the end of the seventeenth century (and this happened with mannerism too), the notion of creativity exceeds the precepts and maxims of the classical-humanist age. Rules have their limits; perception and subjectivity cannot be excluded from the practice of art.

The crisis in the *Académie* came with the election of Roger de Piles in 1699. But that honorific election is the end note in a "quarrel" that began as early as the 1670s: the "Quarrel between the Ancients and the Moderns," which in academic terms translated into a dispute between line and color.

In the traditions of the *Académie* and of Italian art theory, line interests the mind; color the senses. Claiming that the "ancients" knew more about art and nature than we do was an appeal to authority. This often happens, that one looks to the past for answers, as if one had to have lived long ago and to have seen the world fresh and new in order to have any decent ideas. It is amazing to us how much antiquity held the present in thrall. But there were movements against that control, struggles with that cultural domination and jurisdiction. There were those who did not believe that creativity could be expressed in maxims or preestablished rules. Intellectuals of the period knew that art has its perceptual, subjective side, one that can't be entirely rationalized. Rules have their limits.

Roger de Piles's tenure as director of the French *Académie* marked a time when rules, expectations, and opinions relaxed somewhat. De Piles was not so rigid as Le Brun. He understood that pleasure, an emotional response to a work of art, and the variety of styles already existing in art were all things that couldn't be established by academic guidelines.

Roger de Piles upset the applecart of academic theory by saying that color, normally seen as at the bottom of the artistic ladder, is in fact more essential to art than drawing. Drawing, because it's something preliminary, doesn't show up in the final painting.

This debate got people very upset. They knew that some fundamental values were being called into question. At least since the sixth century A.D. there have been debates between the so-called ancients and moderns. It's like a generational conflict projected onto enormous spans of history and onto people who are either trying to seize power or to hold on to it.

But we are not just dealing with a power struggle. The nature of art, as understood by contemporary theorists, critics, and the public, was changing.

Jean-Baptiste Du Bos (1670–1742) wrote *Réflexions critiques sur la poésie et la peinture* (published in 1719) in which he showed painting to be in the service of sentiments—the emotions and feelings of the viewer. Denis Diderot had said that he wanted first to be moved by a work of art, afterward enlightened, instructed, taught. With sentiment replacing reason, there came to be a shift in the very core notions of what is art.

◆

Bibliography

BARASCH, MOSHE, "Classicism and Academy," *Theories of Art From Plato to Winckelmann.* New York: New York University Press, 1985, pp. 310–377.

ENGGASS, ROBERT, and JONATHAN BROWN, eds., *Italy and Spain, 1600–1750.* Englewood Cliffs, N.J.: Prentice-Hall, Inc., 1970.

PANOFSKY, ERWIN, *Idea: A Concept in Art Theory* (trans. Joseph J. S. Peake). New York: Harper & Row, 1968.

PUTTFARKEN, THOMAS, *Roger de Piles' Theory of Art.* New Haven, Conn.: Yale University Press, 1985.

THE EMERGENCE OF METHOD AND MODERNISM IN ART HISTORY

At a certain point in a text, an author will often pause to consider a change that seems to be occurring in his or her subject, to review and elucidate a fresh point of view overtaking older ideas. A historian might claim, for instance, that a "paradigm shift" is occurring, which means that critics, scholars, and thinkers of a certain period were slowly but perceptibly and collectively changing their minds about some scientific, political, or cultural concept. This is what was happening to art in the eighteenth century. Questions about the nature of art multiplied well beyond the limits observed and occasionally crossed in the Renaissance and baroque periods. While writers, artists, and academies had established a curriculum for art—its elements, aims, intellectual and social status—they had left a number of questions unasked. How is art woven into the general fabric of meaning and culture? How does art change within the career of an individual artist and through time? How does one perceive art and what is the aesthetic experience? How do the visual arts differ from the literary arts? How might one study and understand art?

The sisterhood of painting and poetry served the Renaissance and baroque periods well. Although the power of the visual image was asserted again and again, even to the point of suggesting that the visual can move us in a way that the verbal perhaps never can, more often than not paintings and sculpture were based upon written texts, be they biblical, liturgical, historical, poetic, or even fictional. The French *Académie* put text-based paintings at the top of its hierarchy, and those such as landscapes, still-lifes, and portraits—images with virtually no narrative structure or recognizable literary source—at the bottom. But beginning in the eighteenth century, those

who thought and wrote the most about art demonstrated an interest in the unique qualities of the visual arts, not in their derivative or textual properties. In a sense, the idea of "art for art's sake" begins in the Enlightenment, gains momentum in the Romantic through Impressionist periods, and defines a significant part of twentieth-century modernism. Thinking about art is less "iconographic" than before. Gotthold Ephraim Lessing based an aesthetic treatise, written in 1766, on the name of a famous ancient statue, the *Laocoön; or, the Limits of Poetry and Painting* (English translation 1836). In this tract he disagrees with Winckelmann's (see below) somewhat literary analysis of art and argues that the visual arts and poetry are essentially different from one another. Painting and sculpture depict in the blink of an eye an entire scene; poetry as narrative fiction, on the contrary, is suited for unfolding a series of events in time. By undermining the older notions of *ut pictura poesis* (as is painting, so is poetry), Lessing moved aesthetics away from the strict attention to subject matter and toward the essential elements of forms existing in space. Analyzing sculpture and painting in terms of their individual shapes and overall compositions is modern.

So I have chosen this point in my story of the philosophies and criticism of art at which to mark a "paradigm shift." And I begin with Winckelmann, a modern art historian. In a manner similar to that adopted by the brothers Schlegel (August Wilhelm von, 1767–1845; and Friedrich von, 1772–1829), who helped to define the discipline of literary history, Winckelmann established a developmental and contextual method that has remained a necessary element in art historical writing, and, further, he helped to identify and interpret the "classical" in art. After Winckelmann I write about the empiricists and Kant, philosophers who redirected our attention from the objects of experience to the experiencing subjects, from things to people. As you stand and look at a statue, a building, a mountain, or an ocean, the experience of beauty and aesthetic pleasure depends to a large extent upon you as a perceiver. By contemplating the effects of sensation—looking, hearing, smelling, tasting, feeling—aestheticians try to understand and explain the emotions that attend our interaction with objects of beauty and works of art. Those writers of the twentieth century who concern themselves with formalism, style, and connoisseurship owe much to the aesthetics of the eighteenth century.

Hegel, Riegl, and Wölfflin defined principles and created methodology for the discipline of art history by formulating schemes of stylistic development. Riegl and Wölfflin were far less concerned with questions of a general philosophical nature than was Hegel; they pursued, rather, a narrower and more specialized path. The critical theory of art history drew less and less upon philosophy in the first half of the twentieth century and more from its own roots in such writers as Wölfflin and Riegl. But as art history became more professional and academic, more preoccupied with attributions, documentation, names, dates, and periodization, forces from outside the field

never relented. The social, political, epistemological, and psychological implications for art attracted the interest of many, and not just art historians. As Walt Whitman wrote, "One is never entirely without the instinct of looking around." This looking around has reignited curiosity about the larger context for art. What does art mean in terms of semiotics, feminism, culture/ Marxism, psychoanalysis, and the problematics of interpretation? These multifarious questions—ranging from the intrinsic or stylistic and semantic to the extrinsic or cultural—grow from seeds planted in the eighteenth century that continue to bear fruit at the end of the twentieth.

5

Winckelmann and Art History

Before following the more strictly philosophical strains of art theory as developed by the empiricists and German idealists, it is an opportune time to look at an eighteenth-century figure who wrote a book that combines, probably for the first time, the words "history" and "art." His name is Johann J. Winckelmann, and he is often credited with being the creator of both modern art history and scientific archeology. He was born in a small town in Prussia known as Stendal in 1719 and died violently at the hands of a thief at Trieste in 1768. He went to school in his hometown and later in Berlin and Halle. He studied theology, ancient literature, mathematics, and medicine. In the "classical" sense (a term that is apt for Winckelmann), he was a well-educated man whose skills, however, were eventually turned to matters in which he had little preparation. In his earlier years he spent his time in small towns, finally moving to a librarianship near Dresden. There he met a number of artists and had the experience of visiting the excellent museum in Dresden, which had good collections of Renaissance and baroque art, as well as examples of ancient art. His interest in the art of antiquity—which became a spiritual love—began in the 1750s, when he converted to Catholicism and, with a stipend from Augustus III of Saxony, moved to Rome to become librarian and surveyor of antiquities for the noted collector Cardinal Albani. By the mid-1760s he was appointed the Superintendent of Antiquities in Rome, an important position that allowed him to view many of the best examples of ancient art then known. He also was to supervise the excavations, which were just beginning, at Herculaneum and Pompeii. In 1764 he published the book that was to bring him art historical fame, *The History of Ancient Art*. He was responsible, in part, for Greek revivalism and neoclassicism, the key styles in Europe at the end of the eighteenth century, and, in some ways, he anticipated the rise of historicism in the nineteenth century, about which I'll have more to say subsequently in my discussion of Hegel.

In his *History of Ancient Art* Winckelmann finds the important, perhaps

even necessary, connection between culture and art. In this way he differs from both Vasari's list making and Vasari's interest in stages of artistic accomplishment. As Winckelmann formulates the historical process, the art of a culture will develop or change its style from generation to generation according to a characteristic pattern, one that fits that particular civilization. For him, the art of the Golden Age in Greece (encompassing approximately the fifth and fourth centuries B.C.) was the perfect embodiment of the Greek ethos or soul. Their climate, their geography, their society, their history—all led to an art that he characterized as *"edle Einfalt und stille Grosse"*: "noble simplicity and quiet grandeur." When John Keats nearly three-quarters of a century later looked at a Grecian urn, he saw something with a similarly evocative and elusive quality. The urn with its narrative scene was for Keats a "foster child of silence and slow time." The sense of tranquillity and removal from moments within which we must live constituted a particular kind of beauty, one divorced from traditional notions. Winckelmann believed that beauty is mysterious and subtle, indecipherable and unanalyzable. The classical definition of beauty and the one that Kant was shortly to formulate are based, as we have seen, on the idea of measurability and the conformity or proportionality of parts—in short, on harmony. Symmetry was for Winckelmann not in itself a sufficient quality. He believed that there has to be an unmeasurable resonance to the symmetry: a calmness, an equanimity, a self-possession. Beauty is "the loftiest mark and the central point of art"; proportion alone can't explain it. As he was not a philosopher, Winckelmann didn't feel the need to offer a systematic definition of his terms, but his intuitive and imaginative grasp of Greek art has had a powerful effect on subsequent generations of art historians.

There was something archetypal about Greek art for Winckelmann ("Good taste . . . had its beginning under a Greek sky"). It represented the finest examples of what art could be; in fact, in the argument between the twin poles of nature and culture, he sided with culture. But not just any culture, obviously. He accepted that the artist is a mimetic creature who copies visual experience, but he also believed that the truly great artist should use the best exemplars of art as his or her guide. Nature is too various, imperfect, and flawed; it doesn't contain within it the artistic principles discovered in antiquity. In antiquity—and particularly among the Greeks—the modern artist can find the best models or paradigms. Winckelmann was helping to establish the "canon" of great works, those examples of art that (we are supposed to agree) express or somehow embody the highest values of our culture, are most worthy of emulation, and which should be studied throughout history. In these works we should find what it is that makes us human. Winckelmann listed some canonical works, and indeed they still show up in the standard art history texts. His influence continues, although it is being challenged directly and indirectly by some of the more political forms of contemporary criticism.

Winckelmann's promotion of the "spirit of the Greeks" was unusual for his time. After all, he lived in Rome, which had been seen throughout the Latin Middle Ages and Renaissance as the source of European civilization. There the past survived, reminding visitors of ancient glory. Artists from throughout Europe continued to flock to Rome in the eighteenth century, not so much to learn the newest styles, but to drink of that beautiful and tranquil water so many associated with antiquity. It was both brave and audacious for Winckelmann to assert that Roman art was derivative, Greek art original. Yet, since then his assessment has generally been accepted by art historians and classicists. That he could have made this judgment without having visited Greece and Athens is remarkable. One must remember that it was difficult and dangerous to travel in Greece in the eighteenth century, and the rest of Europe was only then beginning to have some sense of what was there, especially with the publications of engravings, commencing in the 1760s, in Stuart and Revett's *Antiquities of Athens.*

Winckelmann was changing the notion of Renaissance, or rebirth: Now, it was believed, the "nascence" occurred in Greece rather than in Rome. It seems that there was a growing movement, beginning in the eighteenth century, against the Latin language and the weight of the Roman past. In their desire to find a uniquely Italian idiom, Italian poets, especially those associated with the Academy of the Arcadians, were especially hostile to Latin literature. And the German writer Lessing wrote somewhat later that "the monks let loose on us the barbarous deluge of Latin speculation. . . . Latin, being considered as an end in itself, is ruining our education."

Despite his imperfect knowledge of Greek art, Winckelmann was effectively shifting the focus of Western attention to a "new" old tradition. And he exhorted artists to follow the example of the Greeks, to abandon their contemporary and misguided practices. He wanted to save art. What Winckelmann objected to was the baroque tradition, then pretty well exhausted anyway and into its death throes as a style. He hoped to put it out of its misery. Here's what he wrote about young, modern artists (his sense of contemporary art is, as I said, out of date; he really seems to have in mind someone like Bernini): "Nothing earns their applause but exaggerated poses and actions, accompanied by an insolent 'dash' that they regard as spiritedness, or 'franchezza,' which to them is the essence of everything that makes for artistic perfection. They want their figures to have souls as eccentric as comets; to them every figure is an Ajax and Capaneus." Winckelmann obviously objected to the nonnormative, the eccentric and strange, the highly expressive and strained. He seems to be saying "take it easy." But it's more than that. The German philologist, archeologist, and now art historian saw something in Greek art that had not really been so carefully identified before, a principle of composition and expression, the essence of that noble simplicity and tranquil grandeur. He saw classicism.

Although Winckelmann didn't use the word "classic," in effect he de-

fined it. By discussing those exemplary elements of style that we associate with such artists from diverse periods as Poussin, Raphael, and Praxiteles, Winckelmann found a unifying element, the one we now call "classical." The term hardly was used before about 1800 (the British poet Alexander Pope seems to be the first to use it in English), but now is an art historical and literary commonplace. In ancient Rome it was a term used primarily to define a certain respectable social class, as distinct from the lowly proletarian. By identifying the quality of classicism, Winckelmann gave life to an artistic concept that could self-consciously express itself in the late eighteenth and early nineteenth centuries. Artists such as Jacques-Louis David and Antonio Canova were now aware not just of creating ideal art, but of making art that in some spiritual manner participates in the rudimentary, original practices of great art as discovered by the Greeks. This is historicist art, paintings and sculpture that intend to recapture a purity and nobleness of expression associated with an innocent and heroic past. There is a redemptive quality to Greek art: "the concepts of the wholeness, of the perfection in the nature of Antiquity will clarify and make more tangible the concepts of the division in our nature." We may live in a flawed, fractured present, but we can in an aesthetic and moral way save ourselves.

Winckelmann evokes more than once his notion of the simplicity and grandeur of the Greeks. At one point he wrote: "Finally, the most prominent general characteristic of the Greek masterpieces is a noble simplicity and silent greatness in pose as well as in expression." Italian *istoria* made explicit a need for gesture and expression in either a painting or statue so as to convey a narrative. But narration for Winckelmann is not one that requires bodily action—or at least it requires only a minimum of action. Perhaps he believed that *istoria* takes place somewhere else, in the ethereal regions of art and of the past. He preferred restraint to expression of the passions of the soul: "expression . . . changes the features of the face, and the posture, and consequently alters those forms which constitute beauty." The blank face is in fact better than one showing anguish. Although he admired the *Laocoön*, a famous Hellenistic statue, it wasn't for what we might see as its highly emotional, almost baroque quality, but rather for the reserve and control evident on the face of one who is about to be throttled by a huge serpent.

At about the same time that Winckelmann was taking a highly educated, historical view of art, wishing to place it within a complex cultural setting, others were taking a fresh look at the world of experience and its role in the understanding of art and nature. Whereas Winckelmann was prescriptive in his discussions of art, the empiricists were descriptive. Their interests dwelt more with one who directly perceives a work of art (as well as other phenomena) rather than with how one can place a painting into a historical context. We might say that their approach was more psychological than academic.

◆

Bibliography

CURTIUS, ERNST ROBERT, *European Literature and the Latin Middle Ages* (trans. Willard R. Trask), Bollingen Series XXXVI. New York: Pantheon Books, 1953.

LEPPMANN, WOLFGANG, *Winckelmann.* New York: Knopf, 1970.

WINCKELMANN, JOHANN JOACHIM, *The History of Ancient Art* (trans. G. Henry Lodge). Boston: J. R. Osgood, 1880.

WINCKELMANN, JOHANN JOACHIM, *Reflections on the Imitation of Greek Works in Painting and Sculpture* (trans. Elfriede Heyer and Roger C. Norton). La Salle, Ill.: Open Court, 1987.

6

Empiricism

The empiricists displaced meaning in art. They moved it from the art object to the process of experience. The belief that art is based upon an independent ideal gives way to the more psychological principle that art is a product of the human mind and emotions. The implications of this switch are enormous.

As most students recall, there is this famous question about reality: If a tree falls in a forest and no one's there to listen, did it make a sound? This is Bishop Berkeley's riddle, and it is typical of the eighteenth century. The good bishop asserted that "to be is to be perceived." So, do things happen unobserved? Well, anyone who has had to deal with a burst water pipe, no matter how hidden when it froze, would probably conclude that things do occur whether or not someone is watching and listening.

Just the same, the posing of the question is important because it calls attention to us as perceiving beings; it ignores or at least diminishes the importance of the independently existing object: the painting, statue, or building.

By suggesting that all that exists is sensory, David Hume revolutionized philosophy and, by extension, art theory. Hume was born in Edinburgh, Scotland, in 1711. Although encouraged to study the law, he followed his own inclinations and eventually published, anonymously, *A Treatise on Human Nature*, in 1739. Apparently he began work on his philosophical system before the age of twenty. No one paid much attention to his work, and some made fun of it, all of which, quite naturally, infuriated the Scottish writer. He rewrote, abstracted, amplified, edited, and recast his ideas on several occasions, but there were few who could really comprehend what he was trying to say. Although he achieved some fame in his own day as an intellectual celebrity and economist, it remained for other generations to follow up on Hume's ideas. Immanuel Kant said that his reading of Hume awoke him from his "dogmatic slumbers."

There isn't space here to write extensively about David Hume, but it is important to consider the substance of empiricism in general and its more

specific application to aesthetics. Empiricism, as I mentioned in passing when discussing Leonardo, is an approach based more upon observation than upon theory. The empiricists of the eighteenth century were directly antagonistic toward the rationalism of the seventeenth century, especially those theories of innate ideas put forth by Leibnitz and Descartes. Rather than saying "I think, therefore I am," the British empiricists would say that the human mind is a *tabula rasa*, a "blank tablet," waiting for experience to start writing on it. I am my experiences.

Beauty is not something internal or specific to an object. Hume said that "beauty is no quality in things themselves: it exists merely in the mind which contemplates them; and each mind perceives a different beauty." Here we have the origin of that troubling notion that beauty lies in the eye of the beholder. Inevitably, I find students have absorbed this lesson far too well. "Art is what I perceive it to be; your opinion might differ"; or "Art and beauty are relative, it's really subjective, no one can say for sure." And so on. For some reason, students wouldn't say this about history or physics, but our very culture has taught them, unconsciously it seems to me, that art is so personal and so obscure, there is no basis for judgment, no place for agreement.

The empiricists struggled with this problem as well. They realized that they were dealing with taste, and that taste is very personal, that it depends upon individuality and experience. But there are standards of taste; as Edmund Burke observed: "for if there were not some principles of judgment as well as of sentiment common to all mankind, no hold could possibly be taken either on their reason or their passions, sufficient to maintain the ordinary correspondence of life." In other words, there has to be some common principle. There just has to be.

The empiricists wrestled with the idea that experience is jumbled and confused, that our response to the world is arbitrary, unprincipled, individual. Hume didn't want to consider the objects of experience—which would have allowed him to make qualitative distinctions; instead he wanted to analyze experience itself—the shape of how we perceive. One approach that Hume suggested was that we look at objects without prejudice, that we be "objective." We need to divest ourselves of those things that might color our perception; we must discover some sort of natural taste. Walter Jackson Bate, the twentieth-century scholar of empiricism and taste, writes that we can make this discovery: "the delight in such manifestations of uniformity as proportion, order, and regularity—though this pleasure depends upon association—is inherent in all minds, in greater or less degree." Is it? And do we discover it by becoming disinterested, by transcending experience, by turning into free spirits who detach ourselves from all instrumental concerns and predispositions? If we open ourselves honestly, we will find, as Hume expressed it, that "upon the whole, necessity is something that exists in the mind, not in the objects." But this "necessity" sounds more like an article of faith than a scientifically proven entity.

Hume also suggests that there is the qualified or ideal observer, one who is well trained and suited for the job of critic. But we know how rarely critics are trusted. Or agree with one another. It's difficult to find an ideal observer, a critic whose taste everyone can accept. But we need one.

◆

Bibliography

AYER, A. J., *British Empirical Philosophers: Locke, Berkeley, Hume, Reid, and J. S. Mill* (eds. A. J. Ayer and Raymond Winch). London: Routledge and Paul, 1952.

BRICKE, JOHN, *Hume's Philosophy of Mind.* Princeton, N.J.: Princeton University Press, 1980.

LIVINGSTON, DONALD W., and JAMES T. KING, eds. *Hume: A Re-evaluation.* New York: Fordham University Press, 1975.

7

Immanuel Kant

Immanuel Kant (1724–1804) did not accept Hume's attempt to justify taste. He felt that we require a more comprehensive understanding of how to resolve the apparent contradiction between the uniformity and individuality of taste. And Kant was a comprehensive man.

Comprehensive and methodical. He was in his late fifties when he published the famous *Critique of Pure Reason,* nearing seventy when the *Critique of Practical Reason* and *The Critique of Judgment* appeared. Essentially Kant was trying to answer some of the questions raised by philosophers earlier in the eighteenth century, especially—as concerns us—the question of judgment and beauty. Kant is one of the first Western philosophers to consider aesthetics as central to his overall epistemological system.

The word "aesthetic" first appears in the eighteenth century, when it came to be used as a blanket term dealing with perception and beauty. If you think of "aesthetic" as the opposite of "anaesthetic," you'll understand why the empiricists needed such a term. It's based on feeling. There are times, such as at the dentist's, when you don't want to feel anything. But there are other circumstances, when pleasure rather than pain is in the offing, under which you want to experience aesthesia.

◆

Immanuel Kant was born and educated in Königsberg, then part of East Prussia. Upon receiving his master's degree, he became an instructor of mathematics, geography, and philosophy at the town's university. His earliest publications were mostly in the areas of natural science. His real interest in philosophy, his awakening from "dogmatism," as he termed it, began after 1760.

As Kant awoke and prepared his philosophical critiques, he realized that he was embarking on something new. He likened his method to the Copernican Revolution, comparable in its radical tranformation of philosophy to the change from a Ptolemaic conception of the universe to the Coper-

nican model. Kant saw a structure to experience based upon the projective human mind; he wasn't particularly interested in the real world. It is the mind that has order, it is the mind that casts pattern and system upon the universe. What Kant called the noumenal world—things in themselves—exists independent of the human mind and we really have no knowledge of it.

The third critique, his *Critique of Judgment*, appeared in 1790 as the capstone of his philosophy. Here he tried to come to terms with that slipperiest of categories—taste. Kant agrees that you cannot logically prove something is beautiful, because the logical faculty occupies and controls a part of the mind that does not, by itself, deal with beauty. Now Kant is not an anatomist nor a neural physiologist; he is not proposing a biological model of the brain in which certain lobes or areas deal with particular concepts. His approach is more metaphorical than that: He's dealing with the mind, not the physical brain.

His philosophical system is like a piece of architecture: Everything has a place, and relates precisely to every other element. For instance, there are three ways of thinking, feeling, and of being conscious; that is, of knowing, desiring, and being aware. These are set out in his three critiques on Pure Reason, Practical Reason, and Judgment. As you would imagine, it is in the judgment wing of his "building" (of his critiques) that beauty is to be known. He constructs an "analytic of the beautiful" as part of his commentary on judgment.

Kant's explanation of how we come to terms with the beautiful is not particularly complicated, although it is quite ingenious. Agree with Kant that we have several distinct—that is, separate—capacities in our minds: the cognitive, the ethical, and the judgmental. For the time being, set aside the ethical or moral. That leaves us with the ability to judge or be imaginative on the one hand, and the ability to be rational or cognitive on the other. In order to understand, we have to put these two capacities—the imaginative and the cognitive—in gear, make them work together. The imaginative mind allows us to perceive, to experience, to take in the world through our senses. The rational part of our mind gives us the ability to subject this "manifold" in perception (all the intake) to concepts. Every rational human has the ability to make sense of the world.

Now put yourself in a contemplative state; let the capacities for imagination (perception) and rationalization (concept formation) just hum along and freely associate. Don't be focused or overtly conscious. Look at the sunset, or a painting. If you just sit and muse without trying to be logical, and if you just let your mind play over things, a certain harmony or pleasure can result. That harmony is beauty, and we all share it. Kant wrote of "a feeling of the free play of the representative powers in a given representation with reference to a cognition in general." This harmony arises when an object we perceive causes "a more lively play of both mental powers." Remember, the beauty is not in the object, but is a product of this wonderful sense of har-

mony in our minds. But doesn't there have to be something in the object, something that plucks those strings of our mind so that we have a harmonic sensation? It's not quite so locatable as that. Beauty is neither in the object nor, finally, in the mind. It happens as a result of the interaction between the thing and the perceiving mind: between the object and the subject. Beauty is the product of a transaction. And it's related to the Platonic and Neoplatonic concept of measure and commensurability.

We perceive in an object an order that suggests purpose. Kant observed that "an object, or a state of mind, or even an action, is called purposive, although its possibility does not necessarily presuppose the representation of a purpose, merely because its possibility can be explained and conceived by us only so far as we assume for its ground a causality according to purposes, i.e., a will which would have so disposed it according to the representation of a certain rule." This sounds obscure and complicated, but what Kant is saying is fairly simple: In a beautiful object we sense a purpose (like in the colors of a still life, the arrangement of its forms), but really there is no purpose. An advertisement has a purpose: to sell something, to influence you. An object of beauty, for Kant, does not have any utilitarian motive. For instance, a tree has a particular form, but doesn't seem to have an end or purpose behind it. Did God make trees to give us shade? We can't know that. But if we do assume such a purpose, we've missed the tree's beauty. The real "purpose" is the form, which seems intelligent and harmonious, but is not trying to do anything to you, to get you to buy or do something. A botanist might look at a rose and find some goal or intention in its structure. If he or she did so, according to Kant, he or she wouldn't see the beauty. As Gertrude Stein wrote, a rose is a rose is a rose . . . we do not ask its meaning. Real beauty is disinterested.

Disinterestedness is important for Kant. It is not uninterestedness. That's different; it shows a complete lack of concern or a desire to avoid an experience. Disinterestedness is really impartiality. In order to experience beauty, we as perceiving beings must be disinterested. If a still life by Cézanne makes the viewer hungry for an apple, then he is not disinterested and is incapable of experiencing beauty.

Still, if we are appropriately disinterested and free in our contemplation of an object, will all agree that we share the experience of beauty? No. But we should. Although not everyone is capable of affirming what is beautiful, everyone ought to. There is a necessity which "claims that every one ought to give his approval of the object in question and also describe it as beautiful." Even if the encounter with beauty is adventitious, happenstance, we should agree on its beauty. In other words, meeting the beautiful can be an adventure, a kind of brute sensation, an unexpected event, like hiking in the mountains and coming upon a spectacular vista.

It may still seem that Kant is begging the question, being arbitrary: Beauty is necessary, therefore it exists. But people do mean something when

they talk of the beautiful; there is a common-sense belief in it. Whether one ultimately accepts Kant's philosophy depends in large part upon a thorough reading of all three critiques. There can be little question, however, about his importance to art theory and to art history. Kant establishes the aesthetic as a powerful category of human response, a potent capacity of the human mind. No longer is the appreciation of a natural phenomenon of beauty or a lovely painting some lesser cognitive response. Acknowledging beauty, for Kant, is not a low-grade use of the mind. The aesthetic response is a fundamental, human activity.

◆

Bibliography

BROAD, C. D., *Kant: An Introduction* (ed. C. Lewy). New York: Cambridge University Press, 1978.
STRAWSON, P. F., *The Bounds of Sense.* London: Methuen, 1966.

8

Georg Wilhelm Friedrich Hegel (1770–1831)

Another German philosopher of the late eighteenth and early nineteenth centuries, one who often frustrates students of philosophy, art history, and art theory by the obscurity of his language, is G. W. F. Hegel. As with Kant, his theory is important because he takes the aesthetic so seriously. Kant, as we saw, gave the aesthetic a special domain, distinct from normal experience. By dividing up the mind, he provided human consciousness with a new kind of freedom. Both in terms of philosophy and in terms of experience, aesthetics becomes marked off, and, by drawing those lines between different kinds of experience, Kant emancipates humankind, makes us free spirits. Hegel may be interested in spirits, but not free spirits or art in which there is free play of forces. In fact, unlike Kant, Hegel wants to restrict his aesthetics to art—forget about natural beauty. Benedetto Croce—an Italian Hegelian of the early twentieth century—wrote that next to art, nature is mute. Hegel would agree.

Hegel really did not believe in the aesthetic per se; he preferred the more accurate category of the philosophy of art. Kant's philosophy of beauty is based upon perception and feeling; Hegel's upon knowing and rational discernment. Art has truth, therefore it is a product of mind, because only mind is capable of truth.

◆

We should stop for a moment and consider Hegel's general scheme of things (to the extent that it's possible in such a short narration as this) and how he discusses his ideas on art. His *Philosophy of Fine Art* derives from lectures that Hegel delivered betweem 1820 and 1830 at the University of Berlin. The book, *Logic,* was compiled and published after his death. One of Hegel's students used the philosopher's lecture journals and notes made by students who had attended Hegel's courses to assemble the book. Therefore,

what results is a text not altogether in the author's words; it is, just the same, authoritative.

Hegel's philosophy depends upon an entity he calls *Geist*, which roughly translated means "spirit" or "mind," a kind of world spirit or essential idea. This spirit unfolds through time and reveals itself through art, religion, and philosophy. It is the essence of all that is, that exists. Spirit moves in its own special way. As Hegel explains it in his *Logic*, spirit first evolves through nature, which represents alienation, a state of being outside of things and estranged. In the system that Hegel considered as absolute idealism, the spirit, after an initial development outside of itself, returns to oneness and reconciliation, to self-awareness. It manifests itself in the individual (the subjective mind), then in the state (the objective mind), and finally in truth (absolute mind). Truth is the object or goal of philosophical thinking. Spirit moves through history with an almost providential intention and speed, so things turn out much the way they're supposed to, which in fact is the self-realization of spirit.

Having presented the abstract—and some might say fantastical—aspects of Hegel, let me try to assess in more concrete fashion what it was Hegel was saying, not just about art but also about the history of art. And again let me try to underline what makes him important to art history.

Hegel, like Plato and the Neoplatonists, was both a transcendentalist and a hierarchist. As a transcendendalist he believed in a higher reality—what he called the spirit—that can in fact be dealt with on this earth. For instance, he saw works of art as dealing with spirit in much the same way that religion does, but on a more sensuous basis. Artworks are "merely a shadow-world of shapes, tones, and imaged conceptions"; they "summon an echo and response in the human spirit evoked from all depths of its conscious life. In this way the sensuous is spiritualized in art, or in other words, the life of spirit comes to dwell in it under sensuous guise." As a hierarchist he believed that the spirit manifests itself better in different forms and that it is always evolving into higher states of self-realization. And, as we shall see, he ranks artistic media such as architecture, sculpture, painting, music, and poetry in an ascending order of spirituality.

The role of art is "to reveal truth under the mode of art's sensuous or material configuration." Beauty is the "sensory appearance [or manifestation] of the idea"—in the original, "*das sinnliche Sheinen der Idee.*" Plato didn't believe art had any capacity for revelation at all. Not until Plotinus and, subsequently, the other Neoplatonists did anyone believe art had this prowess. Hegel may use such Neoplatonic language as "shadow image"—the idea that art is highly imperfect in its revelation of the truth—but in fact he did see art as a potent if not perfect transmitter of spirit. In the work of art, the idea and the sensuous form intermingle: The better the intermingling the better the work of art. Excellence depends "upon the degree of intimacy and union with which idea and configuration appear together in elaborated

fusion.'' Interestingly enough, spirit is most accessible to us in art, even though art is less adequate than religion or philosophy in revealing it. This sounds a little like the earlier Christian beliefs that sacred truths can best be made available to the uneducated through imagery. Hegel uses the word ''immediacy'' when discussing the embodiment of spirit in art.

Art uses symbolism to capture the idea, to wring it from a transcendent realm and body it forth to human eyes. Hegel understands that there's a space between symbol—the image in art—and idea, and that there's always some tension in that distance. He writes that

> symbol is an external existent given or immediately present to contempla-
> tion, which yet is to be understood not simply as it confronts us immedi-
> ately on its own account, but in a wider and more universal sense. Thus at
> once there are two distinctions to make in the symbol: (i) the meaning, and
> (ii) the expression thereof. The first is an idea or topic, no matter what its
> content, the second is a sensuous existent or a picture of some kind or
> other.

His language might sound somewhat tendentious, but his message is clear. A symbol is not identical with the idea; if it were, then it wouldn't be a symbol, it would be that idea. An image of God is not God Himself.

Various art forms embody the symbol differently. Architecture is a highly physical, structural symbol. Sculpture is more abstract, less brute in its weight and scale, and represents the perfect example of the Greek ideal of representing the human figure in a rational manner. Paintings are more abstract, less physical than architecture and sculpture. They come closer to pure representation of the spirit, especially because of what they can do with light, an immaterial phenomenon. Better yet is music, which has practically no physical form. As the spirit evolves—like a carpet unrolling and revealing its pattern—it finds an even more appropriate home in poetry, which is nearly pure meaning. The closest we can come on earth to the spirit is through philosophy. As you can see, art has a built-in obsolescence. At some point in history (perhaps we've already passed it and don't know?), art will no longer be necessary because the spirit will have moved on.

Hegel was an art historian—if not an especially well informed one— who saw certain stages in the development of world art. In his totalizing view, there are three phases in the history of art. The first he calls the Symbolic, which corresponds roughly to what art historians have traditionally termed ''pre-classical,'' ''primitive'' (a pejorative term), or ''orientalizing'' art. He believes ancient Egyptian art best exemplifies this early span in the maturing of spirit. Egypt, he wrote, ''is the land of the symbol and sets itself the spiri-tual task of self-deciphering the spirit, without really attaining its end. The problems remain unsolved and the solution which we are able to provide consists therefore merely of interpreting the riddles of Egyptian art and its symbolic works as a problem that the Egyptians themselves left undeci-

phered." We might think of the Great Pyramids at Ghiza, which in the Western imagination have come to suggest eternity, power, and perhaps the sublime. But, you see, the deciphering, as Hegel calls it, isn't complete, it remains undeveloped, inexplicit. Also, the Great Sphinx at Ghiza, because it is so good at riddles, captured Hegel's imagination. "As a symbol for this proper meaning of the Egyptian spirit, we may mention the Sphinx. It is, as it were, the symbol of the symbolic itself . . . recumbent animal bodies out of which the human body is struggling. . . . The human spirit is trying to force its way forward out of the dumb strength and power of the animal, without coming to a perfect portrayal of its own freedom and animated shape." So the spirit at that time was still primitive; if no longer mineral or vegetable, it was yet animal with only some sense of the human attempting to emerge. He didn't believe the Egyptians themselves were altogether self-aware and capable of articulating who and what they were as a nation.

He then goes on to write about the classical phase, which he—like us—associates with the Golden Age of Greek art, especially the sculpture produced in the second half of the fourth century B.C. Classical art is more rational and uses the human body to reveal spirit. The sculptors of this period discovered a perfect balance between nature and spirit, according to Hegel.

The third and inevitable phase in the necessary evolution of art is the Romantic, which Hegel believes represents all post-classical—that is, Christian—art. And its quintessential expression comes in painting, which is not very physical. That balance achieved by the Greeks is lost, and art tries now to do what is not entirely possible: become spiritualized. There are basically three ways to know spirit for Hegel: art, religion, and philosophy. Although spirit is most immediate and accessible in art, art is not the best lens for us to use in order to view spirit. Religion is better; philosophy is best of all.

For Hegel, art came into existence so that humans could know something about themselves and about ultimate reality. Art is a tool, and when we as a people have become most acutely conscious, we no longer will have use of this tool. It's interesting that Kant simply accepted art as a human faculty, something that in fact makes us human. Discovering beauty liberates us from a more limited existence. But Hegel always has that ultimate goal in mind, the goal of knowing truth.

As any historian of philosophy will point out, there is a great danger in summarizing Hegel. His system is complex, large, and dense. Just his discussion of the Symbolic, Classical, and Romantic stages of art takes up a great deal of space. My summary must finally be judged inadequate. However, I believe having at least a general idea of Hegel's scheme allows us to see him within the context of a history of art theory and as someone who has had indirectly a profound effect on modern art history; he has, in fact, been called the "Father" of art history by Sir Ernst Gombrich.

The reason that G. W. F. Hegel is still taken so seriously is that he con-

tributed certain things to art historiography. Although he was not the first to do this, he conceded—or we might more properly say discovered—a dignity in art, a virtue: It can transcribe or bear meaning. So art is potent. And it is also a historical document: It has no choice but to reveal its culture and its people. He wrote that the spirit drives history and that every aspect of a culture reflects that culture or people: ". . . the work of art can only be an expression of the Divinity if . . . it takes and extracts . . . without adulteration . . . the indwelling spirit of the nation." This is historical determinism of a very insistent kind. And it is very similar to what the art historian Erwin Panofsky was to identify more than a hundred years after Hegel's death as the "intrinsic meaning or content" of a work of art. Panofsky said that the iconological or instrinsic meaning "is apprehended by ascertaining those underlying principles which reveal the basic attitude of a nation, a period, a class, a religious or philosophical persuasion—qualified by one personality and condensed into one work." Like finding the world in a grain of sand, the acute art historian can find an essential part of a historical period in a single work of art.

The third thing that Hegel introduced and which has become a very common method of art historical inquiry is the notion of evolution. Style, in Hegel's view, changes in a certain, predetermined pattern. We can, with our retrospective view, comprehend this pattern and perceive its internal logic. The change from the linear to the painterly in Heinrich Wölfflin's art history falls right in with Hegel's notion of historical development.

◆

Bibliography

HEGEL, GEORG WILHELM FRIEDRICH, *The Philosophy of Fine Art* (trans. with notes by F. P. B. Osmaston), 4 vols. New York: Hacker Art Books, 1975.

KAUFMANN, WALTER, *Hegel: Reinterpretation, Texts, and Commentary.* Garden City, N.Y.: Doubleday, 1965 (reprinted 1988).

9

Alois Riegl (1858–1905)

Another nineteenth-century art historian, whose name and work are not well known outside German-speaking countries, is Alois Riegl. Riegl wrote intricate studies on a variety of artistic subjects, and always managed to come up with interpretations and points of view that flew in the face of much accepted wisdom and opinion. And he did this by following both Hegel's and Kant's conceptions of history and art. He came to art, as many writers and theoreticians do, from other studies. He began in philosophy and law, but switched to art and then graduated from the Austrian Institute of Historical Research in Vienna. His first job was in a museum of decorative art, where he was in charge of and wrote about rugs and textiles. It was this early experience with the so-called minor arts that inspired his interest in the function and life of forms and motifs. He wanted to understand how certain decorative patterns come into art, acquire a particular appearance, and then change. Riegl, like Hegel before him, believed that some creative and driving principle—but not the conscious intention of the artist—is involved in the production of art. Once again, that mysterious but persistent World Spirit—*Weltgeist*—moves through history and gives rise to many phenomena, art among them (Riegl, however, used a different term—*Kunstwollen*). But Riegl is not a warmed-over Hegelian, spouting some mystical view of history. He in fact made many fundamental contributions to art history, ones that have validity today. It was probably his ability to challenge the commonly held presumptions and suppositions about art and its history that made him important and make him relevant to the study of contemporary art history.

At least to a degree, Riegl certified the Kantian notion that the production of art is a uniquely human activity, one that is not necessarily tied to our moral or rational powers. Making or studying art calls upon an individual human sensibility—it's like nothing else we do. But that doesn't mean that art objects are autonomous human products, unmoored in history, unrelated to other human activities, floating around in a pond of free expression. He wrote that

if we take into consideration not only the arts, but any of the other large do-
mains of human civilization—state, religion, science—we shall come to the
conclusion that, in this domain as well, we are dealing with a relation be-
tween individual unity and collective unity. Should we, however, follow the
direction of the Will [*Wollen*] that a particular people at a given time has
followed in these various domains of civilization, it will necessarily turn out
that this tendency is, in the last analysis, completely identical to that of the
Kunstwollen in the same people at the same time.

What Riegl says here is that the Will to create art (which goes beyond the Will
of a single artist) is part of a larger Will that moves throughout a culture. A
statue is as much a phenomenon or expression of a people as a statute. It is of
course this "Will" or "*Wollen*" that requires some consideration.

In his first and perhaps easiest work to understand, *Stilfragen* (questions
or problems of style), Riegl addresses the elusive concept of style and what it
has to do with common and repeated images. Riegl believes that such things
as plant motifs, acanthus decoration on the capital of a column, and decora-
tive devices in general are products of our innate desire for pattern and sym-
metry. Although these plantlike forms derive from nature, they are not
simply examples of the human capacity for copying or imitation. At some
point, artists begin with the emulation of nature—Riegl doesn't speculate
why—but as certain kinds of images become standard (like the acanthus
leaves in the capital of a column), their relation to nature is distant. And,
when styles of ornament change, it is not as a result of artists going back to
nature and looking once again at plants. Rather change comes about because
of a necessary inward development in art. Here is where Riegl, like other Ger-
man art historians of the late nineteenth and early twentieth centuries, cre-
ates problems for modern students. The concept that over time a style must
develop in a certain direction according to a particular logic (think of the
evolution of the structure of the medieval cathedral or the development
from Greek Archaic to Greek Hellenistic sculpture) is very difficult to ex-
plain. Is it that art of the sixth century B.C. must look the way it does? The
artists had no other choices? And then are later styles of Greek sculpture in-
evitably going to look the way they do? This sounds almost like a conspiracy
theory of art: that some committee of artists got together and decreed that
over a certain period of time, painting, sculpture, and architecture had to
change according to certain preordained rules. There is more than a sugges-
tion here that something or someone controls the history of art. Which
brings us back to the existence of geist or spirit, the informing or vitalizing
principle in individual works of art and in sequences or developmental pat-
terns of art. Riegl called this principle *Kunstwollen*. For Riegl, every work of
art is a link in a developmental chain, and every work of art contains within it
the seeds of change: This inner necessity—the need to move from "tactile"
to "optical" qualities for instance—generates transition and movement.

Riegl believes that there is a necessary development to art and that this

suprapersonal will to create art (*Kunstwollen*) is closely tied to the system of change and development. However, the development does not follow some model of the imperfect to the perfect, from the unfulfilled to the fulfilled. Every work of art is a step along the way and is in fact completely self-realized. A late Roman relief such as the Arch of Constantine (fig. 15) is neither a success nor a failure as a work of art, but is merely an expression and instance of a point in an artistic continuum. This is an argument Riegl made in his *Late Roman Art Industry*. As he wrote of late antique art (of which our illustration is an example), it is "in all its essential features . . . the necessary product of the preceding development. . . ." So therefore to speak of late antique art as an art in decline is nonsense; art progresses: "Thus I was impelled by necessity not to envision late antiquity from the point of view of modern subjective taste as an art of decline, but rather, from the standpoint of the universal evolution, as a progressive art, progressive indeed in the most eminent sense of the word."

Riegl assumes that patterns of development—progress as he chooses to characterize it—exist. To understand progress, one has to look closely at each work of art that forms a link in the chain of progression. Riegl believes

Figure 15. Relief, Arch of Constantine, early 4th century. Photo: Alinari, Florence.

that one natural sequence is, as I mentioned previously, the change from the tactile to the optic. However abstract and artificial this may sound, it remains an interesting and useful kind of model to examine. Riegl says that the Egyptian relief (fig. 16) is invariably haptic or tactile, and is best seen from what Riegl calls a near-sighted view. In the Portrait of Hesy-Ra from Saqqara one finds those characteristics that Riegl associates with the earliest artistic traditions. The figure of Hesy-Ra is isolated from any context or setting; it appears clearly and independently. The tactile or haptic qualities have to do with the unknown carver's emphasis upon outline and the suppression of three-dimensional space. Because artists wished to avoid any optical device (such as overlapping or foreshortening), the body appears as if flat and schematic, reduced to characteristic views: The face is in strict profile (although the eye seems to stare out at us from the side of the head), the chest is seen from the front, the hips and legs from the side. Although the artist strives for unity, he does not create full anatomical coherence. The human body cannot, in reality, assume this position. However, working in two dimensions, the artist achieves a maximum of clarity and a presentation of characteristic views of the human figure. As Riegl writes, even though no one ever saw such a person in this projection, "yet it was the most objective one, for it showed as much as possible and did so with the least possible foreshortening." And we can see in all their precision the contours and outlines of the figure, those elements that appeal to our sense of touch. Even though modern museum practice forbids it, Riegl suggests we touch these reliefs so as to feel the edges and ridges of the form. This then is the "objective" experience. But why did artists create such forms? Riegl has no answer: "As for what determines the aesthetic urge to see natural objects represented in works of art by stressing or repressing the features that isolate them or conversely unify them, one can only indulge in metaphysical conjectures that an art historian must absolutely refuse to make."

To move to the other extreme in vision, we can choose a "subjective" Renaissance relief by Donatello, one of the masters of optical experience. Although Riegl uses late Roman reliefs (such as that in fig. 15) to demonstrate his principle of the optical, Donatello provides a more sophisticated example. His St. George and the Dragon (fig. 17), which is a relief below the statue of St. George, now in the Museo Nazionale del Bargello, Florence, has many characteristics of illusion, depth, foreshortening, and shadowing that one does not find in the Egyptian relief (fig. 16). First of all, Donatello provides a distant view past some columns and into a tree-filled and atmospheric landscape. He introduces a dimension beyond the surface, a third or spatial dimension, which is purely illusion. The fluttering drapery patterns of the maiden, whom St. George is saving by his timely killing of the dragon, have numerous and fluctuating patterns of light and shadow so abundant and voluminous that one's sense of touch would be inadequate to identify them all. The optical in Riegl's formulation depends upon the relation of light to

Tactile

Figure 16. Portrait Panel of Hesy-Ra, from Saqqara, c. 2660 B.C.; wood, height 45". Egyptian Museum Cairo. Photo: Hirmer Fotoarchiv, Munich.

Optic

Figure 17.　Donatello, Relief of St. George and the Dragon. Bargello, Florence. Photo: Alinari, Florence.

shade—something intangible—rather than upon solid, self-contained forms with a simple shape and definite limits. The optical reads well from a distance because forms can merge with one another and the pictorial effect of depth can be achieved. The scene is conceived in terms of *valeurs*, that is, values of light and shade. This is all optical, impressionistic, and subjective.

Essential points in Riegl's argument are the necessity of the haptic preceding the optic and the inevitability of change always moving in a predetermined direction. He is not interested in nor does he accept the validity of historical chance or the whim of a particular artist affecting style. Style unfolds continuously, and it rarely responds to historical catastrophe. Riegl doesn't endorse the once popular notion that art evolves from a primitive to a sophisticated, to a decadent style, and then dies, usually because of the collapse of a particular culture, only to be reborn again in another era.

However, we should be careful in our assessment of Riegl's determinism. He apparently doesn't see all of art as fated, as something that had to turn out as it did and that exists today because of the way it began. To a certain extent, Riegl's *Kunstwollen* allows for the conscious intervention of a culture or society. Late Roman art results from a cultural will. And there is the possibility that the artist can make choices, although it must be admitted that Riegl has little sympathy for the autonomy of the artist. At a certain point in the development of art, there can be more than one path to follow, more than one problem to solve, more than one direction that art can take. But whichever path is taken or problem solved, there is nonetheless an inevitable logic in the directionality and the solution.

So we return again to the problem of change. Riegl explains the necessity of change by referring to the principle of *Kunstwollen* and to the idea that a certain aspect of art history is sealed off from its environment and operates according to its own internal demands and structural concerns. The inner

and hidden history of art dictates developmental patterns. Although an artist's identity, creativity, power, and free will have always been given great importance in a romantic reading of history—and in movies, plays, and novels—they form virtually no part of Riegl's scheme. The debate over free will and determinism goes on. Certainly many of us believe that we can make our own choices, whether in a social or artistic context, and yet we cannot avoid the fact that we are to some degree products of our culture. *Kunstwollen* may be, as some critics have pointed out, a prescientific, anthropomorphizing metaphor that belongs more to the world of the Brothers Grimm than it does to modern historical discourse, but at least it is a term that tries to identify an elusive historical process.

Perhaps Riegl's most enduring contribution to art history is not his insistence upon progress and evolution in art, but the way he looked closely at works of art. Whether he is writing about a Dutch group portrait, an early decorative element in Islamic art, an Egyptian relief, or the absence of a cast shadow in late Roman art, Riegl looks closely and carefully, sometimes seeing things that others haven't paid any attention to, and he translates his observations into precise language. He sees that works of art conform to standards and conventions, that they reflect their times in some way (whether or not we accept *Kunstwollen*), that changes within artistic traditions have a logic one can discover, not impose. He is an empiricist, one who observes first and judges after.

◆

Bibliography

OLIN, MARGARET ROSE, *Forms of Representation in Alois Riegl's Theory of Art.* University Park, Pa.: Pennsylvania State University Press, 1992.

PACHT, OTTO, "Art Historians and Art Critics, VI: Alois Riegl," *Burlington Magazine* (May 1963), pp. 188–193.

RIEGL, ALOIS, *Late Roman Art Industry.* (trans., with notes, Rold Winkes). Rome: G. Bretschneider, 1985.

RIEGL, ALOIS, "Late Roman or Oriental," *German Essays on Art History* (ed. Gert Schiff). New York: Continuum, 1988, pp. 173–190.

ZERNER, HENRI, "Alois Riegl: Art, Value, and Historicism," *Daedalus* (Winter 1976), pp. 177–188.

10

Heinrich Wölfflin (1864–1945)

It's curious that one of the most cogent and effective art historians at the turning of the twentieth century was a man who never quite settled on what his theoretical grounding was. And yet what he writes, lucidly based upon direct observation of paintings, sculpture, and architecture, suggests the existence of some principle or law in the history of art. It's just never clear where the principles come from or how they operate. His best-known book, *The Principles of Art History*, has taught generations of art history students a way to look at Renaissance and baroque art in terms of the linear and the painterly. He demonstrates the categories brilliantly, but never really accounts for them. Because Wölfflin's approach appears to be based upon empirical investigation, it has appealed to the nonphilosophical and nonsociological inclination of American academics.

Heinrich Wölfflin, born in Switzerland, came from an academic family (his father was a professor of philology at the University of Munich), and he studied history, literature, philosophy, and art. He wrote his dissertation on the psychology of architecture and received his doctorate from the University of Basel at the age of twenty-four. One of the most telling influences on Wölfflin at Basel was his studies under Jakob Burckhardt, a famous cultural historian who studied the Renaissance. Wölfflin wrote to his parents about his teacher: "What wealth of thought! What a philosophy, based on the experiences of a long life! It is wonderful!" After his doctorate, Wölfflin pursued another degree by writing his first important book, *Renaissance and Baroque*, which was his *Habilitationschrift* (a thesis that qualified a student to pursue an academic career).

He became a famous teacher at Basel, Berlin, Munich, and Zurich, and upon his retirement was heaped with awards. His style of lecturing was legendary and almost measureless in its impact on the teaching of art history throughout the Western world. He saw that the rapid growth in photography allowed many to view works of art in reproduction. Now it was possible to teach about the history of art in strongly visual terms because the professor

had examples in photographs to show the students. Not only could students get an idea of what famous paintings, statues, and buildings look like, they could put works of art side by side and compare them. Wölfflin used the "magic lantern" (an early slide projector), which used large glass plates (approximately four inches square) to project images in a darkened room. What Wölfflin now found himself able to do with art was to use the comparative method, already employed by philologists to analyze texts, to demonstrate hitherto unnoticed or unexamined similarities and differences between works of art. It may be a method he learned from his father. The point of comparing images—something that still goes on in classrooms throughout the world—is to discover patterns, similarities, and differences between works. From these characteristics one can generalize about individual artists, national styles, and period styles.

Alfred Werner, in a brief intellectual biography of Wölfflin, quotes from one of the Swiss professor's students, Wolfgang Born, on his lecture style. For Wölfflin, Born recalled,

> the task of interpreting to his students was a challenge to ever more concise formulations. It was the most exciting intellectual spectacle I have ever experienced. In the darkened room, the tall figure of the professor appeared as a black silhouette. He stood next to the slide machine in the back of his auditorium, very calm, his unforgettable head—the child of one of his friends called it a lion's head—slightly raised. Haltingly and tersely the words came from his mouth, stimulated by the picture which appeared on the screen and elucidating its significance with an uncanny accuracy. How splendidly selected were his examples! Most of them contrasting types. The way in which he compared them was a revelation to all of us. Each lecture was a new adventure in "seeing."

Wölfflin hoped that seeing could be done methodically, even scientifically. A passive experiencing of art was not enough for him; history as a dull recording of facts brought no satisfaction. Wölfflin wrote to his parents, "Can history, which was until now only an experientia, be raised to a science in which, following the model of the natural sciences, one extracts from the profusion of facts the great laws of spiritual development in the human race?" Like other nineteenth-century German humanists, Wölfflin hoped to discover principles upon which cultural sciences—Geisteswissenschaften— could be founded.

One of the great teachers of cultural history in the nineteenth century was Wilhelm Dilthey, who summarized the need for a scientific method in the humanities as follows: "The task of our generation is clearly before us: following Kant's critical path, but in cooperation with researchers in other areas, we must found an empirical science of the human mind. It is necessary to know the laws which rule social, intellectual, and moral phenomena. This knowledge of laws is the source of all the power of man, even where mental

phenomena are concerned." Interest in the human mind and in mental phenomena is psychology; and both Dilthey and Wölfflin sought an understanding of human consciousness in some form or another.

Of the several books written by Wölfflin, the most significant for students of art history is the *Principles of Art History: The Problem of the Development of Style in Later Art.* The book first appeared in German as *Kunstgeschichtliche Grundbegriffe* in 1915, went through a number of German editions, and came out in English in 1932. It still is in print. One writer on the theory of art history commented that "Wölfflin's influence has been so great as to be incalculable. . . ."

It is here that Wölfflin presents a scheme for understanding, on the comparative basis of course, the art of the High Renaissance and baroque periods in Europe (the sixteenth and seventeenth centuries). Before inquiring into the fascinating and problematical implications of his "theory," we need first to review Wölfflin's categories of apprehension.

Wölfflin suggests that there are two basic ways of seeing things or of presenting things seen: They are the linear and the painterly ("painterly" is a somewhat awkward word that was made up to translate the German *malerisch*; "picturesque" has also been used). These two categories are related to Riegl's notion of the optic and haptic. But more of that later. As well as defining the entire system, linear and painterly are also the terms Wölfflin uses to define the first set of his oppositional principles. So, we have these opposites: 1. linear versus painterly; 2. plane versus recession; 3. closed versus open form; 4. multiplicity versus unity; 5. absolute versus relative clarity. Questions and consequences of the psychology of perception seem to drive Wölfflin's writing overall, and these paired concepts in particular interest him. Yet he's never very articulate about where these modes of perception/presentation come from, how they are central to an understanding of High Renaissance and baroque art, nor whether or not they are complete and sufficient as a system. But first let's look at his scheme and how it's supposed to work, before turning to theoretical consequences.

Linear versus Painterly

The linear refers to the elements of line, design, or outline within a work of art. Are the edges, contours, or limits of the figures clear, unbroken, sharp? Line itself can be an important trail for the eye to follow through the thicket of a composition. If edges blur, forms merge, color areas overlap and interpenetrate; if the eye's path is not distinct, clearly indicated, then a work of art will be called painterly or impressionistic. In the painterly mode brushwork is emphasized. The linear has to do with limits and solidity. As Riegl said of ancient reliefs, figures sharply distinguish themselves from their backgrounds, their self-contained and dense qualities make them separate from a sur-

rounding environment. In painterly art, volumes tend to be part of the over-
all composition and merge with the general tonality or atmosphere. Figures
coalesce with one another and are part of a continuous whole; it is difficult to
isolate individual elements and make sense of them. Whereas the linear is sta-
ble, the painterly is not: It suggests the moving, incomplete, and sometimes
indeterminate.

Raphael's *Galatea* (fig. 18) of 1513 is, by and large, a linear painting,
whereas Rembrandt's *Prodigal Son* (fig. 19) falls into the painterly category.
The sharpness and clarity of detail in Raphael's fresco demonstrates Wölff-
lin's idea of linearity: Your eye can follow the border of Galatea's red cloak
more or less without interruption. And the patterns of the cupids' bows lie
crisply against the background sky. Figures of neriads and tritons are com-
pact and tangible and have solid, sometimes swelling muscles and anatomical
forms. But in Rembrandt's more haunting image of redemption and love,
figures emerge from and sink back into a mysterious, obscure background.
The boundaries to the forms, those things that could detach figures from
their context, are not clear and sharp edged; as a result, the figures are im-
mersed in a pool of shadow. The quality of the paint itself and the movement
of the brush over the surface seem so pronounced that one has a difficult
time finding anything that could rightly be called a line. Whereas the linear

Figure 18. Raphael, *Galatea*, 1513;
fresco. Villa Farnesina, Rome.
Photo: Alinari, Florence.

spirited

Figure 19. Rembrandt, *The Return of the Prodigal Son*, c. 1665. Hermitage Museum, St. Petersburg. Photo: The Hermitage, St. Petersburg.

Raphael gives us a scene, however unlikely, that exists in and of itself, the more plausible but nonetheless painterly Rembrandt suggests a highly impressionistic and apparitional scene, one whose existence seems more imagined than real.

Plane versus Recession

Wölfflin's second paired concept deals with the illusion (or in the case of architecture, the reality) of space in a work of art. It's not a matter of how many dimensions we're perceiving—two or three—but how the third dimension is constructed and projected. In the art of the High Renaissance, space appears to be arranged in planes, as if things were painted on glass plates arranged parallel to one another and parallel to the surface of the work itself. In the baroque, depth is created along diagonal lines so that recession is continuous. As Wölfflin explains it, line tends to adhere to planes, to show itself most explicitly when extending left or right, up or down. Contours, surfaces, edges, ridges, sharp demarcations lose some of their character when projected obliquely away from the viewer into depths. Because the baroque artist doesn't normally conceive images in terms of line, he or she fears no loss of concision (which is not to say that the baroque artist is sloppy, it's just that relative rather than absolute clarity is preferred).

Meindert Hobbema in *A View on a High Road* (fig. 20) leads the viewer's eye backward into the illusionary third dimension with a curving road. What could be more continuous? And to frame the movement, Hobbema masses darkened trees to the left and right, both groups bending toward the rutted avenue. Even the clouds gather and direct our eye toward the vanishing point on the horizon. There's no sense of a stepped or sequential movement.

In Veronese's *The Annunciation* (fig. 21), on the other hand, depth appears in registers rather than as a continuous, open recession. Mary at her *prie dieu* and the Archangel Gabriel are lined up in the same plane. Parallel to them in the next register are the balustrade and column of a porch. The trees in Mary's garden also adjust themselves so as to observe, whether "consciously" or not, the basically planimetric arrangement. The clouds flatten out into wisps that are more planar than recessional.

Open versus Closed

Wölfflin's third pair of visual concepts applies to closure. Depending upon the framing devices used, a sculpture, a building, a painting can be essentially open or closed. A relatively "closed" building, for instance, would be Giu-

Figure 20. Meindert Hobbema, *A View on a High Road*, 1665. Andrew W. Mellon Collection, National Gallery of Art, Washington, D.C. Photo: © 1993 National Gallery of Art, Washington, D.C.

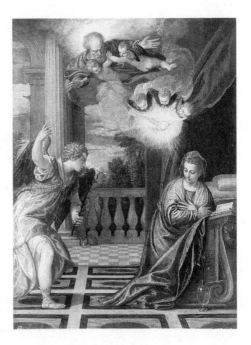

Figure 21. Paolo Veronese, (Paolo Caliari), *The Annunciation*, c. 1580. National Gallery of Art, Washington, D.C., Samuel H. Kress Collection. Photo: © 1993 National Gallery of Art, Washington, D.C.

liano da Sangallo's S. Maria delle Carceri (fig. 22). The walls are flat and the openings in them are relatively few and small. The overall effect is boxlike, with sharp corners, unbroken edges, and simple pediments. Pietro da Cortona's church of Santa Maria della Pace (fig. 23) creates a markedly different effect with its projecting porch, receding wings, and unusually shaped pediment. There are, as well, fairly large passages on either side of the portico, niches, and windows. The portico itself seems open because of the cavernous area of shadow. In an "open" building, architectural elements do not follow the two-dimensional "tectonics" associated with flat architecture; rather, the protruding columns and sunken niches create an almost sculptural effect as if the building were interacting with space, much like a statue does, rather than simply displacing it.

Multiplicity versus Unity
(Or Multiple Unity versus Unified Unity)

This category focuses upon details within a work and the degree of independence each part has. Every ripple of flesh in Michelangelo's *David* (fig. 24), as an example, has a life of its own. Although the details contribute to the structure of the entire figure, they haven't really been subordinated to some dramatic movement or immediate visual impact. Each knobby protrusion, whether it be a knee, muscle, elbow, or cheekbone, has an independent, well-

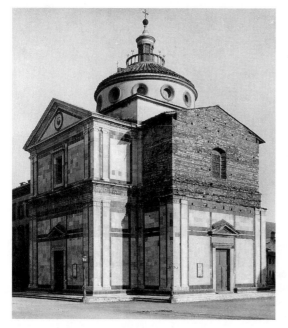

Figure 22. Giuliano de Sangallo, S. Maria delle Carceri, Prato, Italy, 1485–1492. Photo: Alinari, Florence.

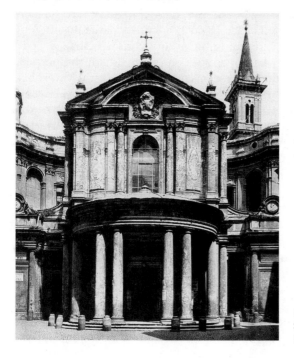

Figure 23. Pietro da Cortona, Santa Maria della Pace, 1656–1657, Rome. Photo: Alinari, Florence.

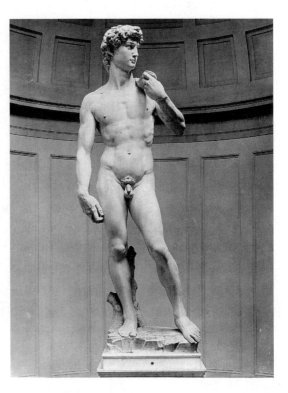

Figure 24. Michelangelo, *David*, 1501–1504. Academy, Florence. Photo: Alinari, Florence.

defined quality. With Bernini's *Cathedra Petra* (fig. 9), admittedly a much larger and more complex work, we nonetheless can see that the individual detail doesn't have the same importance as the larger spectacle. In the baroque—the period of unity—particulars become absorbed by the whole.

Opposing multiple unity to unified unity implies different kinds of focal points. There is the distinction between a painting that has multiple points of interest as opposed to one that has a higher degree of unity, a figure for instance whose gesture joins all the actions in the work. This is a subtle distinction. Wölfflin mentions both Rembrandt's *Syndics of the Clothmakers' Guild* (fig. 25) and Leonardo's *Last Supper* (fig. 26) as group compositions that demonstrate different kinds of unity.

In Leonardo's *Last Supper* the figure of Jesus opens His arms outward, announcing that one of the twelve will betray him. As a result of his gesture, the disciples react individually, each in accordance with his character—at least as best as Leonardo could divine each personality from his reading of the Bible. Although the disciples react to a single event, they behave individually or in groups (there are four groups of three figures each). In Rembrandt's painting, the figures are not so isolated nor so contrived in their assembly. This gathering of the syndics is, apparently, for routine business. The third man from the left, who has been identified as Volckert Jansz,

Figure 25. Rembrandt van Rijn, *Syndics of the Clothmakers' Guild*, 1661–1662. Rijksmuseum, Amsterdam. Photo: Rijksmuseum, Amsterdam.

Figure 26. Leonardo da Vinci, *Last Supper*, 1495–1497(98?). Refectory, Sta. Maria delle Grazie, Milan. Photo: Alinari, Florence.

speaks and the others are drawn not only to the gesturing of his hand in explanation, but to something outside the work itself. We are to imagine that someone attending the meeting, but in the audience (that is, in our position as viewer) rather than on the stage, has risen to speak. This individual draws the syndics' attention. This casual, spontaneous event creates a sense of unity: One event pulls the entire composition together. There are simultaneously two points of view: ours and theirs. And they both follow the same axis. This is the kind of unity that the Renaissance, apparently, couldn't manage.

Absolute versus Relative Clarity

Wölfflin himself recognized how close this category is to the linear versus painterly category. The matter of clarity pertains to the kind of vision expected from High Renaissance and baroque art; the fact that the two periods differ comes from "a different attitude to the world." An instance of absolute clarity is Agnolo Bronzino's *Eleonora of Toledo and Her Son Giovanni de' Medici* (fig. 27). Of course, the one absolute thing here is Eleonora's dress. The remarkable patterning would have far less of an effect in the "obscure" style of the baroque. But absolute clarity concerns more than the two-dimensional patterning of the dress, for it refers to the plastic handling of forms. "Plastic" as understood by the art historian applies to the apparent roundness of a fig-

Figure 27. Agnolo Bronzino, *Eleonora of Toledo and Her Son Giovanni de' Medici*, 1550. Uffizi, Florence. Photo: Alinari, Florence.

ure, its capacity for being modeled. Eleonora's left sleeve, with the bunching of material near her shoulder, demonstrates Bronzino's interest in solid form. In a similarly three-dimensional manner, Eleonora's and Giovanni's heads project convincingly forward and appear stereometric.

But Rembrandt's *Self-Portrait* (fig. 28) lacks that absolute and precise quality. The artist does not emphasize precise textures (except of the paint itself) nor the sense of solidity that comes from Eleonora's compact body. As Wölfflin writes, "explicitness of the subject is no longer the sole purpose of the presentment." We might say that Rembrandt's presence here is more a matter of optical conjecture than visual fact. Yes, his image is observable, but it does not seem to have the solidity and density of Bronzino's *Eleonora*. This relative clarity of the baroque creates an effect of the incomplete and elusive. Perhaps Rembrandt found it difficult if not altogether desirable to "capture" himself on canvas.

Having had this brief overview of Wölfflin's scheme, let's turn to his theory. It seems to me that several kinds of questions come up: Is Wölfflin right? Must works produced in the sixteenth century adhere to the linear qualities? Are all seventeenth-century works painterly? If there are exceptions (and certainly there are), how would he explain them? Has he truly gone to the paintings, sculptures, and buildings and found things that are indeed there? And if the linear-versus-painterly principles exist, how significant are they? Have

Figure 28. Rembrandt, *Self-Portrait*, 1667. National Gallery, London. Photo: National Gallery, London.

they any relation to thematic material, that is, subject matter? Are there other stylistic principles equally or more important, more central in explaining the art of two differing ages? How do you account for these differences? Do these explanations leave any room for cultural and social commentary, or would trying to understand the art of these ages in terms other than the strictly stylistic be superfluous? And have we been misled by Wölfflin into thinking that the sixteenth and seventeenth centuries in Europe were so fundamentally different from one another that we should see them as opposing periods? Or are we simply expecting too much from Wölfflin? All he did, after all, was describe stylistic features of two periods in European art. Must he also explain the essential significance of these differences?

First of all, it's important to remember that Wölfflin was trying to make of art history something more profound than the rhapsodizing of connoisseurs and the fact-finding of biographers. He believed that art could have a firmer foundation than it seemed to claim in the nineteenth century; he wanted, in short, to make art history scientific, although in a somewhat different sense than physics and biology are sciences. By introducing method into art history, Wölfflin hoped to make it a discipline that comprises more than appreciation of beauty and sensitivity to style. For that, it seems to me, we can thank him, or at least acknowledge his contribution. He has had a lot to do with keeping art history in the university curriculum.

Most scholars agree that Wölfflin's critical stance changed with each book that he wrote and that philosophical consistency was not one of his virtues. Depending upon whom you read, the primary influences on Wölfflin were Hegel, Kant, positivist theorists such as Comte, the historian Burckhardt, or the cultural historian and theorist Dilthey. And of course the list can be extended. Whichever of these nineteenth-century German scholars, theorists, aestheticians, or metaphysicians affected, motivated, or persuaded Wölfflin—and he was bright enough to absorb much from many sources— his main basis for explaining things was a form of psychology popular in the late nineteenth century. When he wrote that "our physical organization is the form by which we comprehend everything corporeal," he was invoking Kant's ideas from the *Critique of Pure Reason,* or at least his reading of Kant. And he was taking a position held by other nineteenth-century psychologists. As evidenced by his assertion that buildings in a sense are human or that we respond to them as if they were, Wölfflin entertained an anthropocentric view of architecture in his earlier writings. Your individual psychology affects how you respond to a building: For instance, a slender person prefers slender buildings. And looked at from another angle, a structure can reflect the collective psychology of a people. Not just a building can do this, however, but every product of that society, whether it be something functional like a pair of shoes or a work of art. All things reflect the will to create a form or the particular feeling for forms (*Formgefühl*) of a culture. He uses the phrase "a national psychology of form."

In his *Principles of Art History*, Wölfflin utilizes a kind of psychological explanation for how things, works of art specifically, end up looking the way they do. Wölfflin claims that there are various factors contributing to style, so that one can distinguish a personal style, the style of a school (generally speaking a group of artists working with more or less the same aims), the country, the "race" (Italian, German, English, etc.), and period (Gothic, Renaissance, baroque, etc.). He does use the term *zeitgeist* as that elusive spirit of an age. In fact, it seems that his epistemology falls more under the rubric "relative clarity" than "absolute clarity."

Wölfflin looks for the "central ideas" to a period or style, and by these ideas he seems to have some notion of the consciousness or the awareness of an age. For instance, he writes that seventeenth-century art differs from sixteenth-century art in Europe because "it is obviously a new ideal of life which speaks to us from Italian baroque. . . ." And further on he writes, "the relationship of the individual to the world has changed, a new domain of feeling has opened, the soul aspires to dissolution in the sublimity of the huge, the infinite." Because the awareness of each age differs from preceding and succeeding ages, artists are beholden to their periods and cannot freely choose how to paint: "Every artist finds certain visual possibilities before him, to which he is bound. Not everything is possible at all times. Vision itself has its history, and the revelation of these visual strata must be regarded as the primary task of art history."

Wölfflin's assertions are based upon faith. Something done in a particular period looks the way it does because the mind of the age wills it to be so. How do we know that a period has a mind or temperament? It's something we just accept. And Wölfflin is circular. A baroque painting looks the way it does because it is baroque, because the baroque has its own sensibility. Presumably a shirt button produced in the seventeenth century shares, in some small way, the overall *zeitgeist*. It has to because all objects produced then reveal the same spirit.

Although Wölfflin concedes that an individual artist does in fact produce a work of art, he cares relatively little for his personality, genius, or character. In the first German edition of the *Principles of Art History*, Wölfflin made reference to the idea of an art history "without names." Forget the names and identities of particular artists; they tell us nothing. Of course such an assertion flies in the face of all romantic notions of the suffering artistic talent laboring to find his or her particular vision that will then transform the world. Wölfflin decided to remove that reference to an anonymous art history from the introduction of subsequent editions.

Wölfflin believes that the development in art from the High Renaissance, which is an architectonic or linear style, to the baroque, which is loose and painterly, was a necessary one. It's not just that outward circumstances changed in Europe between the sixteenth and seventeenth centuries—although that is certainly part of the explanation—but that the change wasn't

random, was in fact inevitable. "The concepts have, in themselves," Wölfflin writes, "in their changing, an inner necessity. They represent a rational psychological process. The progress from the tactile, plastic interpretation to a purely optical-painterly one has a natural logic and could not be reversed." You may well wonder why the change in artistic style must follow the pattern Wölfflin sets out. Interestingly enough, he believes it's a matter of common sense: "It is perfectly comprehensible that the notion of clarity had first to be developed before an interest could be found in a partially troubled clarity. . . . The development from the linear to the painterly, comprehending all the rest, means the progress from a tactile apprehension of things in space to a type of contemplation which has learned to surrender itself to the mere visual impression, in other words, the relinquishment of the physically tangible for the sake of the mere visual appearance." You as the reader will have to decide if the development is as common-sensical as he says it is.

And what of those categories of beholding that Wölfflin articulates? Are they central to how we should see the art of the sixteenth and seventeenth centuries? Has he really spotted significant trends? He acknowledges that we only see what we are looking for (which suggests a bias in our searches), but then responds that "we only look for what we can see." In this rather neat and self-evident statement, Wölfflin is referring to how artists (like those of the sixteenth and seventeenth centuries) can be limited in what they see, but it can apply to Wölfflin as well: How he sees art and its changes from the Renaissance to the baroque is confined by what he, whose thinking is the fruit and harvest of nineteenth-century German thought, can see. Wölfflin himself—if we are to accept his "theory"—had a vision that was controlled by the psychology, mind, or consciousness of his age. So his view of past art was as determined as the artistic vision of those earlier artists. "It is true, we only see what we look for, but we only look for what we can see." This is a tricky statement. Does that mean that we of another age will see a different Renaissance and baroque than Wölfflin saw? Most likely. In point of fact, critical thinking today is quite different from what it was in Wölfflin's day, although we continue to be interested in his writings.

Which brings us back to the wide acceptance of Wölfflin, especially in American universities. Since the Swiss art historian kept in the background and to a minimum his speculations on the reasons for certain cyclical patterns in art history, he appears more objective and, in a sense, scientific than Riegl or Hegel. He begins with what can be seen, and then allows the visible, objective, empirically verifiable data to create a system (e.g., linear versus painterly). None of what Wölfflin writes is necessarily based upon the talents and experiences of a privileged, wealthy collector of art (we all can go to museums or sit through slide lectures), nor do we have to understand the complicated idealist philosophies of Kant, Hegel, or the other German aestheticians of the nineteenth century. There's something democratic about Wölfflin: Anyone with the interest and time should be able to look at art and

see what he saw (in order to accept this, however, we'd have to concede that our cultural context is quite similar to Wölfflin's or that cultural context, *zeitgeist*, and historical consciousness has nothing to do with how we see). At any rate, Wölfflin offers us the dream of a value-free, culturally unbiased, objective, more-or-less scientific, apolitical access to works of art. And, through Wölfflin's method of structured looking, we can find a basis for a discipline of art history.

◆

Bibliography

HART, JOAN, "Reinterpreting Wölfflin: Neo-Kantianism and Hermeneutics," *Art Journal* (Winter 1982), pp. 292–300.

WERNER, ALFRED, "New Perspectives on the Old Masters," *Arts Yearbook 1: The Turn of the Century*. New York: Art Digest, 1957.

WÖLFFLIN, HEINRICH, *Principles of Art History* (trans. M. D. Hottinger). New York: Henry Holt N.Y., 1932.

11

Visual Supremacy: Connoisseurship, Style, Formalism

What does it mean to have a good eye? It's not a matter of one of them working while the other doesn't, or that one eye is more virtuous, more moral than the other. It has to do with looking at art in an intelligent way. In critical methods that bear upon the visual properties of art, style becomes the primary datum, and analyzing that style requires developing an educated eye. Connoisseurship and formalism demand an ability to come to terms with style, that elusive and subtle concept. Because style is such a central notion in the theory of art history, it is a good idea to go over some of the things that have been said about it.

Again, to ask a question: In what way is there such a thing as style? We could say that style is in the work of art, the fruit of form, line, space, and color, and is simply waiting to be discovered by the sensitive critic. Or—and this is the position I find more helpful—we can say that style in a sense is invented by art historians. We invent the language of style and determine its patterns. Heinrich Wölfflin, for instance, formulated the opposing stylistic categories of the linear and the painterly. They have proved to be quite useful and for nearly a century have dominated discussions of the art of the Renaissance and the baroque in Europe. That these terms (and their subgroupings, such as relative versus absolute clarity, plane versus recession, etc.) were not articulated in the same way before Wölfflin's time suggests that he didn't so much discover them as develop them as visual concepts.

In its most general sense, style refers to the distinctive patterns or characteristics of some one thing—or of a series of objects: the 1950s style in cars (tail fins, for instance), popular music (rock-and-roll, rhythm and blues,

jazz), clothing, cooking, literature, personal adornment. Anthropologists, archeologists, social and cultural historians, and art historians use style to place objects, behaviors, and events in a scheme or context. If we recognize and can articulate the style of a pot or a painting, we often can speculate in an informed manner on the identity of the artist, the date and place of production. Style in this sense is an important tool for allowing the present historian to order past events.

Because style seems so reflective of an individual and a culture, we feel we can trust it for making identifications. An individual's style is related like a signature to his or her distinctiveness: Banks accept a signed check, for instance. The gestures and brushwork of van Gogh and Rembrandt are like handwriting and are telling aspects of their personal styles.

But style, as it is normally understood and used by art historians, is also suprapersonal. As much as it stands for the artist, it also discloses something about the culture. What it communicates about a social and intellectual circumstance is problematical—and this is both the crux and the rub of art history. What does a 1959 Cadillac tell us about Ike's America? The films of David Lynch: Are they representative of the United States or a particular segment of its culture and society in the waning years of the twentieth century? Do the paintings executed under the influence of the Works Progress Administration provide insight into the "mind" of America during the Great Depression? How does the style of Jean Antoine Watteau's *Pilgrimage to Cythera* uncover certain realities of the lives of the men and women of leisure in early eighteenth-century France? As you will read in the section on Marxism and social history, there are various ways in which art historians make the connections between art and culture.

This brings up another distinction, the one between form and content. Although in practice we often discuss the style of an artist as being separate from his or her subject matter, disconnecting the two results in problems. Does realistic art have no style? And conversely, does abstract art have no content? Art historians nowadays tend to believe that form and content are indissolubly linked. Subject matter only makes sense in terms of how it is conveyed to us; that is, the artist's manner mediates the subject matter and creates significance. This mediation is style. How would you understand Raphael's *School of Athens* without acknowledging the appropriateness of his strategies of composition and his rendering of individual figures with regard to the themes of philosophy personified by Plato and Aristotle? Discussing Polykleitos' style separate from the meaning of the ideal nude in Greek art wouldn't result in a very useful analysis either. This is not to say, however, that style and subject matter or narrative are identical; they are recognizably different concepts, and can be discussed separately. But as devices for analysis, they seem to work best as a team.

As I mentioned previously, somehow a period or culture can show itself in a style. Historians and philosophers traditionally have sought out evidence

of a *zeitgeist*, a spirit of an age. Although terribly intangible and vague, this idea of a *zeitgeist* persists in critical thought. Historians and art historians will write about the Greek or Roman "mind," the "spirit" of the Renaissance, the "character" of the rococo, or the "mood" of modernism. And we expect to find it in style. It's a working hypothesis that *zeitgeist* (or the equally vague "cultural values") is encoded into style, a hypothesis that has never been turned into an accepted law, but one which hasn't been completely rejected either. Erwin Panofsky proposed a system of interpretation that seeks to disclose the essence of a work of art, its "intrinsic meaning or content." This, he wrote (as I quote him in my discussion of Hegel), "is apprehended by ascertaining those underlying principles which reveal the basic attitude of a nation, a period, a class, a religious or philosophical persuasion—qualified by one personality and condensed into one work." The art object is symptomatic of the culture. The task of the art historian is like that of any diagnostician: to decode the meaning, to uncover the principles lying behind the mute face of a work of art. Instead of pathology, however, the process is called by Panofsky "iconology."

Especially for American art historians, there are troubling implications to the concept of a *Zeitgeist*. Does history necessarily imprint itself on every human production? If you were to find a button or a nail from a lost civilization, could you—with the appropriate intuition and skills—reconstruct the values and institutions of that society? Does either a button or nail even have much of a style? What possibility is there for randomness and the free will of the artist?

Heinrich Wölfflin, in the introduction to the first edition of the *Principles of Art History*, suggests that we could have an art history without names. In other words, the identity of individual artists is of such minimal importance when compared with the psychology of the age and the inner necessities of styles and stylistic changes that we could effectively eliminate the artist as a significant agent in the production of style. As this suggestion of an "art history without names" did not appear in subsequent editions of the *Principles*, Wölfflin seems to have backed off from his earlier position. The importance of individual genius and creativity is dearly held by the public; one dismisses it at considerable risk, as Wölfflin probably learned.

Understanding the dynamics, structure, and nature of style requires an examination of how it changes as well. Since the beginning of modern art history with Giorgio Vasari, there have been some basic theories of stylistic change. Vasari's model is based upon a biological metaphor: Styles develop as a human being develops, from infancy through adolescence, into adulthood, and finally into old age and death. Therefore there was the childlike art of Giotto and Cimabue, which was followed by the maturing art of Masaccio. The art of greatest maturity, then, results from the style of Michelangelo, Leonardo, and Raphael. Although Vasari makes no point about the idea of an old age style (called "*spätstil*," from the German for "late style"), other

art historians have observed it in individual artists (such as Michelangelo, Titian, Bernini, Monet) and in historical sequences, such as Hellenistic art or baroque art. The problem with this view is that one might judge certain kinds of art, such as Minoan, African tribal, or Native American as childish, primitive, and not fully realized. The same could be said of Giotto's paintings. Further, we are likely to disapprove of this sort of art because of its apparent immaturity.

Related theories of change have to do with evolution, which borrows ideas from Charles Darwin, and necessary binary oppositions, such as those between the haptic and the optic or the linear and the painterly (see the previous discussion of Riegl and Wölfflin). The evolutionary explanation for change seems dated, and the one based on opposed styles finds less support than it once did because of its mechanical and deterministic character.

The American art historian James Ackerman has proposed a more common-sense approach to the problem of change in artistic styles. He was motivated toward this explanation because he felt uncomfortable with the concept of a *zeitgeist*, which seems mystical to the practical American imagination. He writes: "My primary aim is to explain change in style as the manifestation rather of the imagination of individual artists than of historical forces that guide the actions of men and nations." He believes that there are two tendencies in any culture, one for stability, the other for movement. The stable or conservative patterns have to do with conventions and accepted subject matter and procedure. The need for change springs from normal human restlessness and boredom, and the need to find new challenges. Artists invariably face certain technical and expressive problems. How each generation of artists solves artistic problems will affect the next generation in somewhat predictable or at least logical ways. The notion of "problem solving" is, of course, part of the American character. Ackerman observes that "a style, then, may be thought of as a class of related solutions to a problem—or responses to a challenge—that may be said to begin whenever artists begin to pursue a problem or react to a challenge which differs significantly from those posed by the prevailing style or styles." Whether what Ackerman proposes is a theory is not clear. His desire to find an alternative to the ambiguities of German historicism with its world spirits and obscure destinies is understandable, especially within the American context or worldview that often looks for practical explanations for cultural phenomena. Ackerman concludes that "I have tried to define principles based as far as possible on the examination of the creative process, so that the individual work of art, and not the force of some vague destiny, might be seen as the prime mover of the historical process revealed by style."

Style is a visual pattern within a work of art that has served as an instrument used by art historians to create certain groupings (Gothic, Renaissance, baroque, impressionism) and to explain change. Focusing on historical styles has allowed art historians to create a kind of order in their view of the past, so

that all those artistic events that occurred long ago can be seen as forming a coherent pattern rather than as something chaotic and scattered.

Art historians, especially those writing a survey text for introductory courses, use style in this organizing way. The authors of Gardner's *Art Through the Ages,* eighth edition (New York: Harcourt Brace Jovanovich, 1987) use style as well as historical considerations in their determinations of art historical periods. They write, for example, that "we shall designate as baroque those traits that the styles of the seventeenth and earlier eighteenth centuries seem to have in common" (in the process, they derive some of their language from Wölfflin). And for the early eighteenth century, they note a "softer style we call rococo." And it goes on like this. Although no theory of style has been developed or generally accepted since Ackerman's (soon after mid-twentieth century), art historians continue to use style as a central idea in the telling of art's history.

◆

More than a century ago, having a good eye might qualify you as a connoisseur—one who knows, especially about matters of taste or art. Connoisseurs remain important today, but more commonly in the art market and in museums, where knowing the approximate date, period, and authenticity of a painting is crucial to doing business. By having a wide-ranging knowledge of individual and period styles, the connoisseur is able to date and attribute prints, paintings, statues, and occasionally buildings. A connoisseur's skills are difficult to teach or to theorize about. An expert may be asked "How do you know that's a painting by Giovanni Paolo Panini?" He or she may respond, "Because I've lived in Rome for twenty-five years." Intuition, experience, interest, sensitivity, the ability to muse and contemplate in silence—all of these and more can be the not very scientific talents of a connoisseur. What distinguishes the connoisseur is his or her direct knowledge of the work of art. There can be no reproductions; one can't really encounter a work of art through photographs. Eugene Kleinbauer characterizes the technique and method of a connoisseur when studying the real thing: "Apprehending the shape of a work of art requires close and repeated observation of its physical and formal qualities. Not only the size, condition, medium, technique, and quality, but also the formal traits of a work are the pieces of evidence that guide the connoisseur in pronouncing judgment on authenticity and authorship" (*Modern Perspectives in Western Art History.* New York: Holt, Rinehart & Winston, 1971, p. 43).

So much writing about art and art history in the nineteenth century was hot air: emotional effusions, romantic expostulations. The German Friedrich von Rumohr (*Italienische Forschungen*), the English diplomat and writer Sir Joseph Archer Crowe with his Italian coauthor Giovanni Cavalcaselle (extensive writing, mostly on Italian art), and the Italian publisher and art historian Adolfo Venturi (more than 1,300 articles, dozens of books, including the

twenty-five–volume *Storia dell'Arte Italiana*) all sought, as a way of rising above the hated dilettantes, a firm grounding for the study of art history. Connoisseurship provided just such a method for studying the art of a period, a culture, or a particular artist.

These authors, and others like them, wanted art history to be taken seriously, and they believed that the best way to accomplish that was to use a method based on fact. The connoisseur will generally focus on a single problem: the art of a single period or nation, or, more characteristically, the production of one artist over his or her lifetime. This latter form of art historical writing is called the "monograph," a definitive study of the *oeuvre* or total production of that artist.

In constructing the monograph, a connoisseur utilizes evidences of style and documentation. The resulting book generally consists of several sections: the critical study of the artist, including a biography, a *catalogue raisonné*, extensive bibliographic references, and a publication of original documentation. All of this is arranged to make a case for the artist's position in history; in fact, the author of a monograph becomes, in addition to the traditional historian, something of a combined detective and lawyer. The detective searches for evidence, the lawyer presents it to the publisher and, eventually, art historical public. The biographical and critical section of a monograph sets out, first of all, the facts known about the artist's life: birth and death dates and places, habitations, training, and influences. Traditionally, it has been the task of the connoisseur to identify those characteristics of style that are peculiar to the artist, then to show how they reflect the direct influences of his or her training and the more general impression made upon the artist's art by the stylistic milieu and the "age." Using the old biological model of stylistic change, the author traces the artist's stylistic maturation. The early style (or juvenilia) is contrasted with middle and late styles. A logical pattern of development will often emerge. Judgments regarding the artist's position within his or her age must also be made, and this can be difficult. Was the artist a "leading" figure or more of a follower? Was he or she a good artist? Making assertions about artistic value challenges the connoisseur to be fair, balanced, and to try to rise above the tenets of his or her own age. And it is quite natural for an author to hail the accomplishments of an artist he or she has been studying or writing about for years: One's own academic star is sometimes fastened to the reputation of a long-dead artist. And further, because of egalitarian interests in our culture and the suspicion of "high" art, the whole issue of quality is fraught with difficulties and subject to accusations of elitism. Adherents of multiculturalism often attack the very notion of "great art" as exclusionary, prejudiciary, and as a more-or-less sinister way of maintaining "Eurocentrism."

The connoisseur must in good conscience make an effort to see every work of art he or she lists in the catalogue. This again is like good detective work, especially for paintings or sculptures that have moved from their origi-

nal location and now are in private collections or distant places. Receiving permission to visit and study a work that is normally not available to the public requires patience, tenacity, and not inconsiderable diplomatic skills. Making photographs will often require lengthy negotiations and guarantees of privacy. I have spent long hours either sitting in offices in the Vatican awaiting the right official to give me permission to photograph and publish a work of art, or making contacts with people who know other people who might be able to provide me with an introduction to a collector. I've traveled to stately homes in England, museum storage areas in the United States and Europe, and obscure churches throughout Italy to see works of art. Often buildings are closed, and the caretaker is not easy to find. Once a pharmacist had to close his drugstore to accompany me to a nearby church where I wished to look at some sculpture that hadn't seen much light in many generations. How he came to be the custodian I never discovered.

In addition to listing an art object's location and the history of its travels, a catalogue entry for a work of art consists of all relevant published information, especially references made to the object near the time of its execution. Documents of payment preserved in church or public archives are difficult to find but extremely valuable in explaining the circumstances of commissioning and execution. I once heard an Italian art historian who was searching, endlessly it must have seemed, through the Vatican's Secret Archives shout out *"Finalmente!"*—"finally!" He had found the note he needed, some crumbling bit of paper with all the dates, facts, and names that solved whatever puzzle he was working on. Archivists tend to frown at such outbursts, but the emotion experienced when a document reveals new (or I should say rediscovered) information can be powerful. The evidence of the eye is persuasive, but a document (if you know it to be reliable) can clinch an attribution or dating of a work of art.

A connoisseur's work, therefore, is interesting and varied, ranging from the investigations of a gumshoe to that of the expert with a knowing eye who can spot the genuine article from across the room. And what this leads to is not a theory or a new interpretation, but a case study of one artist working within a limited time span and in a particular tradition. A successful monograph, however conservative in its critical approach, produces solid, dependable results that will be useful decades, perhaps even a century after publication.

The skills of the connoisseur who writes a monograph or a more extensive study of an artistic tradition (these larger studies generally do not have catalogues) are readily transferable to the tasks of the art dealer or museum curator. Being able to identify and authenticate works certainly assists in making a sale or establishing a museum collection that is representative of a period or a school of art. More than in the university, it is in the art world of exhibitions and sales, where the presence of the actual art object is essential, that connoisseurship continues not only to be prized but deemed necessary.

Giovanni Morelli

A fascinating connoisseur, one who has been compared with Sherlock
Holmes and who inspired Sigmund Freud, was a nineteenth-century Italian
critic masquerading as a Russian physician, Giovanni Morelli (1816–1891).
While a great deal has been written about Morelli—it would be interesting to
inquire into the reasons for his popularity—I'll only mention some of the
more unusual and telling aspects of his method.

Born in Bergamo, Morelli was educated first in Switzerland and later as
a physician and anatomist in Berlin. He returned to Italy, took part in the
Italian *risorgimento,* and served as a senator. It was only in his later years that
he published his studies on art, first in the book *Italian Masters in the Borghese
and Doria-Pamfili Galleries in Rome,* which has a preface entitled "Principles
and Method." Morelli uses the old Platonic method of a dialogue, between a
young Russian tourist and an older, wiser Italian amateur, to demonstrate his
approach to art. Like some before him and many since, Morelli belittles and
laments the fact that so-called experts don't really look closely at works of art.
When authenticating a painting or statue, they are more likely to respond to
the general impression rather than to the particular details. Art historians, as
opposed to connoisseurs (in Morelli's book), spend most of their time read-
ing and repeating empty banalities about art; they eschew direct experience,
preferring instead the comfort of firmly held beliefs that may or may not con-
form to reality and experience.

Although his hostile and somewhat subversive attitudes hold a fascina-
tion, it is the particulars of his method that have certified Morelli's approach.
He was a shrewd man. He noted that an artist's style will reflect the conven-
tions and expectations of his school or age in the more obvious and central
aspects of a work. If we are looking at a portrait, for instance, the overall com-
position and coloring will in some degree reflect the prevailing style and will
therefore be impersonal. The physiognomy of the sitter is, also to a certain
extent, his own. But smaller, less obvious, marginal details, like the end of a
finger or the lobe of an ear, will betray the artist's manner. Here, Morelli be-
lieves, an artist no longer will suppress his personal style. An ear is altogether
too insignificant or perhaps private, so the theory goes, to command a period
style or depict the sitter's identity. It is a feature the painter must render, but
with minimal consciousness to the official or formal style. It becomes routine
and automatic—like one's handwriting. These small details give us the artist:
Here we have an insight directly into his or her unself-conscious manner, and
we can know the artist. For Morelli, knowing the artist directly through the
work of art grounds the study of art history.

These are the kinds of clues that would fascinate a famous detective
such as Sherlock Holmes (Sir Arthur Conan Doyle, Holmes's creator, read
Morelli) and, similarly, intrigue a psychoanalyst, like Sigmund Freud, who is
always alert to the smallest things that betray an individual's inner being or

unconscious mind. Freud writes of Morelli that "his method of inquiry is closely related to the technique of psychoanalysis. It, too, is accustomed to divine secret and concealed things from despised or unnoticed features, from the rubbish-heap, as it were, of our observations" (Sigmund Freud, "The Moses of Michelangelo," *Collected Papers*, Vol. IV. London: Hogarth Press 1948–56, pp. 257–287). It is worth pointing out, as Richard Wollheim does, that these details that attracted Morelli's attention were not (in his mind at least) despised or just so much flotsam. A fingernail or nostril or hands can intensify an artist's concentration, because he finds them expressive and interesting forms in themselves. By his investment of attention, therefore, he also reveals himself.

Although Morelli did not believe that we can know an artist solely through his or her rendering of hands and ears, he felt that the connoisseur ignored these significant details at the risk of misidentifying the artist. Morelli did not suggest that through details the whole can be utterly known, yet the details of hands and ears and drapery are crucial to our understanding, in fact are so vital that Morelli the anatomist provides drawings of distinctive hands and ears characteristic of particular artists. Because his approach provides clues to the operation of artistic form in its general as well as in its specific applications and gives suggestions as to how the identity of a maker can insinuate itself into the object that he or she has produced, there seem to be profound implications for Morelli's methods. And, as Edgar Wind has observed, that fascination with the fragment or morsel came to be a thematic concern in modern art, which often deals with parts of things rather than wholes. Cubism, for instance, shatters space and figures. What does that tell us about modernism? There are, perhaps, more questions than answers with Morelli. It is this problematical situation that moved Wollheim to write that the value of Morelli's method lies "not so much in what it achieved, but in the significance of what it left undone."

The Vision of Roger Fry

The essays of Roger Fry (1866–1934) remain an articulate voice for the aestheticist position in art history and criticism, one which relies heavily on an understanding of style. Baldly stated, he sees little evidence for any intimate connection between art and life; like Kant, Fry believes that art has a special domain, cut off from normal experience. What he means by "life" is, loosely speaking, what those who write about material culture and the social history of art mean: the social and economic structures, the mainstream thoughts and feelings of a period. There are historical eras, such as the Renaissance, when art and life seem to meet and illuminate one another. But much more often, as Fry sees history (and it is Western history of which he writes, not that of the Eskimo or Navajo), the connection is minimal and relatively insignifi-

cant. He claims that the revolution in modern art (beginning with cubism) finds no direct parallel in the more general changes of thought and social activity. For Fry, art has its own history which, while not absolutely isolated from other human concerns, nonetheless is independent and must be understood on its own terms.

With the beginning of impressionism, the interests of art shifted from imitation of the real world to the stylistic concerns of art objects independent of common-sense, everyday, or ideal experience. Art is now more about art than about the world. It is self-contained, and "we find the rhythmic sequences of change determined much more by its own internal forces . . . than by external forces." Fry can discern no comparable shift in other aspects of life. He writes that "the usual assumption of a direct and decisive connection between life and art is by no means correct." One would have to aver, I believe, that those who write about the social history of art do not usually say that the joining of art and life is simple; rather, they readily admit that the interaction is indirect and complex. Fry would probably argue, in turn, that even an oblique and tangled association between culture and art is hard to sustain and demonstrate.

In Fry's well-known and often reproduced "An Essay in Aesthetics," he writes about the difference between an artistic experience and one in real life. Seeing an accident in a film is not the same as coming upon the actual event; despite the differences in emotional reaction (knowing the filmed accident to be fictional), we actually will see more and perhaps understand different things by witnessing an artistic expression of something familiar. Art allows us detachment. We live our actual life one way—morally and with responsibility; our imaginative one another—freely. Because it has no practical consequence or reverberation, as far as Fry can tell, the imaginative life of art need have no association with the moral or the ethical. Further, the imaginative life concerns the desirable, not just the pleasant, and this is something that is important to us, even if we do not always understand what it is that we desire.

Art conveys the imaginative life to us: ". . . it is by art that [the imaginative life] is stimulated and controlled within us, and, as we have seen, the imaginative life is distinguished by the greater clearness of its perception, and the greater purity and freedom of its emotion." In this imaginative life we really see, see as the artist sees, free of prejudice and preconception: "It is only when an object exists in our lives for no other purpose than to be seen that we really look at it. . . ."

Because our reactions to actual stimuli and events proceed from the need to act, to do something about a situation, they are different from an aesthetic experience. In reality, we do not have the necessary distance to see a real-life event or a scene for what it is; we are too close, too interested in immediate needs, and we are ruled by what Fry calls "responsive action." Can one really detach oneself from a landscape and view it aesthetically? We may be on our way somewhere, have blistered feet, be too hot, too cold, wind-

blown, preoccupied with other things like money, time, duties to view a landscape with detachment. Of course, seeing a landscape painting in a museum doesn't guarantee that we'll be free of preoccupying emotions either. Still, Fry's point, in the abstract at least, is well taken. A disinterested contemplation of an event, scene, or object is aesthetically more vital than one that requires a particular response. (Indeed, without a certain detachment, one might wind up calling an ambulance after viewing a painting of a saint being tortured.)

Fry would find plenty of agreement among artists, critics, and art historians that art and life do indeed differ along the lines that he suggests. He would also find agreement from such philosophers as Aristotle and Kant.

Having established the particular province of art—at least as it is separate from the workaday world—Fry goes on to discuss what makes up a work of art (what he calls "graphic art"): "If, then, an object of any kind is created by man not for use, for its fitness to actual life, but as an object of art, an object subserving the imaginative life, what will its qualities be?" He answers his own question in several stages. First of all, the viewer should perceive in the work an "intention," by which Fry means evidence that the artist is in fact trying to convey an emotion, a sensibility that we can share with him or her. This might be so deep within us that we haven't even been aware of its existence until the artist reveals it. But once we see it, we recognize its basic humanness. So there is a communication between artist and spectator.

Fry enumerates the design elements that elicit from us primary human feelings. Because we'd be upset by its absence from a work of art, there must be order; because we'd be bored without it, there must be variety. In addition, we look for the rhythm of line, mass, a ground plane, space, light, shade, and color. Fry believes that all of these elements appeal to us because they're so essential to our existence as human beings; they are the stuff that dreams are made of.

> Now it will be noticed that nearly all these emotional elements of design are connected with essential conditions of our physical existence: rhythm appeals to all the sensations which accompany muscular activity; mass to all the infinite adaptations to the force of gravity which we are forced to make; the spatial judgment is equally profound and universal in its application to life; our feeling about inclined planes [the ground plane or "floor" of a painting] is connected with our necessary judgments about the conformation of the earth itself; light again, is so necessary a condition of our existence that we become intensely sensitive to changes in its intensity.

All these parts of a work of art feed our fundamental desires and call upon the instincts attached to the basic facts of our physical existence.

Fry concentrates on these abstract components of a work of art to show on the one hand that they carry emotional weight and on the other to demonstrate that art need not imitate nature. This is what makes him a for-

malist. A painting or statue can look like something recognizable, but it doesn't have to. Natural objects have their own emotional messages, of course, and an artist can take advantage of that, but it is how the artist constructs and presents his or her image rather than the image's agreement with nature that is at issue in Fry's aesthetics.

Conclusion

The prevailing model for art until about the middle of the nineteenth century was imitation. The primary basis for judgment in art was the work's conformation to an ideal conception of nature. As modern art itself showed fewer tendencies toward representation, art history and criticism turned from mimesis (imitation) to style. The effect of this shift in paradigms (this shift in the way the subject is viewed) has been to focus our attention more on the actual marks made by the artist and how these forms relate to our basic humanness, and to our cultures. An interest in style has provided us with a more sensitive appreciation and awareness of the spectrum of visual experiences, their historical determinants, and the role played by the individual artist. We can authenticate paintings and statues based upon visual evidence. The fundamental relation of art to life has been reconsidered as a direct result of our interest in the formal qualities of art. However many new directions art history and criticism take in the future, it is highly likely that style will remain an important consideration and will generate lively interpretations and assessments.

◆

Bibliography

ACKERMAN, JAMES, and RHYS CARPENTER, *Art and Archeology*. Englewood Cliffs, N.J.: Prentice-Hall, 1963.

FRIEDLANDER, MAX, *On Art and Connoisseurship* (trans. T. Borenius). Boston: Beacon Press, 1960.

FRY, ROGER, *Vision and Design*. Cleveland, Ohio: Meridian Books, 1956.

GIBSON-WOOD, CAROL, *Studies in the Theory of Connoisseurship from Vasari to Morelli*. New York: Garland, 1988.

GOMBRICH, E. H., "Style," *International Encyclopedia of the Social Sciences*, vol. 15. New York: Macmillan, pp. 353–360.

GOODMAN, NELSON, "The Status of Style," *Critical Inquiry* (June 1975), pp. 799–811.

PANOFSKY, ERWIN, "Iconography and Iconology: An Introduction to the Study of Renaissance Art," *Meaning in the Visual Arts*. Garden City, N.Y.: Doubleday Anchor Books, 1955, pp. 26–54.

SCHAPIRO, MEYER, "Style," *Anthropology Today* (ed. Morris Philipson). Chicago: University of Chicago Press, 1953.

WOLLHEIM, RICHARD, "Giovanni Morelli and the Origins of Scientific Connoisseurship," *On Art and the Mind.* Cambridge, Mass: Harvard University Press, 1974, pp. 175–201.

12

Sociological and Marxist Perspectives

Remember that story of our "first parents"? In Genesis, about the beginning of things, about how our ancestors lost Paradise? God said unto Adam: "Cursed is the ground for thy sake; in sorrow shalt thou eat of it all the days of thy life; Thorns also and thistles shall it bring forth to thee; and thou shalt eat the herb of the field; In the sweat of thy face shalt thou eat bread, till thou return unto the ground; for out of it wast thou taken; for dust thou art, and unto dust shalt thou return" (Genesis 3:17–19). Here, east of Eden, begins work, loss, pain, and death. Although much of Christian art illustrates redemption and deliverance from this sweating agony of existence that we brought upon ourselves, many art historians and critics look at art—subject matter aside—as further evidence of our Fall. Not that art necessarily depicts human struggle directly; rather, in a more complicated and oblique manner it expresses our situation in society, which has its tragic side. Instead of living in the Garden of Eden with God, we live in association with others; we have become social beings who must work for our existence rather than pluck our fruit from trees. Although I am casting this story in mythical terms, I want to emphasize the apparent reality of survival and work. Life as experience, as a series of active and conscious moments, can lead to an understanding of art that is not idealized.

At least since the time of Karl Marx, scholars and writers have tried to understand art—and other human activities—in terms of how we actually spend our lives and occupy our time, and of where we find ourselves situated in the social order. Supposedly, the social-historical critique deals with actual not fictional events and reveals how art "really" works in society. Such views can sometimes be extreme. One critic has characterized the Marxist perception by saying that art objects are "weapons or toys of the ruling classes."

Wölfflin's sensitive analyses of paintings—although revolutionary in their own time—have no place in this fiercely antagonistic world. The more conservative or "softer" position of the social historian seeks rather to "set the artist and the work of art into a broad historical and economic context in order to ground it upon the fundamental facts of material life," as Albert Boime writes in the preface to a series on the social history of modern art. Between these two positions there are various permutations and alternative readings. But on the whole, the social historians of art (and those interested in "material culture") agree that understanding the work of art as a self-contained object, autonomous and subject only to its own rules, a product of a creative mind working in virtual isolation from the determinants of social living, is inadequate. Social historians find it almost impossible to write about art without using the word "context." To understand the full, human dimensions of art, one must look at the larger environment, especially the one that involves the concepts of labor and money.

I began with the story of the Garden of Eden. One interpretation of the Fall of woman and man from Grace sees this tragic but necessary event as a fundamental explanation for much of the travail and disorder in the world. Such a view of the human condition understands labor as the wages of sin, what we must do to survive, now that we have put so much distance between ourselves and God. Understanding work and the economic circumstances surrounding it in something other than religious terms is a product of more recent times, especially in the writings of Karl Marx and Friedrich Engels. It is remarkable how Marx took work, such a common experience, one that might appear utterly natural, humble, and inevitably a part of the human condition, and turned it into a theory. And not just any theory, but a theory that reveals the continuing exploitation, alienation, and dehumanization of the worker (an artist, by the way, is a worker in the Marxist system). Suddenly there was an explanation for human behavior where there hadn't been one before, and with that interpretation came hope for redress of unacceptable treatment of one class of men by another. Antonio Gramsci in a well-known assessment of Marx wrote: "Marx was great, his activity was fruitful, not because he invented out of nothing, not because he extracted an original vision of history from his fancy, but because in him the fragmentary, the incomplete, the immature became maturity, system, comprehension." In the early 1990s, with the fall of Communist regimes in Eastern Europe, the dissolution of the Warsaw Pact, and the virtual end of communism in the (former) Soviet Union, it has become less fashionable to use Marx's name in interpretive and political discourse. But in order to understand much of the recent criticism in the humanities, one has to look at Marx's influence and method of explaining the world. And, even though Marx wrote little about art and literature, the Marxist critique has been powerful and its authority continues.

Although there are those who find Marx's materialist-based conception of human activity (including art) at odds with any sense of pleasure, there's

evidence that he thoroughly enjoyed art. We know that he wrote poetry and admired Balzac and Shakespeare, read widely in aesthetics (Hegel and Winckelmann), and was sensitive to the human capacity for creativity (which of course could only be fully realized when the oppressive class system had broken down). But whether or not he liked art and was capable of understanding it in a disinterested fashion, it is the system of his philosophy that counts here. Perhaps the thing that fascinates Marxist critics the most is the traditional association of art with the privileged and idle. To fight the capitalists with one of their favorite enchantments is to strike a particularly telling blow. Marxists demystify art and show it to be one more tool in the conspiracy of the moneyed classes to keep labor down. This is a radical interpretation of art, however, and one which ignores many of the other nuances of socialist theory. (And such an interpretation has been described, disparagingly, as "vulgar.") It is best to look first at Marx's basic method, then move on to art historical applications.

In short, Marx believed that all human activity is a product or manifestation of economic circumstances, especially since the advent of the Industrial Revolution. The owners of the means of production—the factories—are the bourgeoisie, the workers are the proletariat. These two classes are naturally in conflict because they have different needs and desires. Therefore social relations, how people interact with one another, are not based upon natural, organic patterns but upon the exigencies of producing certain commodities (cars, lipstick, rock-and-roll). The worker relates to his boss, the producer, in terms of his wages and his job security. Such a situation is inevitably exploitative. It is in the interest of the owners to maintain the relation, of the worker to change it: hence tension and conflict. Marx believes that the means of production—factories, assembly lines, film companies—is the engine that drives history and establishes the foundation or base of a culture. The superstructure of a society—the laws, practices, customs, art, popular entertainment—necessarily reflects the material base.

There are two things of relevance to the study of art here: One is how we understand historical art within the social context; the other is the role of art in the struggle of the proletariat to overcome the capitalist oppressors. The function of an activist art, the second point, is really outside the scope of this book. Whether one believes that art can be a tool of liberation, either as a socialist or realist, or as a subversive, has been and continues to be hotly debated. But my concern is the historical treatment of art, how art can have meaning and significance for its audience, past and present.

The Mechanics of Meaning

Marxist and socialist interpretations of art begin in earnest after World War I. One of the reasons for applying these new perspectives was the state of art historical inquiry as it existed at the end of the nineteenth century. Wölfflin,

Riegl, and others had deplored the nonintellectual treatment of art so typical of the Victorian age. One's confrontation and engagement with art in those days was mostly a matter of romantic expostulation, moral fervor, appreciation, connoisseurship or taste, antiquarianism (knowing lots of facts about the past but with no theoretical comprehension), fascination with individual genius, and enjoyment of biographical gossip and tidbits. There was, in other words, a desire upon the part of professional art historians to find some more suitable basis for the study of art than a sigh, a twitch of the eyebrow, an impressionistic flow of adjectives. As a result, we have the perceptual and historicist schools growing out of Kant and Hegel, the empiricist attention to style of Riegl and Wölfflin, and now the materialist or economically based system of Marx and his followers.

How does a work of art connect itself with the superstructure of a culture and reveal the economic base? Richard Wollheim distinguishes among three separate approaches used by art historians: the causal, the expressive, and the parallel or anecdotal. In the first approach, art is seen to be caused directly by a particular social class or the economic base as a whole. The cause and effect are as necessary, if not so obvious, as the actions of billiard balls hitting one another. Arnold Hauser writes: "All factors material and intellectual, economic and ideological, are bound up together in a state of indissoluble interdependence." Berel Lang and Forrest Williams in their source book of Marxism and art state that "all parts of the ideological superstructure—art being one of these—are crucially determined in content and style by the behavior of a more basic structure which is economic in nature." This is, in effect, a hypothesis accepted as law, a restatement of the basic Marxist-socialist premise: All human activity at its most fundamental level is related to (caused by) social events and circumstances. However, the connection between the work of art and material factors need not be obvious and direct. Marx himself commented on the need for an understanding of the complex, dialectical relationship among people and economic activities. Art may not so much "reflect" the material base, as find some resonance with that base through its play of forms.

The second kind of connection between art and society is the expressive. In this approach, the work of art expresses some cultural value or crisis. Here one talks about a work of art *and* culture, not about a work of art *because* of culture. There are those who maintain that Picasso's *Guernica* expresses the dilemma of modern art, impotent in the face of the powers of darkness that consumed Europe in the 1930s and early 1940s. Arnold Hauser believes that mannerist art expresses the political and spiritual crisis of the sixteenth century in Italy. Similar terms, such as "epitomize" and "reflect," can give voice to the same sort of connection between art and society. Boime, in his excellent study of the social history of art between 1750 and 1800, writes of Jean-Baptiste-Siméon Chardin's *A Lady Taking Her Tea* that it "seems to epitomize in its quiet sanctity a middle-class domestic ideal"; and, in his general

discussion of Chardin, he notes that the artist's "carefully worked surface, passion for domestic objects, and modest themes reflect the thrifty and practical-minded French artisan sure of success within the current social structure." However, such a writer as T. J. Clark has cautioned against the haziness of an expressive connection. He writes in *Image of the People*, "I am not interested in the notion of works of art 'reflecting' ideologies, social relations, or history. Equally, I do not want to talk about history as 'background' to the work of art—as something which is essentially absent from the work of art and its production, but which occasionally puts in an appearance. . . ." Those critics who do not view artworks as a manifestation or mirroring of society often try to demonstrate both how the work *shapes* the material culture and, by extension, the ways in which it can be used as a tool in reforming political realities.

Frequently, in the expressive form of sociological art history, one's attention is drawn to subject matter, what the work of art seems to be about. Monet's series of paintings on train stations is an example: The importance of steam power, and by implication the Industrial Revolution, becomes thematic material for the artist. Also cities with all their newness, evidence of modern forms of construction, and testimony of prodigious growth had a direct fascination for the realist artists of nineteenth-century France. Of course the means and process of production and its influence on social relations need not show up just in subject matter. Technique (using newly manufactured colors), structure or style (a more fragmented way of seeing, as in impressionism), and a less formal manner of composition (as in realism and impressionism)—all can reveal the basic forms of an economic system. In terms of social history, the artist's vision can't help but be shaped by the larger society.

The third sort of connection, as suggested by Wollheim, is the one based upon parallelism or anecdote. In this approach, a critic does not posit a necessary connection between the art object and material or social circumstance; rather, he or she sees some parallel. This may be the safest position to take, since you don't have to defend the underlying laws and principles of your assertions. It also posits the weakest connection between art and society. For instance, one can comment that in general there was a sense of alienation in American culture in the 1950s and that various works of art also suggest alienation, such as Jasper Johns's *Flags*. Certain of Johns's images float in an ambiguous field, with none of the traditional figure/ground (foreground/background) relationships established. Given the importance in the 1950s of patriotism and belief in the national symbol, the American flag, one can speculate on the role of the saddened and depressed, the alienated and aloof artist in American culture. And, in fact, if you study Johns's biography, that very image of estrangement can be found. So the anecdote—a casual comment or story—finds a connection between the social mood and the artist or work of art.

Alienation and Ideology

The theme of alienation, so prominent in the sociology and literary criticism of the mid-twentieth century, comes out of Marxist discourse—although Marx didn't invent the notion. Because the worker neither owns the tools nor the means of production (the factory or business), nor has any say in the direction and intention of the business, he or she is fundamentally alienated from what is produced. Although the worker's labor is the essential element in the production of goods and services, he or she has no intimate connection with the product. As the product, say a jar of jelly, enters the market place, it passes through the hands of other mediating agents (wholesalers), and eventually appears on the shelf, where it is sold at a greatly inflated price, because its value no longer is based upon the worker's efforts or wages. Now the worker pays dearly for this very same jelly with which he or she no longer has any direct connection. The worker has no ownership in the store that sells the product he or she helped to manufacture. There are disconnections and estrangements all along the way. Because labor and production are so divided, so too is the laborer, divided within his or her own self.

Since so much of our mass culture is based upon the idea of assembly-line production and the separation of owners from workers, is it any wonder that there exists so much frustration, loneliness, and a sense of purposelessness in our culture? We seem to achieve our identity through acquisition of material products, which in and of themselves offer little human nurturing or satisfaction. We are urged (but by whom? is there a conspiracy here?) to imitate imaginary people in movies, on soap operas, on talk shows, on MTV, in sports; or real people who make fabulous sums in illegal activities. The influence of alienation is so pervasive that no aspect of social living can be entirely free from it.

Even the apparent pleasures of cafe society in late–nineteenth-century Paris can divulge the sadness lying beneath the surface. Edouard Manet's *A Bar at the Folies-Bergères* (fig. 29) betrays the dark side of conviviality. It's not just that the woman in the center of the picture bears a blank expression in the midst of gaiety, it's that she so powerfully dominates the composition and blocks our view of the room. There are other fracturing devices used by the painter: The man shown reflected in the mirror doesn't appear on our side of the counter; the woman's reflection is utterly wrong, making no sense in terms of the laws of optics (the angles of refraction and reflection); and the room itself, reflected in a mirror (therefore the viewer actually occupies the space depicted), is out of focus, distanced, and inaccessible. The paradoxes proliferate. Many critics have indeed perceived a quality of alienation in Manet's painting.

The free-floating, cloudlike forms in Mark Rothko's last canvases might also be seen to disclose a sense of disorientation and alienation. Human fig-

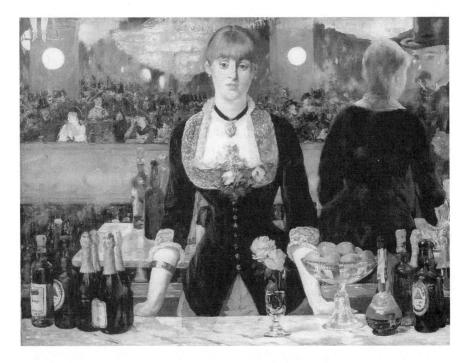

Figure 29. Edouard Manet, A Bar at the Folies-Bergères, 1882. Courtauld Institute Galleries, London (Courtauld Collection). Photo: Courtauld Institute Galleries.

ures and other recognizable images are conspicuous by their absence. The artist, no longer a part of the larger community, is himself distanced from normal interaction with policemen, garbage collectors, lawyers, business people. He has no desire to celebrate the capitalist system, and finds little else to body forth other than a mysterious journey into the unknown. It's been said that Rothko's sense of disconnection with the rest of the world was so great that his suicide in his studio was a final gesture in his desire for separation.

◆

The ideological superstructure of society, with all its manipulations, disruptions, and pathologies, is to be found in social practices, such as etiquette, and in laws, institutions, education, and art. It is the task of the Marxist critic to unmask and display the system of ideas (ideologies) hidden by the so-called beauty or disinterestedness of art or within the apparently natural social practices of the culture at large. An art historian describes the Marxist mission at the end of the 1980s: "Today, piercing the veils that disguise the functioning of superstructural elements which conceal economic, political, and social reality from consciousness, creating false consciousness, has

turned out to be one of the most important tasks of criticism." In this radical Marxist line there is the assumption, more explicit than tacit, that you can do this with all art. Unmask it. What you'll find within the layers of obfuscation are the bare bones of social relations and the naked devices of oppression and subjugation.

But what do you do with a work that seems to be about escape, such as Jean Antoine Watteau's *Pilgrimage to Cythera* (fig. 30)? Certainly nothing overtly political is going on here; rather, the pilgrims seem to be engaged in one of the oldest, we might say pre-political, pursuits: that of happiness. This is so fundamental and so much a part of natural law, that it is written into the United States' Declaration of Independence: "We hold these Truths to be self-evident, that all Men are created equal, that they are endowed by their Creator with certain unalienable Rights, that among these are Life, Liberty, and the Pursuit of Happiness." Considering the fact that the Declaration is as much a product of eighteenth-century thinking as Watteau's painting, couldn't we say that to politicize the statement or the painting flies in the face of what each insistently avows? What we have here is not so much social and economic circumstance as evidence of the Enlightenment's interest in things that are "natural"? One can respond that the Declaration is a political document, of course, so even in its appeal to "Nature" and "Nature's God," it acknowledges a social context for its propositions.

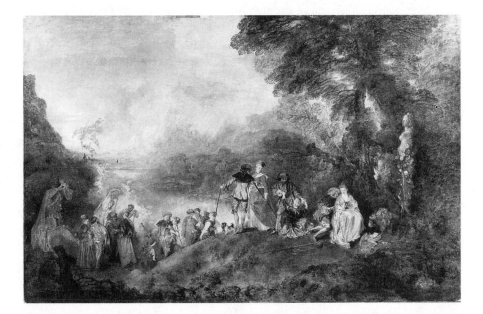

Figure 30. Jean Antoine Watteau, *Pilgrimage to Cythera*, 1717. The Louvre, Paris. Photo: © PHOTO R.M.N.

At first glance the painting looks to be anything but political. The figures occupy a world of dreams and wishes, more a psychic phenomenon than the work-a-day world familiar to Marxist critics. The men and women are equal in status and action, liberated from work, seeking happiness on Venus' Island of Cythera, a mythical place where love can be found and realized fully. On the surface, at any rate, this seems to be a return to Paradise. *Putti* fly about the enchanted boat, the pilgrims all assume balletic poses, as if this were staged and choreographed. Rather than concern themselves with the *polis*—the problems of the people or community—the lovers are cosmopolitan, absorbed with themselves as individuals and the universal desires associated with the human condition.

But a Marxist might ask, how do these French aristocrats find their leisure? Who provides for them? The workers. Their conspicuous ease and withdrawal asserts implicitly their dominance over the working classes. In this painting's emphasis upon the aesthetic experience (note the sugary, globular paint, the pastel and misty colors, the beautifully articulated figures), it can't help but make you wonder about the absence of a more common-sense reality. By the way, although the work suggests frivolity, it is not itself frivolous: Happiness, fulfillment, liberation are indeed serious human themes. But critics, whether or not they are Marxist, have been commenting for centuries on the escapist aspect of this painting. A Marxist would seize on that very issue, and attempt to show it as "false" consciousness, because the pursuit of happiness by one class occurs at the debilitating expense of another. The ideology of aesthetic isolation and Kantian disinterestedness evidences one class's urge to soar beyond the petty concerns of survival. Many of this class and much of rococo art wish to exist for the sake of beauty and human pleasure. One can accept that indifference to pragmatic concerns as a fundamental human drive; or, we can see it as irresponsible and exploitative. Those who take the latter view might want to point out that Watteau's painting hides the messy, struggling reality of the larger part of French society in the early eighteenth century.

◆

The Marxist/socialist critique of art can have a reductive and sometimes judgmental character. Rather than expanding our understanding of art within many contexts, the Marxist may insist upon one form only for "grounding" art. Understanding art as a social phenomenon is not meant just to enrich our perspectives; Marxists claim to show the true form of interpretation. There is little room in this approach for acknowledging the historian's own biases and awareness that he or she is scripting the political setting (although Marx did caution the critic to be conscious of the degree to which he or she was determined by class conflict). And "enrichment" apparently is for less serious pursuits. As Arnold Hauser, a strong advocate for the social history of art, admits, the sociological interpretation has little to say about

quality or changes in a particular artist's style—or even abrupt changes in a national or period style. The internal history of art, where the style and accomplishments of one generation directly influence the next, seems to make relatively little sense to a Marxist. While it may be unfashionable to talk about beauty, greatness, genius, masterpieces, or the canon—representing the best that has been thought and created—these are important ideas and beliefs in the history of art. It seems to me to be a mistake to devalue them utterly, to dismiss them as bourgeois mystification. Must art be about struggle and domination? Is it always true, as some critics have maintained, that the relation between viewer and image is confrontational and antagonistic, and that in this conflict, someone (preferably the critic?) has to win? (I have images of violent harangues and the shakings of fists in museums and galleries.) Social historians sometimes have difficulties defining the connection between works of art and society. Is it a matter of grounding, generating, or situating; of reflection, contextualization, expression, or causation? There doesn't seem to be much agreement on this point. On the other hand, those who see art purely in formalist terms (see the previous section), or as products of visual and deconstructive strategies or gamesmanship, ignore the social dimension of art at some considerable risk. The debate between the so-called intrinsic and extrinsic perspectives continues.

◆

Bibliography

ANTAL, FREDERICK, "Remarks on the Method of Art History," *Burlington Magazine*, 91, 551 (1949).

HAUSER, ARNOLD, "Sociology of Art: Scope and Limitations," in *The Philosophy of Art History*. New York: Knopf, 1959.

LAING, DAVID, *The Marxist Theory of Art*. Sussex, N.J.: Humanities Press, 1978.

LANG, BEREL, and FORREST WILLIAMS, eds., *Marxism and Art: Writings in Aesthetics and Criticism*. New York: David McKay Company, 1972.

RISATTI, HOWARD, ed., *Postmodern Perspectives: Issues in Contemporary Art*. Englewood Cliffs, N.J.: Prentice Hall, 1990.

ROSE, MARGARET A., *Marx's Lost Aesthetic: Karl Marx and the Visual Arts*. Cambridge: Cambridge University Press, 1984.

13

Feminism

Does it make sense to divide the world of humans and of history into male and female? What could be more natural? What could be more culturally determined? The tools used by historians and art historians, by critics of literature, politics, culture, and economics have varied with the times. But over the past several centuries, it has been apparent to many that understanding a culture requires a grasp of class, customs, economic factors, and belief systems. Add race (or ethnicity), sexual orientation, and gender to the mix and you have some of the important methods, points of view, and political perspectives that today dominate discussions (sometimes called discourses) in academies, think tanks, journalism, and politics in general. Often these critical methods are not only tools just for understanding, but also instruments for change.

Does it really make any difference what the sex of the artist or the viewer is when confronting a work of art? Does gender have anything to do with subject matter in a painting, with the impact or the response of a viewer, with the style of an artist? Virginia Woolf, when pondering the issue of women and fiction in *A Room of One's Own*, saw three possible ways of confronting the issue of gender and artistic expression: women as they are depicted in fiction, women as writers of fiction, and "women and what they are like"—or a mixture of the three. In the past generation, Woolf's basic theoretical structure has stood the test of time and been greatly expanded upon. All of this is feminism, and there can be few around today who deny that feminism is anything other than a legitimate critical concern.

There is, of course, always the question of bias. One sex—the male—has traditionally been given, at least in the arenas of legal, political, economic, and artistic activity, priority over the other. Therefore woman has become the other—a radically different and problematical identity. It's hard to imagine a more consistently demonstrable system of segregation and power distribution than has existed between men and women throughout

Western history. Although there is now a degree of equality between the sexes that is unmatched in our history, the fallout from all those years of discrimination continues to affect us. We are still trying to understand what gender has meant and continues to mean to us, and to learn what the lessons of feminism signify to our institutions and our very consciousness.

Perhaps it would be worthwhile to set out some of the evidence for Western culture's discrimination and patriarchal bigotry toward women. The cultures of antiquity were extensively, sometimes thoroughly, misogynistic. Women were treated as property rather than as actual humans by the early Hebrews and Greeks. In the Old Testament we find that wives had to speak to their husbands as slaves addressed their masters, that daughters could be sold like any other property, and that a man would pray, "I thank thee, Lord, that thou has not created me a woman." Because Eve was created out of the side of Adam, according to Genesis, woman was not thought to be fully human, not really in the image of God. She is derivative. As Saint Paul wrote, "For a man . . . is the image and glory of God; but woman is the glory of man. Neither was man created for woman, but woman for man." This is a powerful and pervasive attitude that has dominated the relation between the sexes for more than 2,000 years. In the Middle Ages, Canon Law (the law of the Roman Catholic Church) permitted men to beat their wives.

In the eighteenth and nineteenth centuries, the submission of women came to be questioned by a number of socially conscious thinkers. Mary Wollstonecraft's *A Vindication of the Rights of Woman* (1792) and John Stuart Mill's *On the Subjection of Women* (1869) are important documents that challenge Western culture's need to keep woman in her place. In the twentieth century women have largely won equal rights under the law, although it is notable that the Equal Rights Amendment to the Constitution of the United States of America failed to be ratified by the states. Because the Constitution is based upon English common law of the eighteenth century, it contains within it no genuine protection of the legal rights of women. Title VII of the Civil Rights Act of 1964 prohibits discrimination on the basis of sex: yet this is a legislative act rather than a constitutional document. So far, it appears to be law, even though it does not carry the weight of a constitutional amendment.

At any rate, feminism as a form of political action has been transmuted into a form of critical study. In the areas of art, aesthetics, art history, and criticism, the debates and controversies have been lively. In their somewhat skeptical view of art history, feminists first posed the question: Where are the women artists? We have documentary evidence that women have been professional artists in the West at least since the Renaissance, even though their numbers are few. Just the same, you would expect that their work could be as good as that of their male counterparts, and therefore worthy of study in an introductory art history survey. Yet the textbooks available to art history students before about 1970 showed few if any works by women artists.

There is in art history, as with other fields in the humanities, a list of

great monuments, what has come to be called the "canon," those works judged to be the great ones. For instance, before H. W. Janson published his fundamental textbook *History of Art*, in 1963, he edited a selection of high-quality photographs of what he called the "Key Monuments of the History of Art." It is a book of nearly 1,100 illustrations, without an accompanying text. In his introduction he tells us that he had sought the consensus of a number of art historians to find a core list of great works by great artists. He hoped that the album of photographs would be useful for a "disciplined and systematic perusal in conjunction with an introductory lecture course" If you were to compare the illustrations in the major art history texts today against his list, you'd find that his list has remained mainly intact. On the whole, generations of art historians have sanctioned his canon. Except for women artists. Janson, in his original list and in the first edition of his textbook, names not a single woman artist.

How is this possible? That there weren't any talented and historically significant women artists is nonsense. Subsequent texts devoted exclusively to resurrecting the reputations of women artists have shown quite the opposite. And the newer editions of Janson, Gardner, and Hartt contain greater numbers of women artists. But we are left with the idea that women have been systematically excluded, although probably not through any conscious malice or conspiracy. This is an example of what has come to be called the "masculinist bias," the belief that there is a prejudice against women even when we are trying to be objective and disinterested in our choice of works to illustrate in art history texts and courses. "Masculinism" is so pervasive, we might not see it. It is feminism's goal to point out masculinist bias so that we will acknowledge it as a real critical stance, not just some natural, common-sense way of deciphering the world. It is worth pondering a moment the absence of women in art history.

How does one get into the canon, the honored list of artistic "greats" and "geniuses"? And—a different kind of question—what purposes do these lists serve? Let's consider the second question first. Some feminist critics believe the very construction of a list of the greats reveals a masculinist point of view. Privileging some artists over others arises from so much favoritism, so much prejudice that the results are inevitably skewed and oppressive. Creating hierarchies means putting someone—in this case, women—down. Since men have been making up the lists, mostly men will be on them. Besides, a discussion of greatness and genius is an anachronistic holdover from the romantic period. Maybe we don't need to believe in the unique, transcending artistic genius as much as we once did. The art history of "great men" is becoming a thing of the past; somehow, the "hall of fame" seems more appropriate for male-dominated sports like baseball, football, and basketball, rather than for some human activity as amorphous and enigmatic as the making of art.

Still, art history texts as often as not organize their material by artist.

And, in choosing works of art to include in an anthology, we inevitably notice the gender of the artist. Scholarly books also frequently focus on the artist, the human being behind the work of art. For instance, American art historian Mary Garrard recently wrote *Artemisia Gentileschi: The Image of the Female Hero in Italian Baroque Art*, a book that is strongly feminist. In it she argues that Artemisia has been kept out of the canon because she shows many feminist scenes, such as the brutalizing of women (she herself was raped by another artist) or the triumph of women, and that she sometimes does this in an unfeminine way. Men are repelled by Gentileschi's approach, so have paid scant attention to her in the scholarship of art history. Whatever the strengths of her argument (which of course is far more complicated than I've suggested here), it is clear that Garrard cares about the artist as well as the work of art, that she wants to reclaim for the purposes of art history this woman and her identity and her heroism. So we are, in fact, back to the question that I posed initially: How does someone get on the canonical list?

The traditional explanations can be summarized easily. To join the ranks of worthy artists—past or present—one often must display ability and vitality, and this can be independent of the economic or political circumstance of the individual artist. There are many recognized artists who came from poor and powerless social positions. And he or she must be at the right place at the right time with the right style. Someone painting in the manner of, say, Paul Klee, but living in Siena in the sixteenth century (if such a thing were at all possible), probably would have been ignored. Just as an artist painting in the style of Watteau, but in the 1990s in Chillicothe, Ohio, would be just as unlikely to make it big. Further, a successful artist, then and now, should be lucky enough to attract attention, to be supported however minimally, even to make contacts and promote his or her own work. Also, when the influential art historians of today create the list of past artists, they like those artists who were creative, innovative and new, unique and fresh. An artist who simply represents her own time is perhaps not as interesting as one who influences it, defines it, or transcends it. We value these things because romanticism and modernism have taught us the merit of the potent and the new.

But as the previous paragraph suggests, list making is also implicated in the social and political concerns of the present. Studying the canon is like watching the stock market: Issues go up and down, and the reasons are not necessarily tied to inherent values. Some of the most skillful art produced, that of the French *Académie* in the second half of the nineteenth century, was ignored for quite a long time by art historians because it wasn't as avant garde as impressionism. Now it's taken seriously again.

List making is in part capricious, arbitrary, and biased. By its very nature, it depends as much upon the character of the canonizers (who are sometimes hard to identify), as upon the artists. Nonetheless, despite male prejudice, women artists are now more than ever considered part of the

canon, because a number of feminist art historians have "nominated" them and promoted them, and have done so with great skill. And not incidentally, these artists are good and historically significant. In the best of all possible worlds, those in the artistic "hall of fame" would be there only because of some intrinsic value which we could all agree upon. Or an alternate utopian view would simply eliminate the "hall of fame." But that's not the world we live in. The project of art historians (how one seeks to understand, and also how one gets the Ph.D. and publishes in order to win tenure and recognition) is constantly to reconsider the past, to reclaim overlooked artists, and to refocus the light of the present into the shadows of history. We reinvent the canon every day. And the ranks of previously ignored greats have not yet been exhausted.

There is another feminist point of view that asserts an essential, feminine vision. Women artists are trained in a masculinist art world, so a feminist artist has at least two tasks: to uncover the masculinist element of traditional art and to show the experience of women as distinct from that of men. And that experience is frequently one of oppression. Feminist art and aesthetics tend to arise from social relations. Witness the art of Mary Cassatt at the end of the nineteenth century, for instance (fig. 31): She emphasizes the domestic, although not as tyranny. In this painting, at least, a woman is not a pris-

Figure 31. Mary Cassatt, *Girl Arranging Her Hair*, 1886. National Gallery of Art, Washington, D.C., Chester Dale Collection. Photo: © 1992 National Gallery of Art, Washington, D.C.

Figure 32. Audrey Flack, *Queen*, 1975–1976. Private Collection. Photo: Courtesy Louis K. Meisel Gallery, New York.

oner of home and children. But we can see here and elsewhere how society has made gender important, and has systematized it. The feminist artist, according to one account, "calls attention to that system, displays it in detail and renders it intelligible." Feminist art usually comes out of experience and tries to make that experience palpable, reflective, symbolic. Audrey Flack's *Queen* (fig. 32) is a more recent example of feminist art. As many feminists demonstrate, these objects or details of experience have frequently been judged by mainstream culture as only marginally important. Audrey Flack shows stuff not normally thought of as constituting high culture. She presents the detritus, the overlooked, the supposedly inconsequential details of society. By giving these things attention, the feminist artist advocates a kind of destabilizing process. Art supposedly presents the great themes and images of the world; when it doesn't do this, it tends to disturb us and to raise questions. Flack's art gives rise to a certain skepticism and uncertainty without providing simple answers. This sort of art is interested in its subject matter; Kant, who has in some minds come to represent a masculinist perspective, could not conceive of this as art. In the Kantian tradition, art is disinterested and autonomous: It's free of the world and utilitarian or economic concerns. But feminist art often follows what has recently been termed the "Principle of Worldly Attachment."

This is not just thematics or subject matter. The feminine vision involves style as well as imitation of the visible world. Take Georgia O'Keeffe, for instance. One of the strains of criticism or interpretation of her art has to do with the strongly organic and feminine aspect to her imagery and the way she presents it. Or take the abstract expressionist artist, Helen Franken-

thaler—critics have pointed out the soft and sometimes blurry way that paint stains her canvas. This is very different, say, from the "slash and burn," almost violent splattering of paint that one sees in the canvases of Jackson Pollock. To make a convincing demonstration of what makes this less violent, softer style feminine or feminist would take a longer discussion than I have space for here. What I am suggesting is that there are, in fact, possible feminist strategies for making interpretations.

Another product of feminist art and criticism has revealed the "male gaze." This was first proposed and demonstrated by Laura Mulvey in an article on film that appeared in the mid-1970s. Her claim is that movies tap into the unconscious desires of the viewer and that viewer is gendered. He is male and is a "scopophiliac"—one who loves to look—a voyeur, a peeping Tom. The idea of the male gaze depends in part upon psychoanalytic theory, which often makes of art a means of satisfying unconscious wishes. The eye of the camera and the eye of the audience, according to this theory, is male. And in the act of looking and being looked upon, the male is active, the female passive. Vision is a powerful tool in establishing power relations. In our Western tradition, the one who does the gazing seems to have influence over the one gazed upon. The one who looks makes the purchase. The object of the gaze is like a precious object in a glass case: desirable, perhaps expensive, but obtainable. One who sees is a "seer," and that word has almost prophetic implications.

An early example of a work in which the male gaze seems important is the *Aphrodite of Knidos*, produced about 350 B.C. (fig. 33). Stories from antiquity tell of her original placement and the response of viewers. She was located in a small sanctuary surrounded by columns on the island of Knidos in the Aegean Sea. She was shown emerging from her bath, picking up a towel, about to dry off. Even such teenage exploitations movies as *Porkys* know how to use this age-old topos (repeated theme). The early accounts say that sailors would climb the hill to Aphrodite's sanctuary and, hiding behind columns, watch her. They would leave their "stains" on the marble. The psychology here is like that involved in a surreptitious reading of *Playboy* or *Penthouse*. In a sense the woman is demeaned, is objectified, is made the victim of pornography. On the other side of the argument, one could say, however, that the Aphrodite has survived in a number of versions, now hallowed as art by placement in museums and by canonization in art history texts, no longer the unwilling prey of the male gaze. And the sailors have died long ago. But saying this doesn't dismiss the effect of the male gaze. And who's to say that the museum really protects the work of art from "nonaesthetic," prurient interests? A feminist critic might point out here that what we take to be unadulterated pleasure in a piece of art really isn't that. There always is working some concealed codes (a man's conscious or unconscious desire to possess a woman—his mother?—to control what frightens him), some

Figure 33. Praxiteles, *Aphrodite of Knidos*, c. 350 B.C.; Roman marble copy of marble original. Vatican Museums, Rome. Photo: Vatican Museums, Rome.

gendered bias or ideology. Let's be honest about it, recognize it, and—perhaps—correct it.

In other words, feminist criticism is not disinterested, its purpose is not just to find another perspective for critiquing works of art. The adherents of feminism often claim that it is a fundamentally new approach to art history, one that exposes the discipline's traditions and critiques its patriarchal beliefs. In this sense, feminism hopes to bring about change in the arena of cultural politics.

◆

Bibliography

BRAND, PEG, and CAROLYN KORSMEYER, eds., *Journal of Aesthetics and Art Criticism*, Special Issue: "Feminism and Traditional Aesthetics" (Fall 1990).

BROUDE, NORMA, and MARY D. GARRARD, eds., *The Expanding Discourse: Feminism and Art History*. New York: Icon Editions, 1992.

————, eds., *The Power of Feminist Art: The American Movement of the 1970s, History and Impact*. New York: Abrams, 1994.

DALY, MARY, "Social Attitudes Towards Women," *Dictionary of the History of Ideas*, Vol. IV. New York: Scribner, 1973, pp. 523–530.

GOUMA-PETERSON, THALIA, and PATRICIA MATHEWS, "The Feminist Critique of Art History," *The Art Bulletin* (September 1987), pp. 326–357.

HARRIS, ANN SUTHERLAND, and LINDA NOCHLIN, *Women Artists 1550–1950*. New York: Random House, 1976.

MULVEY, LAURA, "Visual Pleasure and Narrative Cinema," *Screen* (1975).

MUNSTERBERG, HUGO, *A History of Women Artists*. New York: Clarkson N. Potter, 1975.

NOCHLIN, LINDA, "Why Are There No Great Women Artists?" *Women in Sexist Society. Studies in Power and Powerlessness* (eds. Vivian Gornick and Barbara Moran). New York: Basic Books, 1971, pp. 480–510.

PETERSEN, KAREN, and J. J. WILSON, *Women Artists: Recognition and Reappraisal from the Early Middle Ages to the Twentieth Century*. New York: New York University Press, 1976.

TUFTS, ELEANOR, *Our Hidden Heritage: Five Centuries of Women Artists*, New York: Paddington Press, 1974.

14

Deconstruction

Coming out of Continental (a word preferred by contemporary critics to "European") schools of criticism, and especially the writings of Jacques Derrida, no movement in critical theory has caused more consternation and excitement than deconstruction. For more than a decade, from the mid-1970s until the late 1980s, you couldn't pick up a copy of *PMLA* (a publication of the Modern Language Association) without reading one or more articles about how some text deconstructed or subverted its own meaning. Deconstruction is a game (critics love to write about "moves"), was hot, and had many players. It is not yet passé, but is making way for new, more centered and historically based critical approaches.

Like the best games, deconstruction is serious and philosophically exacting. And like many of the recent theories of criticism, it is combative, confrontational, threatening. It threatens to dissolve the work of art in its own hidden self-negations. Not unlike those tapes in the television series "Mission Impossible," the text promises to self-destruct in a few seconds' time. The reason for this disappearing act (more figurative than literal, admittedly), is that art is not really about what we've always thought it was about. Deconstruction, along with some companion modern theories (there are, according to the formulation of M. H. Abrams, three modern types of criticism based upon the idea of undecidability), is out to get and to overthrow our assumptions about art: that art has meaning, that the meaning is contained and expressed (a suspicious word to the new theorists) by the object, that the object is a unique and privileged product of human culture that contains commonly held values of virtue and creativity. Kenneth Clark's book *Civilisation*, originally a widely admired television show produced by the BBC, began with the assumption that individual works of art are products of individual genius. Go out today and ask visitors to a museum if they believe art is an expression of the artist's genius: Most will answer yes. Wrong, says the deconstructionist. Other and more complicated factors are at work.

Let me begin this discussion with some passages from a wildly funny

academic novel, *Small World: An Academic Romance,* by David Lodge (New York: Macmillan, 1984). The romantic and "theoretical" lead is one Morris Zapp, a fictionalized combination of two well-known American literary critics. Zapp, a practitioner and purveyor of a version of criticism more or less identical to deconstruction, arrives at a conference sponsored by the British university "Rummidge" (as in the Britishism "rummy"—odd, queer, singular) and proceeds to scandalize the demure and conservative academics in attendance. With cigar in mouth, pacing the floor, Zapp begins:

"You see before you . . . a man who once believed in the possibility of interpretation. That is, I thought that the goal of reading was to establish the meaning of texts." Of course, he's setting us up to hear precisely the opposite: " . . . it isn't possible, and it isn't possible because of the nature of language itself, in which meaning is constantly being transferred from one signifier to another and can never be absolutely possessed."

Zapp returns to his favorite phrase, one fit for a T-shirt: "Every decoding is another encoding." Simply put, this means that whenever a reader or art historian feels he or she has broken the code of a work, so to speak, the result is not so much clarification and understanding as it is a new code. Anything one writes in criticism is as bound by language and its conventions as the original text or the original painting is determined— or overdetermined, as some like to put it—by visual thinking, images as codes, and the social-historical context (although the social-historical context is of least interest to the deconstructionist). In the act of interpretation, we do not so much express the truth about a work of art as create another code, which must in turn be interpreted. Therefore, meaning is forever deferred. We simply can't get to it, any more than we can find the final image when holding two mirrors face to face. It's called infinite regression, and it's a paradox for critics. But Zapp has consolation for us:

> Now, as some of you know, I come from a city notorious for its bars and nightclubs featuring topless and bottomless dancers. I am told—and I have not personally patronized these places, but I am told . . . that the girls take off all their clothes before they commence dancing in front of the customers. This is not striptease, this is all strip and no tease, it is the terpsichorean equivalent of the hermeneutic fallacy of a recuperable meaning, which claims that if we remove the clothing of its rhetoric from a literary text we discover the bare facts it is trying to communicate. The classical tradition of striptease, however, which goes back to Salome's dance of the seven veils and beyond, and which survives in a debased form in the dives of your Soho, offers a valid metaphor for the activity of reading. The dancer teases the audience, as the text teases its readers, with the promise of an ultimate revelation that is infinitely postponed. Veil after veil, garment after garment, is removed, but it is the delay in the stripping that makes it exciting, not the stripping itself; because no sooner has one secret been revealed than we lose interest in it and crave another.

Zapp concludes the metaphor as follows:

> To read is to surrender oneself to an endless displacement of curiosity and desire from one sentence to another, from one action to another, from one level of the text to another. The text unveils itself before us, but never allows itself to be possessed; and instead of striving to possess it we should take pleasure in its teasing.

The art historian who considers himself or herself a post-structuralist/deconstructionist has little difficulty in substituting "to see" for "to read," and "art object" for "text."

All this talk of teasing and displacement comes from the way post-structuralists read the theory of the Swiss linguist Ferdinand de Saussure, whose *Cours de linguistique générale* was based on a series of lectures he delivered between 1907 and 1911. Saussure developed a definition for language as a system of signs. The primary element of language, the sign, is constituted by the "signifier" (more or less corresponding to a word as it is spoken or as it is marked on a page) and "signified" (what the word refers to). All signs are arbitrary and gain whatever meaning they have by their difference from other signs. A usual example given is that the word "cat" is what it is because it isn't "bat" or "hat." Things are what they are because they aren't something else (we're talking about language right now, but the translation to visual art can be made). A text (passage of literature or art object) has its own interior code or system of rules and composition that is not necessarily connected to an independent reality or a creator. The text does, however, inherit the conventions and inferences of the language it employs. To use an example from the history of art, Botticelli's *Birth of Venus* is neither a function of an independently existing reality nor is it necessarily a product of the artist's imagination. Its codes of colors, lines, arrangements of forms, presentation on a flat surface of a particular dimension—all work together to confer meaning. And further, there are Renaissance substances, such as the orthodox manner of arranging the composition around the central figure, which affect our interpretation of the work of art. But before we attempt this "uncovering" or "decoding," we have to defer to Jacques Derrida, who explains why we never can come to a decidable interpretation or understanding of this or any other cultural artifact.

Saussure's lectures led the structuralists to find definable, limited, comprehensible meaning in a text, as suggested in the previous paragraph. Derrida opens the text and lets meaning spill out, "disseminate" as he says. The reason for this is related to what I wrote previously: Words get their meanings by interacting with other words (something similar can be said about images). Every word in a sentence leaves its traces on the word behind, and is open to the word ahead. Every word marks or is marked by other words. Only within the web of the total language can any one element have (partial)

meaning; and since language is, theoretically at least, always open—there never is a final word—meaning is contextualized and deferred. When you look up a word in the dictionary, you find other words, which in turn have to be defined. The process goes on and on. This probably does not sound too surprising to anyone familiar or unfamiliar with literary criticism. Without some belief in God, or the Idea as first principle, or a "transcendental signified"—to use Derridian language—we realize that meaning is evasive, contingent upon our readings and other circumstances, other meanings, human error and human desire. Many undergraduates, for instance, already and wholeheartedly believe that literary texts and works of art are subjective and open to many readings, maybe any reading. But Derrida and the deconstructionists push this ordinary "subjectivity" in some radical directions, while simultaneously requiring intellectual rigor to avoid sloppy thinking.

I would like to summarize here some of the implications of deconstruction for the "text," by which I mean a piece of literature—or any writing, including this one, for that matter—or a work of art. But first, a reminder: I am simplifying an involved critical strategy about which books have been written. Also, I should acknowledge that, although there is not the space to offer a philosophical defense or present counterarguments, desconstruction has stirred up real philosophical anger and has been subject to some vicious attacks. In general, then, desconstruction emphasizes the following:

1. **Meaning.** It is never clear, sufficient, inherent in the text, identical with itself; it is always suspended and deferred.
2. **Instability.** Language and art are not determined, limited, or stable. Things tend to fall apart. Neither language nor art can express inward thoughts and make them external and comprehensive.
3. **Unreality.** Language and art are not about reality.
4. **Presence.** It's absent. Meaning is not present in the work of art or word. What is present in the artist's or writer's mind does not appear in the text. Meaning isn't in the word or image or the brushstroke or the chiselmark or the masonry. Derrida borrows Heidegger's phrase "the metaphysics of presence" to describe the way we thought literature, art, and human discourse in general worked. But, we have been wrong. There is nothing outside of us to center meaning, determine indwelling significance. If there were presence, the speaker could utter what he or she really means, and have it come out pure and unmediated. The artist could paint what he or she exactly proposes, and have it appear perfectly realized on a canvas. Presence enables the artist to have an intention that he or she expresses; presence declares that intention is the real motivation for the work of art, an intention that can in fact be found in the text. But all of this, according to the post-structuralists, is an illusion: There is no intention, there is no presence. So when a

reader responds to my critique of a work of art with: "Do you really think that's what the artist intended?" (this being said with apparent impatience, disdain, and disbelief), I can respond that he or she is merely deluded by a desire for the metaphysics of presence.

5. Logocentrism. This is a term favored by post-structuralists because it is ancient and broad. Logocentrism means (insofar as any word has meaning) that our culture—the European-American one—desires truths, essences, presences, meanings, and that the Word (Logos) can hold all of these. The same could be said for the the image (eidos-centrism? imago-centrism?). But it is not to be.

6. Binary oppositions. Here we come into the heartland of deconstruction, the place where this critical approach does its work. For Derrida, the notion of ideology implies hierarchies, systems in which objects, ideas, attitudes, and people are ranked by level of importance. The class system in social history is an obvious example; the so-called ecclesiastical and celestial hierarchies in the Roman Catholic Church is another famous instance. But hierarchies are often simple pairings: either/or; light/dark; truth/falsehood; cosmos/chaos; rational/irrational; science/superstition; man/woman—with the first term privileged over the second. Let's take the last example and show how the deconstructionist deals with it. A patriarchal society accords man his priority over woman: In order for man to be the privileged member of this polarity, he must gather all power to himself, denying any to woman. He is central; she is marginal. He is essential; she is supplemental. As he is elevated, she must be repressed. Derridians point out, however—and with pleasure in their irony—that man requires woman for his status, his identity. Man's opposite—the other—has an enormous power in determining his identity and therefore his destiny, because in order to know what he is, he must know what he is not. And because woman's otherness can in fact be threatening, man must push her away, attempt to banish her. But he cannot. What he fears in woman is probably something he denies in himself, so woman is in fact part of man—as man is part of woman—and the presence of each in the other creates eternal vigilance, a need to police the borders, so to speak. Like the torment of an occupied city where uprisings against the oppressor are frequent, a man's soul suffers in its struggle for control. In a sense, then, the master/slave relationship is shown not to be so simple. The victimizer is in turn victimized by himself, by his need for hierarchy and control. His privileged role in the hierarchy is threatened, undermined, subverted, sometimes inverted.

A literary text is largely about its meanings; subvert and disassemble them, leaving their parts scattered about in a state of indeterminancy and undecidability, and you've done much to annihilate the text. An art object is dif-

ferent; it has a tangibility, a presence that can be irrefutably physical (certain examples of conceptual and performance art do not have this same status as objects, admittedly). With your knuckle, tap on a Greek statue (keeping an eye out for the museum guard), and you can reassure yourself that the statue is there (although the deconstructionist might ask whether the physical object is identical with the work of art). Just the same, it seems that the visual arts resist some of the annihilating effects of deconstruction. But discourses on art—interpretations, historical assessments, identifications of subject matter, attributions, and so forth—do not escape the hydra-headed deconstructionist, as we will see.

A famous example of classical Greek art, one which supposedly embodies the essence of "order" (as opposed to disorder), is Polykleitos' *Doryphoros* (the *Spear-Bearer*, fig. 5, p. 36).

As I discuss in the section on ancient treatises in art, the *Doryphorus* was made by Polykleitos to exhibit certain principles set forth in his book *Canon*. Neither the text nor original statue survive; however, other ancient sources do comment on Polykleitos and his theory. These sources allow us to reconstruct (before we deconstruct) Polykleitos' theory. *Canon* was about the necessity for and meaning of proportionality in a work of art. As I quote earlier, Galen writes that beauty consists "in the proportions not only of the elements but of the parts, that is to say, of finger to finger and of all the fingers to the palm and wrist, and of these to the forearm, and of the forearm to the upper arm, and of all the parts to each other, as they are set forth in the *Canon* of Polykleitos."

This use of commensurability reflects the Greek view that the world of appearances has some underlying cosmic system. Things are ordered. If the arithmetical and geometrical appear in a work of art, then that object is connected to the permanent values that constitute the universe.

Derrida's strategy for unraveling a text begins usually with some detail that at first appears insignificant or marginal; he tries to work that detail back through the body of the text to show how it can invalidate what apparently was the original enterprise. So I would begin with a fact that rarely is discussed when explicating the meaning of the *Doryphoros*, namely, the absence of the original statue and text. If indeed the *Canon* was about perfection, order, and stability, what could more ironically betray that discourse than its disappearance? Admittedly text and image survive in traces, in reconstructions by other writers and in statuary, but that merely demonstrates the dissemination of the original image/meaning, which cannot be recovered. A text and statue embodying permanence become the victims of impermanence, chance, unpredictability, chaos, destruction. The surviving examples of the statue, some made by the Romans, the one illustrated here reconstructed with the intention of capturing Polykleitos' original idea, are inadequate. None really demonstrates the lost *Canon*. And even if the bronze version achieved perfect geometrical commensurability, would there be an exact correlation between

statue and text, word and image? No. If we could infer a coherent system of symmetria from the statue, would that somehow exhaust the work, use up all possibilities of dealing with it? The statue itself overwhelms the interpretation: Its irreducible presence as an object annihilates the idea of presence in the traditional critique. In other words, whatever we say about the *Doryphoros*, we can never capture the statue entirely with words.

We know through inference that the *Doryphoros'* counter-poise is a convention of mid–fifth-century Greek sculpture; there are numerous examples of this contrivance appearing at about the same time. Can one say with certainty then that this arrangement of a figure means order? As a studio practice, it was relatively common among sculptors, so how could it have a set, determinate meaning deriving from principles supposedly laid down by a sculptor in a book? And, if you were to look at one of the knuckles, supposedly the locus for the measuring off of those intervals which confer meanings of symmetria on the entire figure, would your vision adjust in the proper way? Would you see simply a narrow and turned bronze surface? A certain configuration of material, scratches and creases, that through an imaginative leap you could translate as a human knuckle and section of finger? Or an embodiment, instantiation, or presence of symmetria? All three simultaneously? In any order? Or is there a suspension and undecidability of meaning here—an *aporia*, in the language of deconstruction? Perhaps the mute presence of the statue is enough. Decisions about meaning can be deferred. In fact, the process of interpretation can continue indefinitely.

Pablo Picasso's *Les Demoiselles d'Avignon* (fig. 34) creates a paradox because, in a historical sense, it deconstructs. Compare the unity and continuity of space in Raphael's *School of Athens* with Picasso's whopper-jawed room. In the tradition of the Renaissance, figures that occupy rational, perspectival space comport themselves with a certain rhetorical dignity, and have bodies that appear to be dense, continuous, integrated, stereometric. Picasso's women, apparently prostitutes, pose themselves provocatively for the male gaze, and have such rearranged bodies that even their eyes do not remain on the same plane. This is probably the first example of cubism: a style and conceptual form that confronts order and rationality, logical representation, and the embodiment of Western values so necessary to European painting since the Renaissance. Picasso's provocation and gesture of defiance are against his contemporaries and predecessors. He is lashing out as a result of his own "anxiety of influence," as Harold Bloom might call it. So he attempts to deconstruct a tradition in the following ways.

First of all, Picasso fractures the space; it is no longer Euclidian. It is as if he had painted the scene on a glass plate and then dropped it. The painting has that sense of disruptive violence. The women are neither muses, saints, allegorical representations, or biblical: They are, according to tradition, denizens of the prostitute district (Rue d'Avignon) in Barcelona. In a gesture meant to disconcert European sensibilities, Picasso renders the heads of the

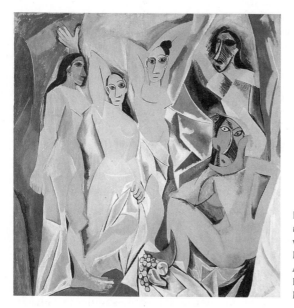

Figure 34. Pablo Picasso, *Les Demoiselles d'Avignon*, 1907; oil on canvas, 8' x 7'8". Collection, The Museum of Modern Art, New York. Acquired through the Lillie P. Bliss Bequest. Photo: The Museum of Modern Art, New York.

figures as African masks, thereby transgressing his own Western tradition. In the binary opposition of civilization against primitivism, he chooses the second and normally discredited term. So in these and many other ways, it is Picasso undermining a text (tradition) inscribed with a multitude of consistent, stable values persisting at least since the Renaissance and originating in antiquity. So how do we deconstruct the arch-deconstructor?

According to Derrida, any text is subject to reconsideration and deconstruction. Derrida has in fact written about the visual arts in *The Truth in Painting*, a curious book that contains an essay on the parergon, or frame, and a long, apparently rambling (although things are not always what they appear in Derrida) panel discussion—in which Derrida is all of the panel members—on Vincent van Gogh's *Old Shoes with Laces*. It's worth pausing here a minute to look at his method, or to put it in Derridian language, his "strategy." The panel discussion, entitled "Polylogue for $n + 1$ Female Voices," considers the work of art intrinsically and extrinsically: The speakers or voices go on for more than 120 pages asking questions. First, they ask seemingly endless questions about shoes in general, about these shoes, about whether or not they're a pair, what their relation to the ground is, and so on *ad nauseum*. Then there are questions about this object as a canvas with a painted representation of shoes; these questions are not so extensive. Thirdly, from an extrinsic perspective, the poly-panelists worry the interpretations put forth by Meyer Schapiro and Martin Heidegger, who for reasons that the speakers cannot quite determine spent a great deal of time writing about who owned the shoes: van Gogh or some peasant. Derrida does pre-

sent one axiom: "the desire for attribution is a desire for appropriation." In other words, the actions of Heidegger and Schapiro have little to do with the work of art as a work of art. Their acts of interpretation are, in part, a desire to own the work, to have a lock on the truth about the work, and to struggle with one another. By having these $n + 1$ female voices carry on a meditation at length, a sustained reflection, a quizzical investigation of motive and meaning, Derrida greatly undermines the whole point of the arguments about this painting: about who owns the shoes. By producing a myriad of questions, Derrida causes us to wonder why, other than for reasons of convenience, we ask so few and such limited questions about art and critiques of art.

Perhaps a similarly long and exhausting (but of course never exhaustive) conference on the meaning of Picasso's images in *Les Demoiselles d'Avignon* would eventually undermine the normal critique. What did Picasso know and think about African masks? Has he captured anything essential about African masks, or has he misinterpreted them? What part of Africa are the masks from? How are these different from Iberian masks? What and why is something being masked? What about the history of European colonization of Africa? What visual codes make these masks African rather than Spanish? How can he be reacting against a tradition that isn't in the painting? What agenda or ideology leads to an insistence upon the primitivism of this painting? Why was Picasso and why are we are so invested in the values of primitivism? Is the very use of the word "primitivism" and the depiction of African masks not evidence of Western bias, distortion, and condescension? Why are some men afraid of women? Was Picasso afraid of women? Why? Do women represent primitivism? Are we proud of our fear of primitivism? Who are "we"? Do we (whether male or female) deny our attraction to prostitutes? Are we proud of denying our Western heritage? Is it "our" Western heritage? Does any "we" really have an identifiable heritage? And so on and so on. It seems to me that one could simply wear out both speaker/writer and auditor/reader with these questions. Derrida's technique seems to be one of critical attrition. Perhaps the entire enterprise is, as Derrida suggests at one point, hallucinogenic. And circular too. Maurice Blanchot commented on the difficulty, really the impossibility, of coming to conclusions because the philosophical (and deconstructive) enterprise remains open, sometimes in a paradoxical manner: " 'I must explain things clearly to you,' I said. 'Up to the last moment, I'm going to be tempted to add one word to what has been said. But why would one word be the last? The last word is no longer a word, and yet it is not the beginning of anything else. I ask you to remember this, so you'll understand what you're seeing: the last word cannot be a word, nor the absence of words, nor anything else but a word.' " (Maurice Blanchot, *Vicious Circles*, trans. P. Auster. Tarrytown, N.Y.: Station Hill Press, 1985, pp. 52–53).

Derrida wears out traditional, thematic interpretations that claim to explain the work of art. The questions he asks and the complex issues he con-

siders reflect on van Gogh's painting as a work of art, and bring forth issues that thematic criticism excludes. Good criticism is long, perhaps tiring, and never final. Easy answers are like junk food: desired but undesirable; popular but ultimately unsatisfying.

◆

Bibliography

ABRAMS, M. H., and JAMES ACKERMAN, *Theories of Criticism: Essays in Literature and Art.* Washington, D.C.: Library of Congress, 1984.

CULLER, JONATHAN, *On Deconstruction: Theory and Criticism After Structuralism.* Ithaca, N.Y.: Cornell University Press, 1982.

DERRIDA, JACQUES, *Of Grammatology.* Baltimore, Md.: Johns Hopkins University Press, 1976.

——, *Writing and Difference.* Chicago: University of Chicago Press, 1978.

——, *The Truth in Painting* (Trans. G. Bennington and I. McLeod). Chicago: University of Chicago Press, 1987.

EAGLETON, TERRY, "Post-Structuralism," in *Literary Theory: An Introduction.* Minneapolis: University of Minnesota Press, 1983, pp. 127–150.

NORRIS, CHRISTOPHER, *Deconstruction: Theory and Practice.* New York: Routledge, 1991.

15

From Word to Image: Semiotics and Art History

It may seem that contemporary movements in critical theory sweep through the academy like so many new fashions announced in the fall issue of *Glamour* magazine. The novel positions tend to take on lives of their own, like the older artistic "movements" of the early twentieth century. Critics establish turf and battle plans, draw adherents, offend the old guard, demarcate zones of "discourse," create tensions, and become self-conscious. Shortly after semiotics was "introduced" to professional art historians in the pages of the *Art Bulletin*, several letters were published that took issue with the polemical nature of this application of semiotics to works of art. One art historian observed that Norman Bryson and Mieke Bal (in their article "Semiotics and Art History") had probably made semiotics more argumentative and controversial than was necessary. Wrote another traditional and highly respected scholar:

> The present proponents of semiotics seem too indifferent to concrete evidence, to research, and to verification, to lead one to believe in a fruitful application of their theories and methods to works of art, to artists, and to the problems of art history. They are not concerned enough with the definition of key terms and their sign processing too often seems conceived in terms of verbal texts or derived from linguistic theories not always specifically applicable to works of art, as if the latter need not be accounted for directly, but merely by transfer or implication. (Francis Dowley, letter to the editor, *Art Bulletin*, September 1992)

But for all this brouhaha and seeming trendiness of critical theory, the practitioners usually take seriously the problems of interpretation and the issues of theory in general. For all the claims of hucksterism and opportunism, those who are interested in critical theory care deeply about literary texts and works of art and the ways that the human mind confronts, sees, reads, reacts

to, and values these human products. For all the numbing jargon, the impenetrable prose, the suspicion on the part of some that these critics are darkening the picture so as to hide their own ineptitude at clear thought—for all the real and imagined misdeeds and shortcomings—contemporary theory is earnest business, and it isn't going to go away.

Semiotics, like Marxism, Freudianism, feminism, deconstructionism (to name the most prominent), proposes a critical approach that goes beyond, and even denies, the notion of common sense and a natural order in art. It is, as a scientist might say, counterintuitive. Semiotics offers the reader and viewer ciphers and cryptographic systems for decoding and uncovering hidden meanings: What we think we mean is not what we really mean. For these reasons, in part at least, semiotics joins the ranks of contemporary theory, which tends to be ironic and disconcerting. There are, as we might expect, advantages and disadvantages, gains and losses, clarifications and obscurities associated with this method.

As I note in the section on deconstruction, semiotics comes out of linguistics (which deals specifically with the verbal and the written), especially from the theories of Ferdinand de Saussure, whose *Cours de Linguistique Générale* inaugurates, constructs, and grounds the modern notion of semiotics. He's the source. Although the implications can be wonderfully complex and subtle, the basics of Saussure's linguistics are relatively easy to grasp. Positing his ideas in terms of written and spoken language, Saussure conceives of the sign as composed of two things: the signifier and the signified. The signifier is the spoken word (noise) or written symbol (mark on a surface); the signified is what the signifier means or signals. Meaning of course is always contingent upon the shifting ground of language itself. As is often noted by critics, we look up a word in a dictionary only to find other words which must in turn be looked up. The process goes on and on. One word, such as "brillig," is what it is (whatever it may be) because it isn't "brunswig" or "beetlejuice." Bats are not cats; dogs are not bogs. Language lives in the realm of "difference," that crucial notion of modern critical thought. Saussure said that "in language there are only differences. . . ." By creating a system of words we create meaning. By themselves, words are like nuts and bolts shelved in some mechanic's storage case: Until they help to fasten together a form, they don't do anything. They're abstractions. In fact, words are so arbitrary, they don't even reach the apparent intentionality of nuts and bolts. Language isn't motivated: there is no logical connection between the arrangement of the letters in "baseball" and the rawhide-covered spheroid object, for instance.

Well, what's the big deal here? So language is arbitrary, the connection between signifier and signified is unplanned, accidental, random. So what? I believe that what makes this realization significant has to do with our desire for a natural, common-sensical, immediate way of knowing, of being sure about the world. We want things to be what they seem; life's meaning to be

obvious, always present, self-evident. The word "boy" and a painting of a boy running in a sun-drenched, grassy park should be naturally and spontaneously connected. And we should need only celebrate; to inquire further should be not only unnecessary but tragic. Would that it were so.

For the purposes of art history we have to make the leap from the verbal or linguistic system (with all of its artificial structures) to the visual field in order to find once again not natural, imitative art, but conventional forms arranged according to certain kinds of codes. Visual art, like much (perhaps all?) literature, is fiction. A painting may be a real object, but we don't necessarily look at it that way; rather, we tend to look through its surface (in the case of representational art) and see another reality, one that we know isn't real, but one which we may want to be real. At the same time, the critical viewer of art notices and analyzes how an image is refracted or represented: He or she pays attention to style and visual conventions. Because of the tradition of connoisseurship and the interest in style, art historians have for a long time been semioticians of sorts. The differences between formal or stylistic analysis and the critiques offered by semioticians are, however, important.

One critic, trained in comparative literature and linguistics, who writes extensively about the history of art is Norman Bryson. His book *Word and Image: French Painting of the Ancien Régime* deals directly with how a knowledge of linguistics (and especially semiotics) can affect our analyses of works of art.

Bryson points out that there is an extensive history in Western culture of the intimate association between word and image. Because so much of Christian art functioned as an illumination of sacred text, we have become, as a literate culture, habituated in the process of connecting text with image. A painting of the Crucifixion of Christ derives from a narrative that first appeared in the Gospels of the New Testament. Although one can think about and look at a painting of the Crucifixion with no knowledge of the Christian story, doing so is not consistent with how meaning is construed by observers and viewers in the Christian tradition. Understanding of the text affects your understanding of the image. The meanings of word and image intersect. And, since it came first, the word takes precedence. As the Book of John opens, we read: "In the beginning was the Word, and the Word was with God, and the Word was God." "Word" here translates the Greek *Logos*, which also can mean "reason." Christian theologians extended the use of *Logos* to indicate Christ, the Incarnation of God: God made flesh. So we can see that, in the Western intellectual tradition at least, "Word" came to be invested with powerful notions such as "beginning," "reason," "God," "Christ." On the other hand, images were for those who couldn't read. So not only were images derived from texts, they had a distinctly inferior quality.

In Bryson's *Word and Image* he posits a visual semiotics in which there is an essential distinction between the "discursive" and the "figural" image, which in a loose sense are comparable with "word" and "image." The opposition between discursive and figural is not the only term possible to use; it

happens to be the one Bryson finds useful for discussing seventeenth- and eighteenth-century French art. He makes the assertion in a later study that "It still needs saying: painting is an art made not only of pigments on a surface, but of signs in semantic space. The meaning of a picture is never inscribed on its surface as brush-strokes are; meaning arises in the collaboration between signs (visual or verbal) and interpreters" (*Looking at the Overlooked: Four Essays on Still Life Painting*, Cambridge: Harvard University Press, 1990, p.10). We can't help but "read" paintings—even abstract expressionism—as so many signs; it just seems to be our nature—and our historical circumstance. As Bryson puts it, ". . . there is no viewer who looks at a painting who is not already engaged in interpreting it . . . " (ibid.).

By "discursive" Bryson means the images that draw close to language, that derive from prescriptions handed down by tradition or some contemporary authority, such as the French *Académie* in the seventeenth century. A discursive image is the most conventional kind, one whose appearance is well established by custom—like a man standing in contrapposto. For instance, Polykleitos' *Doryphoros* would be a discursive image: Its whole appearance was predicated upon a text, the *Canon*. Images that derive from written texts (histories, literature, the Bible, etc.) also have a strongly discursive quality by virtue of the story they "tell." A figural image is one that escapes determination by language. Watteau's *L'Indifférent* (fig. 35), as an opposing

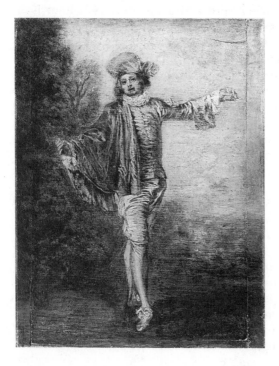

Figure 35. Jean Antoine Watteau, *L'Indifférent*, c. 1716. The Louvre, Paris. Photo: © PHOTO R.M.N.

example to the *Doryphoros*, is more figural than discursive because it is not arranged according to the contrivance of contrapposto (in fact, the young man assumes a ballet position), does not reflect any known text, and is not constructed according to academic principles of proportionality and the "ideal" figure. The figure is still semiotic—it is an object of interpretation, it has meaning—but it no longer is linguistic or discursive—that is, largely grounded in language.

It is impossible in the space available to provide a full explication of Bryson's "discursive" and "figural," which are notions that evolve in admirable complexity throughout his book. My treatment here is necessarily brief, simplified, and somewhat reductive. But I hope it gives an indication of how semiotics can operate in art history.

Bryson, along with Mieke Bal, has written more generally about the function of semiotics in art history. Together they published an article in the *Art Bulletin*, the most prestigious and traditional of art history's journals, that provides a kind of sanction and official recognition of semiotics as a legitimate critical tool in the study of art history.

The American philosopher, mathematician, and physicist C. S. Peirce (1839–1914) formulated a semiotics that may be more adaptable than Saussure's linguistics to art history. Generally speaking, Peirce's notion of the sign system is triadic: There are abstractions (ideas), objects, and the perceiving mind. And there are three aspects to a sign: the iconic, the indexical, the symbolic. Let's pass over the subtleties and details of Peirce's overall semiotic system (it's not at all easy to follow: He had a basic system of sixty-six sign categories, an expanded one of nearly 60,000) and concentrate on some of the practical aspects of his terminology.

First of all, it's important to point out that there is not the same degree of arbitrariness in painting or sculpture as there is in writing. A recognizable image of a woman bears a closer relationship to a living woman than does the combination of letters "woman." Which is not to say that painting and sculpture are natural copies or imitations of "real" objects. They aren't. As Peirce acknowledges, "every material image is largely conventional in its mode of representation" (*Collected Papers*, Vol. II, p. 276). But there's more than an accidental and uncertain connection between a representational image and its object. The visual signifier can be termed "motivated," whereas the verbal one cannot. By positing the three-part scheme of icon, index, and symbol, Peirce gives us tools that work more handily than Saussure's signifier/signified paradigm and that grant the similitude between image and recognizable object.

Peirce's first type of sign, the icon, refers directly to its object. The image on the U.S. half dollar pertains iconically to the historical personage John Fitzgerald Kennedy. It looks like him. The indexical relationship "points" to or results from something, as the index finger directs our attention toward an object or an event; an entry in the index of a text tells the

reader where to find a reference or name; smoke means fire. A brushstroke can be the tracks or index of an artist's hand; further, a pictorial effect such as *sfumato* (smokiness, as in Leonardo's *Mona Lisa*) can be an index of mood or sensibility. The symbol comes closest to Saussure's conventional signifier: Rather than looking like its object, it alludes to it by virtue of a tradition, a rule, a compact. The dove is a well-established symbol of the Holy Spirit; the First Person of the Trinity; irises of Mary's virginity. The list can go on, of course, and fill encyclopedias. Symbols are closely bound to language, and therefore tend to be, as Bryson would explain it, discursive.

Let's expand our discussion and illustration on Peirce's icon/index/ symbol paradigm by considering two paintings that differ significantly in terms of style, content, and meaning. The first example is traditional and European; the second is avant-garde and American.

Jan van Eyck's *Arnolfini Wedding Portrait* (fig. 36) is a painting made in Flanders (corresponding roughly to modern Belgium) in a period sometimes referred to as the Northern Renaissance. On the iconic level, we recognize a room with two figures in it. The man and woman, rather stiff and self-conscious, stand in a comfortably furnished bedroom typical of the early fifteenth century in Flanders. His expression is pensive and his gesture formal

Figure 36. Jan van Eyck, *Arnolfini Wedding Portrait*, 1934. The National Gallery, London. Photo: Reproduced by courtesy of the Trustees.

(the iconic does permit us to interpret a face as "pensive" or "happy," a gesture as "formal" or "spontaneous"). She, with her hair fashioned into horns, pulls up a length of her ermine-lined robe, sways forward at the hips—which makes her seem almost pregnant—and assumes a shy countenance. Clogs to one side, a dog at their feet, and fruit on their windowsill contribute to a sense of the ordinary, comfortable, and domestic. A pale light enters from the window and suffuses the room with the sense of a particular time and creates a believable space.

In my description of van Eyck's *Arnolfini Wedding Portrait*, I'm assuming that you will see pretty much the same thing as I do. I'm presupposing a community of viewers who can look at a flat surface covered with pigments in such a way that recognizable, three-dimensional images conveying understandable feelings emerge. This is the first step in our decoding of the painting, a step that seems relatively simple and automatic. The next level presents a few more problems, but nothing particularly difficult. Imagine a wiring diagram, a schematic of a VCR, for instance. Although this blueprint doesn't look like the machine into which we insert videotapes, it is an iconic representation because it reveals the significant, operational structure of the object. In a painting, we might notice the relation of lines and shapes. Here we have the structural approach: How does the painting hold together, how are things balanced (we can include color in this discussion as well), what is the effect of its structure on the character and impact of the work of art? Does the artist arrange the space according to a consistent scheme of linear perspective (actually, studies have shown that there is more than one vanishing point here)? Are the lines mostly vertical and horizontal, parallel or perpendicular? Do we have a sense of the limited and contained? We are still dealing with representation, but we have examined the skeleton beneath the skin.

An index does not resemble its object, but it does refer, oftentimes obliquely, to it. Perhaps the best way to consider the indexical in visual art is to think of it in terms of style (see the chapter on connoisseurship, style, formalism). Style, as we know, indicates the manner in which a painting is executed, and indexically signals the presence of the hand of the artist. Style points back to the creator. Van Eyck used oil paints with extraordinary finesse to recreate the visible world from its minutiae (note the details of the dog's fur and the weave of the garments) and from its light. This ability to impress the beholder with remarkable detail is arresting and has something to do with the significance of the work. What does this obsessive recording with paint of the visible world signify? Is it a matter of faith, of a belief in the world—not just in men and women—as divine image?

Because of the amazing precision in painting the tiniest datum of visual experience, van Eyck's style seems almost not to be a style. It's hard to see the artist through his brushwork—except by implication. What would you think of someone who could sign his or her name on a personal check with all the mechanical uniformity of a typewriter? Does that really constitute a signa-

ture? Technically yes, if it came from the person's hand and was signed consistently in the same manner; but in terms of our normal experience, it does not qualify as a signature. A handwriting expert would be baffled by such a mark, except to observe that this must be a marvelously dexterous and perhaps very controlling person, an individual who prefers to withhold his or her identity rather than reveal it. At any rate, the art historian will accept van Eyck's miniaturist's technique as a style, per se, be it ever so self-effacing and "objective."

Peirce writes that an index is "a sign, or representation, which refers to its object not so much because of any similarity or analogy with it, nor because it is associated with general characters which that object happens to possess, as because it is in dynamical (including spatial) connection both with the individual object, on the one hand, and with the senses or memory of the person for whom it serves as a sign . . ." (*Philosophy of Peirce*, p. 107). Not only does this explanation permit us to consider style as part of the indexical sign, but also it opens up the whole issue of context, because you and I as viewer can be aware of circumstance and setting, which make a call upon our memory. The contextual, when thus loosely but nonetheless legitimately construed, can refer to the artist's life, patronage practices at the time, as well as the artistic, social, and political milieu.

It is a daily occurrence at the National Gallery in London for a spectator to draw close to the *Arnolfini Wedding Portrait*, lean over, and look as intently as possible at the details, all the while shaking his or her head in near disbelief that any artist could have gotten so much into such a small painting. The viewer's gaze and his or her wonder at van Eyck's skill are legitimate events for the semiotician to study when considering the indexical significance of a painting.

The indexical can also include documents relating specifically to this painting. In fact, some interesting research has gone on in this area of documentation and context. An ingenious and classic study of van Eyck's panel, to which all subsequent studies refer, was written by the learned German art historian Erwin Panofsky.

From the inventories of Margaret of Austria, who owned the painting in the sixteenth century, we read about "*Hernoul le Fin avec sa femme*" (that is, "Arnolfini and his wife"; a later inventory says that they are touching their hands). As Panofsky points out, those references in the inventories almost certainly identify this particular painting and refer to a man named Giovanni Arnolfini (inconsistencies of spelling are common enough in the sixteenth century) and his wife Giovanna Cenami. From accessible and reliable documents of the fifteenth century, we know a fair amount about these two. He was an agent in Bruges of a prosperous Lucchese family; she came from French and Italian parents of similar fortune and dignity. As the Lucchese community in Bruges was relatively small (perhaps no more than a few dozen, according to the records, according to Raymond de Roover, *The*

Bruges Money Market Around 1400, Brussels: Paleis der Academien, 1968, p. 28, note 10), Panofsky speculates that the couple may have been both lonely and private. He argues that they chose to be married in their own home without a priest. This painting, then, is the certificate of marriage.

With this documentary evidence and a knowledge of the practices of the Roman Catholic Church, Panofsky moves smoothly to the next level of inquiry, the plateau of signs: the symbolic. Certainly the most immediate signal that something out of the ordinary is happening is the arrangement of the two figures. Giovanni takes Giovanna's right hand in his left, then raises his other hand. Panofsky interprets the joined hands as *fides manualis* ("faithful partners") and the raised forearm as *fides levata* ("constant helpers"), both actions associated with the joining in marriage and the taking of an oath. The single candle burning in the exquisite chandelier symbolizes, still according to Panofsky, the all-seeing eye of God and, in addition, the Brautkerze or marriage candle. That no priest is present is consistent with Catholic practice before the Council of Trent. All that was necessary was that there be a qualified witness (*testis qualificatus*), given to us deftly by the mirror reflection in the background (we see two people occupying what is more or less our space) and the signature in legal script "*Johannes de Eyck fuit hic*" or "Jan van Eyck was here." And he dates it 1434.

This stage of interpretation creates more controversy, yet offers a fascinating insight into the artistic consciousness of fifteenth-century Flanders. Panofsky proposes "hidden symbolism," a strategy for interpreting common things as sacramental objects relating to marriage. The bed makes this a *benedictio thalamis* ("a nuptial chamber"); the mirror is a *speculum sine macula* ("spotless mirror," symbol of Mary's purity); the small figure on the headboard is St. Margaret, patron saint of childbirth; the dog is *Fides* (Fido), meaning faithfulness; the removed clogs, or pattens, signify the sacredness of the setting; the fruits on the windowsill recall our innocence before the Fall. Although not every object depicted is saturated with sacramental significance, the picture is transformed by this attitude of finding the divine in the ordinary. Panofsky relates how "disguised symbolism could abolish the borderline between 'portraiture' and 'narrative,' between 'profane' and 'sacred' art" (1953, p. 203).

Although articles have appeared that challenge Panofsky's identification of the subjects and suggest that no disguised symbolism exists, his assessment still commands general acceptance. A recent study focuses more on Giovanna than Giovanni and argues that what is represented here is not the actual marriage, but a document of the delivery, by Giovanna's father, of the dowry. Linda Seidel explains that this is "a financial transaction that is enacted as a marriage ceremony, wherein the bride's father is the understood payer and the groom the payee. The woman is the commodity or credit, the price of which has previously been negotiated in her absence" (p. 79).

It should be clear from this brief discussion that a semantic understand-

ing of a work of art does not guarantee a secure interpretation. There are stronger critiques and weaker ones; more insightful and complex commentaries, and those that are impoverished or misinformed. But utilizing Peirce's, Saussure's, or Bryson's semiotic tools does not result in the discovery of the essential truth. That remains—thank heavens—elusive.

Barnett Newman's monolithic paintings, such as *Vir Heroicus Sublimus* (fig. 37), can give fits to a Peircian critic. First of all, is there anything iconic here? What do we recognize other than flatness, paint, a couple of vertical stripes, and the shape of the canvas? Well, in a diagrammatic sense at least we can make some observations. This painting relates to a tradition of a rectangular support with some tincture adhering to its surface. In other words, this looks like a painting, we think of it as a painting, but it doesn't have the kind of images to which we can easily relate. That isn't much to go on; there are a lot of painted surfaces around. What's next?

Possibly we can say that this painting is not iconic, but indexical. Like a large finger pointing toward something else—the disembodied absolute, maybe (to borrow a phrase from abstract expressionism). It certainly doesn't point back to the artist in the same way that Jackson Pollock's paintings do. There's nothing very expressionistic about Newman's art.

The indexical sign here may have to be seen entirely in terms of context: the context of American paintings between 1945 and 1970, and the context of traditional "meanings" in Western art (these are just two contexts that strike me as significant; contexts can be multiplied almost infinitely). The art historian sets out the historical circumstances, examines the prevailing styles and movements in abstract art, and considers comments made by artists and critics. He or she understands that Newman's avoidance of tradi-

Figure 37. Barnett Newman, *Vir Heroicus Sublimus*, 1950–1951; oil on canvas, $7'11\frac{3}{8}''$ x $17'9\frac{1}{4}''$. Collection, The Museum of Modern Art, New York. Gift of Mr. and Mrs. Ben Heller. Photo: The Museum of Modern Art, New York.

tional iconic meaning is significant by virtue of its evasion. His art, although part of a tradition of abstract or nonobjective art, is new because we don't find there what we expect: something iconic (that is, something identifiable).

The context of abstract art and Newman's paintings in particular includes the viewer's expectations. The artist withholds something from us, and that piques our interest, heightens our perplexity. Deconstruction especially likes to play with the concept of *aporia*, the indecipherable and undecidable. Semiotics can in fact come to terms with the nondecodable by shifting our attention to the problems of decoding itself. We try to unravel and manage those things associated with the insoluble. A lot of literature and criticism deals with the undecidable, and in fact we can find pleasure in contemplating things that escape our understanding. C. D. Friedrich's *Monk by the Sea* gives us an image of a man withdrawn into the contemplative life trying to come to terms with the infinite, the sublime, the sea, and the universe. Maybe that's why Newman used such absolute terms as "heroic" and "sublime" in the painting I mentioned previously. In Stanley Kubrick's film *2001: A Space Odyssey*, scientists discover a monolith buried beneath the moon's surface. What does it mean? It is smooth, featureless, enigmatic. No explanation seems forthcoming. The rest of the film deepens rather than solves the mystery.

I haven't mentioned yet the symbolic aspect of Newman's painting, because there is no symbol. Remember, a symbol requires an agreement, a contract, a tradition of some sort that says what it means. You need a dictionary. No dictionary of signs, symbols, or emblems will help you with Barnett Newman. The imageless and largely undifferentiated surface of Newman's painting is clueless. If, in fact, the canvas is a signifier, it has no signified. But again, this lack of signification is not insignificant. Because the visual arts before the advent of modernism nearly always had an image that people could identify, we continue to be struck, even after nearly a century of abstraction, with the absence of identifiable symbolism in much of modern art. We may be forced to consider our semiotic approaches very carefully, but there's no call to abandon them.

◆

Despite the fact that one of the guiding principles of art, from antiquity to the nineteenth century, was mimesis (imitation), it nearly always has been the practice of critics and historians to go beyond the apparent or natural meaning of paintings and statues. One does not just say, when looking at the *Arnolfini Wedding Portrait*, "dog," "man," "woman," "bed." And there's more to an encounter with Barnett Newman than saying "Wow! Sublime!" The arrival of linguistics and semiotics in the academic disciplines of literature and art history has encouraged critics and historians to find more complex, subtle, and sophisticated modes of interpretation than had been usual before. Different and new terms such as "discursive" and "figural," and fairly common terms such as "iconic," "indexical," and "symbolic" are now

doing duty in art history. They assist us in our encounters with images and with our own language of art history.

◆

Bibliography

BAL, MIEKE, and NORMAN BRYSON, "Semiotics and Art History," *Art Bulletin* (June 1991), pp. 174–208.

BRYSON, NORMAN, *Word and Image: French Painting of the Ancien Régime.* Cambridge, Mass.: Harvard University Press, 1981.

CARLETON, DAVID L., "A Mathematical Analysis of the Perspective of the Arnolfini Portrait and Other Similar Interior Scenes by Jan van Eyck," *Art Bulletin* (March 1982), pp. 118–124.

CULLER, JONATHAN, *Ferdinand de Saussure,* rev. ed. Ithaca, N.Y.: Cornell University Press, 1986.

CULLER, JONATHAN, *The Pursuit of Signs.* Ithaca, N.Y.: Cornell University Press, 1981.

EAGLETON, TERRY, *Literary Theory: An Introduction.* Minneapolis: University of Minnesota Press, 1983.

KRAUS, ROSALIND, "Notes on the Index," *October* III (1977), pp. 68–81; and IV (1977), pp. 58–67.

PANOFSKY, ERWIN, "Jan van Eyck's Arnolfini Portrait," *Burlington Magazine* 64 (1934), pp. 117–128.

PANOFSKY, ERWIN, *Early Netherlandish Painting,* Vol. 1. Cambridge, Mass.: Harvard University Press, 1953, pp. 201–203.

PEIRCE, CHARLES SANDERS, *Collected Papers,* 8 vols. Cambridge, Mass.: Harvard University Press, 1931–1958.

PEIRCE, CHARLES SANDERS, *The Philosophy of Peirce* (ed. J. Buchler), London: Routledge & K. Paul, Ltd., 1956.

SAUSSURE, FERDINAND DE, *Course in General Linguistics.* La Salle, Ill.: Open Court, 1986.

SEIDEL, LINDA, " 'Jan van Eyck's Arnolfini Portrait': Business as Usual?" *Critical Inquiry* 16 (Autumn 1989), pp. 54–86.

16

Psychoanalysis and Art History

There are two remarkable but contentious attributes of psychoanalysis as a critical method in art history: the unconscious and the "reductive." To put it differently: The artist doesn't really know what he or she is doing, and it's all a result of illness anyhow. In the first instance, the critic must accept that much of what appears in a work of art was not present in the artist's conscious mind, and in the second, that art can be reduced to a few basic—but pathologically distorted—human drives.

In either case connoisseurs, critics, and art historians are not entirely comfortable. How can a philosophical point of view be built upon a "psychical phenomenon," as Freud calls it, that is not conscious and that therefore can't be studied in the light of day? And can art be dismissed as so many symptoms of a diseased mind? These are contentious issues, and they don't go away. The theories of Freud, like those of Marx, have been termed the philosophies of suspicion: Nothing is what it seems.

Sigmund Freud (1856–1939) was born in Moravia (modern Czechoslovakia) but settled while yet a child in Vienna, where he spent the greater part of his life. With the assistance of friends and many colleagues, he fled the Nazis and lived his last few years in London, dying there late in 1939 from cancer of the jaw.

Freud was a psychiatrist. His fame comes from devising the therapeutic method of psychoanalysis and from formulating a model of the human mind that includes the id, ego, and superego. Because they are not just geographical areas of the mind but are also complex conceptual phenomena—or even psychic systems (the language here tends to be figurative and metaphorical)—it's difficult to speak of these terms anatomically or mechanically. A primer of Freudian psychology will help us to understand his scheme and its importance to the study of art history.

The Id, Ego, Superego, and States of Consciousness

If we were to translate *Das Ich und das Es* into English (rather than into Latin, as we normally do), it would mean "The I and the It." The "I" or ego seems to be that part of ourselves that is most insistently the essence or core of who we are. You are you; I am I. But it's not so simple. In fact, what carries our identity in a more primary way is the "it" or id, the place of instinctive, that is to say libidinal, or sexual, desire. This is what we bring into the world from our genetic background—the nature of our parents and of our species. And here the "pleasure principle" reigns. As Freud wrote in the *Outline of Psychoanalysis*, the id "contains everything that is inherited, that is present at birth, that is laid down in the constitution—above all, therefore, the instincts, which originate from the somatic organization, and which find a first psychical expression here [in the id] in forms unknown to us" ([trans. James Strachey] New York: W. W. Norton, 1969, p. 2). Our very genesis, shrouded in darkness, brings with it needs (although not those of survival, exactly) with which we must come to terms whether we understand them or not. Freud believes in the instincts of eros (libido) or love, aggression, and Thanatos or death.

The ego develops from the id, seeks in some degree to control it, and is our interface with the world. It evolves with our life experiences. The ego "has the task of self-preservation. As regards external events, it performs that task by becoming aware of stimuli, by storing up experiences about them (in the memory), by avoiding excessively strong stimuli (through flight), by dealing with moderate stimuli (through adaptation), and finally by learning to bring about expedient changes in the external world to its own advantage (through activity)" (ibid., p. 2). The ego, although not always conscious (it can be dreaming or "preconscious") itself, controls consciousness, primarily with language.

As a result of our long period of childhood, we learn about ourselves in a larger sense from our parents, from our cultural, social, and economic milieu, and about educational institutions and history. This authoritarian system implants itself within us as the superego: our moral, ethical, and civilized center. Because it can be forbidding, insensitive, and demanding, the superego as the source of repression also can cause us some problems. While the ego seeks acceptable outlets for our erotic drives, the superego frequently wishes to frustrate and finally deny them. It can be like a domineering, scolding parent. When the superego functions in harmony with the ego, we probably will remain—barring other, accidental traumas—free of neurosis. The superego is our ego ideal.

Now for the matter of consciousness and its absence. One kind of unconsciousness is sleeping, a time when the ego rests and allows its boundaries to come down. The id creeps in, as does the superego, and we have a kind of war of the spirit. The id is insistent upon certain wishes, mostly erotic in na-

ture; the ego, being asleep, can do little to accommodate those desires; the superego tries to interfere. What results is a dream, a dream in which the images represent desire but, because the superego does not allow direct expression of forbidden urges, in a very indirect, symbolic way. Dreams therefore must be interpreted, symbols decoded, narratives unpacked. This is the work of dream analysis that goes on in a psychoanalytic session, or when a critic seeks to give to a painting a psychoanalytic interpretation.

There is also the more profoundly unconscious, that insensibility or nonawareness that, although informing dreams, lies much deeper. The unconscious and the id are intimately connected. Our basic drives for love and sexual satisfaction, and the desire to return to an inorganic state of nature (the death wish) constitute the primary stuff of the id. But there are other deposits down there, material placed by the ego in the process of its development. This is what Freud calls the "repressed," and it remains inaccessible to the conscious mind without the assistance of psychoanalysis. Repressed desires are those basic promptings that we become aware of in our external erotic development, but which our superego will not tolerate. Down they go again, to the id, where, however, they do not remain quiet and friendly. The disturbances they create—the difficulty with which the ego has in reconciling these repressed impulses of the id with the requirements of the world—lead to neuroses—and sometimes to art.

Because of the long period of attachment to our parents, we develop what are called "object relationships," that is, strong identifications with both father and mother. Fundamental to Freud's notion of the developing psyche is a particular "complex" coming out of these object relationships, the so-called Oedipus complex, deriving from the Sophoclean character who killed his father and married his mother. According to Freud, the young boy falls in love with his mother and sees his father as a rival. His love of his mother is erotic; his hatred of his father is murderous. But out of a fear of castration, the boy gives way before his father's power, relinquishes his mother, and represses his sexual urges. He then goes into a period of "latency," when his libido is not active. This is, according to Freud, an important stage for the male child. Similarly important, a girl has an Electra complex, which reflects her love of her father and her rejection of mother as a foe. Psychoanalysis focuses on infantile sexuality and the Oedipus and Electra complexes as sources of many adult neuroses. The artist fits into this scheme because, as Freud writes in his *Introductory Lectures in Psychoanalysis*, he or she is especially adept at "sublimation," which is Freud's term for how we express forbidden desires.[1] The artist cannot satisfy his or her wishes in the real world, so he or she turns to fantasy—the world of art. There the artist resolves conflicts, confronts anxieties, deals with complexes, and purges the psyche.

This makes a work of art sound like the jumbled detritus that emerges from an analytic session; and, in the Freudian sense, that's true. But Freud

also acknowledges that there are "formal and technical qualities" in art, or-
dering devices of greater importance to the artist than to the psychoanalyst.
It's safe to assume that these artistic qualities are to a large extent conscious
and intentional and therefore not strictly controlled by the unconscious
mind. Just the same, Freud believes that the artist fundamentally is not seek-
ing beauty, form, or disinterestedness; rather, he or she desires gratification.
The problems of life must be harmonized with primitive urges and with those
that are more conscious as well. The artist wants to solve the problems of life
to possess security, pleasure, power, fame, and—as Freud puts it in his
gender-specific way—the love of women. This means that the artist is a little
crazy, "close to" neurotic anyhow, and makes art for therapeutic purposes.
He or she uses style to make this sublimated process visible. Within the world
of the work of art, both the artist and we as spectators find consolation and
solace from the troubled world of reality.

As many critics point out, the problems here are those of the restrictive
and the pathological. Restrictive in the sense that all artworks seem to be, in
the Freudian view, direct results of an inner struggle between and among
competing forces (id, ego, superego) that remain unconscious; pathological
because this discord results from illness.

And the arts ensue from relatively few "unwell" springs. As Arnold
Hauser puts it in an important essay on Freud and art, the unconscious
mind seems to be driven by so limited a number of desires that it is relatively
uncomplex in its sickness. He writes, "If psychoanalysts never stop repeating
that writers and artists are concerned, above all, with repressed sexual
wishes, the Oedipus complex, the dread of castration, sadistic, masochistic,
or narcissistic trends, then perhaps the unconscious mind, as psychoanalysis
interprets it, does not contain much more than this." If that's all the uncon-
scious mind encompasses, then is it a basis for art historical theory and criti-
cism?

I've written about the Freudian interpretation of art in fairly negative
terms so as to capture the general tone of the venerable psychoanalyst's crit-
ics—and he has had many. But largely because of Freud's impressive mind
and extensive writings, psychoanalysis does remain an important form of crit-
icism. Even as the number of psychoanalysts declines in the mental health
field, the level of interest in Freud as an intellectual force remains steady.

Freud himself wrote several studies aimed at artists and artworks. The
most famous is probably his *Leonardo da Vinci and a Memory of his Childhood*, a
monograph that has been both savagely attacked and vigorously defended.
The attention this book has attracted is remarkable, perhaps because Freud
offended art historians by not following "good" art historical procedure (he
mistranslated some documents and generalized from scant evidence), and by
his attempt to explain paintings in terms of the artist's mind and childhood.

The attention this book has attracted is pivotal to an understanding of
the fortunes of psychoanalysis as a critical tool. Freud's approach to elucidat-

ing an artist and his work has been called "pathography" because it depends upon a description of the artist's disturbed or pathological mental state. Although *Leonardo* was published in 1910, which is before Freud had fully developed his complex system of the human psyche, it nonetheless reflects his method as a psychoanalyst. The idea of analysis is to study whatever evidence about the analysand (patient) is at hand so as to understand the sources of his behavior. What results is a narrative, called in psychoanalytic circles the "case study." The difference between the case study of Leonardo and the usual one is that the patient is dead. It's hard to listen to a recounting of dreams, be attentive to the "Freudian slips," and respond to the free association of an analysand who hasn't been around in centuries.

Freud himself said that biographers choose their subjects often because of hero worship, with the result that the author tends to idealize his subject. Then there is the other form of misrepresentation, in which the author sees in the subject a memory of his own father. Because of unresolved issues surrounding this object relationship, the author may try to dethrone or unmask his subject, to show him to be a fraud, to destroy him and therefore discharge a foe. In the introduction and conclusion to the study of Leonardo, Freud writes that he has no intention of dragging down the great artist and that he is in fact in awe of Leonardo. He qualifies the book by saying that he is not absolutely sure of his interpretations. We could speculate on Freud's unexpressed or unconscious motivations in writing about Leonardo (was it a matter of narcissism—Freud wanting to understand certain tendencies and behaviors of his own—or was he looking for his own father, whose death in 1896 had greatly shaken him?), or we can accept that Freud as author and analyst is sufficiently self-aware that he's not imposing (countertransferring) his own neuroses onto the subject.

At any rate, Freud seems especially concerned with Leonardo's dilatory work habits. With all of his artistic skills, why didn't he finish more paintings? Why would an artist spend so much time with scientific investigations? Why the consuming interest in flight? Why the odd smiles in his paintings? What about Leonardo's homosexuality? And, in Freud's reading of Vasari's account of Leonardo, he felt that the artist was something of an enigma even to his contemporaries. All of these questions and complexes fascinated Freud.

We can imagine with what delight and interest Freud came across the following passage in one of Leonardo's scientific notebooks. The artist recalled a childhood memory of a bird who came to his cradle and "opened my mouth with its tail, and struck me many times with its tail against my lips." That is certainly Freudian! The analyst saw this not as a real memory, but as an infantile fantasy (or "screen" memory) relating to the time Leonardo was suckling at his mother's breast. Freud mistranslates the Italian word *nibbio* as meaning "vulture" (actually it is a kite, a different kind of bird), which led him to other symbolic inferences. According to legend the female vulture requires no male partner, but is inseminated by the wind. This image Freud re-

lates to Leonardo's absent father. Certain documents also tell us that Leonardo's biological mother was a peasant whom the artist's father had impregnated. He later married another woman, who remained childless. A parish record shows that Leonardo at the age of five lived in his father's household with his stepmother and paternal grandmother. Freud concludes that Leonardo had been kept from his real mother by his stepmother (apparently his father wasn't around much), and therefore as a result of this fracturing of his original family, Leonardo formed an unusually desirous relationship to his biological mother.

From this scant biographical information, Freud develops an interpretation of the painting of *The Madonna, Child, and St. Anne* (fig. 38). St. Anne—in Freudian terms Leonardo's biological mother—is separated from the Christ Child (Leonardo) by Mary (Leonardo's stepmother). St. Anne's smile is both envious of the stepmother and blissful because she is near to the child that she had nursed but could not raise. Freud goes on to say that Leonardo as an adult remained sexually abstinent (and was a latent homosexual), and, because he had sublimated his libidinal desires (that remained unconsciously directed toward his first mother), didn't have enough strength

Figure 38. Leonardo da Vinci, *The Madonna, Child, and St. Anne*, c. 1508–1513 (?). The Louvre, Paris. Photo: © PHOTO R.M.N.

to finish his paintings. His energies went into scientific investigation instead, where he apparently was seeking some lost love object.

A schematic description such as I've just offered inevitably misrepresents Freud's discussion, which has been described by most commentators as beautifully written and full of spirit. But for all its charm and persuasion, Freud's study of Leonardo remains problematic. Even the artist's analyst wouldn't have been able to interpret his paintings with absolute assurance. After all, there is no secure way of determining a dead artist's intentions, whether conscious or unconscious. So what does that leave us with? Perhaps it gives us only an anachronistic reading using a dubious technique to understand someone who exists only as a memory, who left behind some paintings, more drawings, and a host of scientific manuscripts? Is there, in fact, a "truth" to be known about Leonardo? Or should we judge Freud's analysis of Leonardo on the same basis that we judge a piece of fiction, in terms of its artfulness, internal consistency, and its enlightening view of a novelistic character? One recent writer has endorsed a kind of "fictive" reading of *Leonardo*, when she concludes that ". . . I have called Freud's approach 'fictive,' not in a derogatory sense, but to emphasize its special qualities as an imaginative piece of interpretative writing that serves to raise, if it does not fully answer, intimate and searching questions about Leonardo and his work" (Spitz, p. 65).

Although much has been written about Freud as a source of critical discourse, applications to art history have been slight. According to Jack Spector, an authority on Freudian aesthetics, there have been few references to Freud in the pages of the *Art Bulletin*, American art history's most important journal. As he writes, "contributors to the first forty volumes make very little reference to psychoanalysis, and then only superficially or mistakenly." In the past twenty years or so, the discussion on Freud and psychoanalysis has picked up some, but mostly in the *Art Bulletin's* book reviews rather than in its articles. It's interesting that traditional art history, probably because the discipline believes itself to be grounded in verifiable documentation and truth, avoids psychoanalytic speculation.

Variations on Freud's basic psychoanalytic model are numerous. Freud laid enormous importance upon infantile sexuality and the Oedipus complex; as a result of this position, there were early defections by his followers Adler, Jung, and Rank, who felt that Freud had too greatly limited his method. Feminist writers have found the Oedipus complex "patriarchal" because of its bias against women (similarly there are few feminists who believe that a girl's development is controlled by "penis envy"). And although Freud considered the id as a powerful source of human behavior, many analysts in England and the United States have concentrated more on the ego, which has the virtue of containing a large measure of consciousness. The French psychoanalyst Jacques Lacan believes that one should return to an id-centered psychology, for which he posits a structural linguistics. The uncon-

scious has a language. Analysts find little to use in Lacan's writings, due in part, undoubtedly, to Lacan's dense and paradoxical prose. But literary critics, never ones to be put off by difficult language, have taken him seriously.

In addition, there has been serious debate about Freud's formulations on infantile sexual fantasy. In his earliest writings, Freud believed in actual childhood seduction, genuine sexual abuse by parents. But he moderated that finding and suggested rather that children manufacture their memories of incestuous sexual contact. Many of Freud's critics now say that there is an enormous difference between a fantasy and a reality and that Freud would not face up to the implications of this distinction. Whichever side one takes—fantasy or reality—it's not clear what that could mean for a Freudian analysis of art. It certainly has, just the same, fueled the public discussion of incest.

Conclusion

So long as art historians believe they are seeking the truth about a work of art, Freud's methods will not receive much attention in mainstream research. Many scholars have an aversion to psychoanalyzing a dead artist. Results are open to dispute. Freud's reading of an individual work such as Michelangelo's *Moses*, however, suggests a psychological (if not, strictly speaking, psychoanalytic) approach that does not take into account the artist. Freud writes a highly detailed and, from my point of view, persuasive analysis of Moses' movements, unintentional gestures, wrathful expression, and suggested rising from his seat, and Freud shows how these perturbations reveal a conflicted inner state for the great Hebrew prophet. The tradition of distilling an unambiguous mental state through gesture, facial expression, and placement of a statue or a figure in a painting is an old one. Xenophon quoted Socrates as saying that an artist should show the state or disposition of the subject's soul, emotions, and character. Traditionally, these inner lives have been shown in a manner that might be called "univocal"; that is, one emotion or one voice comes out to us as spectators. Michelangelo, in Freud's viewing, equivocates, reveals somehow an internal struggle that then is mastered by the mighty will of Moses. Could one find a similar conflict and final resolution in Michelangelo's *David*, I wonder? The point here is not to go into a detailed review of Freud's article on Michelangelo's *Moses*, but to suggest that a Freudian interpretive strategy can in fact be applied to a work of art rather than only to the artist.

There also has been the complaint that psychoanalytic interpretations of works of art tend to concentrate on recognizable imagery, what art historians call iconography, at the expense of style. Donald Kuspit, for instance, calls for a psycho-stylistic rather than a psycho-iconographical approach. The argument that Freud was insensitive to the stuff of art, the dense field of

color or obdurate mass of marble, has been made throughout the twentieth century, especially by those formalist critics of midcentury. And Freud himself admitted that he cared more for human interest in subject matter than for style and technique. Just the same, there's no need for a banal, simple-minded psychoanalytic reading of the subject in works of art. Although a psychoanalytic interpretation may not unlock whatever unconscious and libidinal secrets are contained in highly abstract paintings and constructions and make them finally comprehensible to the masses, it might just the same provide an insight, shine a searchlight, so to speak, into a dark corner. And with the slightly clearer but obviously threatening paintings of Anselm Kiefer (fig. 39), psychoanalysis might speak of how the imagery and language of the unconscious manifests itself in inexplicit, inchoate forms. Those underground chambers, those deep mysterious cellars, relate to dark impulses within the human psyche (Kiefer himself has connected some of his figures and spaces to the Nazi Holocaust).

Long after his death, Freud remains a controversial figure. Although his model of the human mind, his emphasis upon infantile sexuality, his "masculinist" bias, and his sense that most of our behavior is a result of some basic inner conflict have been sharply questioned and often dismissed, his presence remains. Because he wrote so powerfully about such a mighty subject—the human mind, its behavior and motivations—he continues to be taken seriously.

Figure 39. Anselm Kiefer, *Sulamith*, 1983; oil, emulsion, woodcut, shellac, acrylic, and straw on canvas, $114\frac{1}{4}$" x $145\frac{3}{4}$". Saatchi Collection, London. Photo: Saatchi Collection, London.

♦

Note

1. In the twenty-third of his introductory lectures, called "The Paths to Symptom Formation" (1917), Freud speaks of the artist:

> Before I let you go to-day, however, I should like to direct your attention a little longer to a side of the life of phantasy which deserves the most general interest. For there is a path that leads back from phantasy to reality—the path, that is, of art. An artist is once more in rudiments an introvert, not far removed from neurosis. He is oppressed by excessively powerful instinctual needs. He desires to win honour, power, wealth, fame and the love of women; but he lacks the means for achieving these satisfactions. Consequently, like any other unsatisfied man, he turns away from reality and transfers all his interest, and his libido too, to the wishful constructions of his life of phantasy, whence the path might lead to neurosis. There must be, no doubt, a convergence of all kinds of things if this is not to be the complete outcome of his development; it is well known, indeed, how often artists in particular suffer from a partial inhibition of their efficiency owing to neurosis. Their constitution probably includes a strong capacity for sublimation and a certain degree of laxity in the repressions, which are decisive for a conflict. An artist, however, finds a path back to reality in the following manner. To be sure, he is not the only one who leads a life of phantasy. Access to the half-way region of phantasy is permitted by the universal assent of mankind, and everyone suffering from privation expects to derive alleviation and consolation from it. But for those who are not artists the yield of pleasure to be derived from the sources of phantasy is very limited. The ruthlessness of their repressions forces them to be content with such meagre daydreams as are allowed to become conscious. A man who is a true artist has more at his disposal. In the first place, he understands how to work over his daydreams in such a way as to make them lose what is too personal about them and repels strangers, and to make it possible for others to share in the enjoyment of them. He understands, too, how to tone them down so that they do not easily betray their origin from proscribed sources. Furthermore, he possesses the mysterious power of shaping some particular material until it has become a faithful image of his phantasy; and he knows, moreover, how to link so large a yield of pleasure to this representation of his unconscious phantasy that, for the time being at least, repressions are outweighed and lifted by it. If he is able to accomplish this, he makes it possible for other people once more to derive consolation and alleviation from their own sources of pleasure in their unconscious which have become inaccessible to them; he earns their gratitude and admiration and he has thus achieved through his phantasy what

originally he had achieved only in his phantasy—honour, power, and the love of women.

◆

Bibliography

FREUD, SIGMUND, *Complete Psychological Works*, 23 vols. (ed. James Strachey). London: Hogarth Press, 1955–1975.

GAY, PETER, *Freud: A Life for Our Time.* New York: W. W. Norton, 1988.

HAUSER, ARNOLD, *The Philosophy of Art History.* New York: Knopf, 1959, pp. 41–110.

JONES, ERNEST, *The Life and Works of Sigmund Freud,* 3 vols. New York: Basic Books, 1953–1957, reprinted 1974.

SPECTOR, JACK, "The State of Psychoanalytic Research in Art History," *Art Bulletin* (March 1988), pp. 49–76.

SPITZ, ELLEN HANDLER, *Art and Psyche.* New Haven, Conn.: Yale University Press, 1985.

17

Culture and Art History

An African-American woman with hair shaped like a stove pipe—a "high-top fade"—stands before an audience of about thirty-five upper-middle-class whites. The setting is an American university classroom; the theme is multiculturalism and art. As she puts up slides of her quilts and bead work, her resonant voice hums the beginning of a song that is both spiritual and pop. The audience, transfixed, struggles a bit to free itself from an uneasiness it can't quite define. Somehow they want to convey their good will and support— love that hair!—but aren't used to being sung to before a slide lecture. The speaker is at ease; the audience is not.

This circumstance is not at all unusual in an academic age of liberalism and multiculturalism. Groups and individuals of different community and ethnic backgrounds, often meeting on the white person's turf, attempt to understand one another and try to "communicate." Such a tense situation may be as old as human culture itself.

One self-effacing member of the audience has a question: "I'm just an up-tight WASP; do I have any right to sing 'scat' like Ella Fitzgerald?" The speaker knits her brows and gives the slightest shake to her head, as if unsure she heard the question right. "If you can sing scat like Ella, do it. What do you think, I can't borrow images from Dutch art because I'm black and from Baltimore? If I put a little bit of Mondrian in my quilts, am I denying my heritage or stealing someone else's? Look, we're all the same species; there's plenty of common ground. Don't get so up tight, like you say." Such common-sense advice sweeps away some of the fear of intercultural encounters, trepidation over victim/victimizer relationships, and apprehension over meeting the "other."

But the plight of alterity—otherness—doesn't just dissipate or blow away because there are people of good will from diverse ethnic and economic circumstances. As James Clifford terms it, we face the "predicament of culture." Culture with its quandaries and burdens is part of all things: Art his-

tory is no exception. Saying this, of course, does not imply that identifying culture and what it means is easy.

The awareness of diversity that so permeates academic life (university professors as a group aren't very ethnically diverse, however) has called into question many of the postulates of Western art history. No longer can we say, at least without qualification and justification, that the Western tradition is the most natural one, the one that tells us who we are as a nation and as a culture. No longer can we get away with assuming that an appreciation of European art history makes us more civilized and more sensitive to the undying values of the human spirit. Platitudes do not go unchallenged.

In fact, the editorial "we" creates difficulties. When I invoke the "we," am I not saying we're all in this together, whether or not I have any real idea who you the reader are? I seem to be assuming that there is some bedrock or substratum of identity that binds us all together, and that art addresses directly that very commonality. For instance, it's not unusual to hear something like the following in a Renaissance art history class: "Although Michelangelo may be long dead, what he painted and sculpted speaks to us in as fresh a voice today as when he lived in Renaissance Italy; after all, he was one of the greatest artists of all time." The discussion of greatness and universality is in fact one of the myths of Western consciousness. The "we" makes us all unwitting—or at least unquestioning—participants in that myth. I am a middle-aged, white, American-educated male. Am I not co-opting all of your identities or being at least somewhat patronizing when I say "we"? I'm not sure; but, I have to consider that possibility. Postulating the reader requires some thought. I will at least assume that you have an interest in this text, that you have political (taking this term in its broadest context) concerns, and that they are not separate from the act of reading. You have a will and an identity that derive in part at least from your culture.

But then there is the other problem, the one of divisiveness and separation. If I (we) abandon the "we," am I not giving up the idea of a democratic culture, the sense that I, as an academic, am speaking to a wider public, one that will, if I am persuasive enough, agree with the things I write? I believe there once was the sense of a common viewer and a common reader. So far as we can read and interpret intentions, Italian baroque art, for instance, seemed to be geared to what today is called a mass audience. Baroque painting, sculpture, and architecture certainly had a strongly public character. And it assumed, in fact insisted upon, a common, religious viewer. As the baroque style spread to the Americas, this "common" viewer was from a profoundly different cultural stock. For advertising and marketing reasons, much of television today (as another example) has tried to appeal to a large audience; indeed, if it does not, it fails.

But getting back to the common reader/viewer, the eighteenth-century British writer Samuel Johnson wrote that "I rejoice to concur with the common reader: for by the common sense of readers, uncorrupted by literary

prejudices, after all the refinements of subtlety and the dogmatism of learn-
ing, must finally be decided all claims to literary honors." Although critics
disagree on just what Johnson might have meant by the common reader, he
at least was making an inclusive and anti-elitist gesture. He apparently felt
that a reader outside a select literary group was more to be trusted precisely
because that reader didn't suffer from the sins of oversophistication. Irving
Howe, in an essay that laments the disappearance of the common reader
from literary criticism, sees the academic community drawing in upon itself
at the same time as the broader American public loses its curiosity in intellec-
tual matters. He echoes the thoughts of many when he explains some of the
reasons behind the growing estrangement between academic and public in-
terests: "The spreading blight of television, the slippage of the magazines,
the disasters of our school system, the native tradition of anti-intellectualism,
the cultivation of ignorance by portions of the counterculture, the break-
down of coherent political and cultural publics, the loss of firm convictions
within the educated classes—these, in merest summary, are among the rea-
sons for the decline in both the presence and the idea of the common
reader." And, I might add, the common viewer.

Perhaps like me, the reader of this text sees a paradox here. Is the aban-
donment of a spurious "we"—which has been white, patriarchal, European,
and heterosexual—tantamount to a repudiation of commonality, a broad
community of interest and shared values? Might multiculturalism be feeding
the divisiveness that already eats away at culture and that creates an atmos-
phere of suspicion and resentment? Is multiculturalism a facet of anti-intel-
lectualism on the one hand, and intellectual snobbery on the other? I believe
I'm oversimplifying the issues here. At the same time, however, concerns
throughout our culture about ethnicity and the simultaneous stress placed by
academics on the intricacies of theory—something that concerns the broader
public very little—are probably related. Public disputes about apparently
meaningless or offensive (to some people) art, such as Richard Serra's *Tilted
Arc* or Andres Serrano's *Piss Christ* (these are merely the more notorious ex-
amples of contention in an art world awash with controversy), have alienated,
amused, or simply passed by much of the museum and gallery going public.
The issues here are so multifarious as to be almost unmanageable in a short
chapter. But let me try to sort things out a little.

The Other

Both the identification of and the discourse on the "other" is often Western
in orientation. Which means that we need to come to terms with the concept
and consciousness of the West. Like "bourgeois" and "middle class," "West-
ern" is not easily defined. The term Western identifies enormous numbers of

people of diverse concerns, ideologies, economic backgrounds, historical origins, classes, and ethnicities. But it isn't universal. It basically means European, Anglo, and American white men and women, educated beyond the secondary level by the study of great books, great works of art, great scientific theories, great philosophical systems, great forms of government, great religions, and great social institutions. The adjective "great" is obviously Western and my use is, to an extent at least, ironic; Westerners see themselves in a proud mirror.

Westerners trace their intellectual origins from Plato and Aristotle; their notions of civility and government from the Greeks of the Golden Age. Herodotus, writing about the Persian wars in that Golden Age (approx. fifth-century B.C. Greece), made a significant contribution to the creation of East versus West. East, for him and subsequently for Western consciousness, represented slavery and despotism; the West was Athens and stood for freedom and independence. The contrast of East and West arises from conflict and the historical enterprise: "These are the researches of Herodotus of Halicarnassus, which he publishes in the hope of thereby preserving from decay the remembrance of what men have done, and of preventing the great and wonderful actions of the Greeks and the Barbarians from losing their due meet of glory; and withall to put on record what were their grounds of feud."

With this creation of the barbarian other, Herodotus splits the world in two and denies the idea of a cultureless, essentialized humanity. He cleaves the world into warring camps that ineluctably are at odds, locked in struggle and desirous of domination. The relation between the West and the pathologized East is characterized by power and exclusion: However deviant and mysterious—and therefore potent—the East may be, the West will conquer and then discount it. The Greeks, of course, won the Persian Wars. And, one might say, because of that victory and the subsequent flowering of Greek art and culture, the West has "invented" ancient Greece as the ancestor of the present capitalist, European culture.

From one multiculturalist viewpoint, the Greek tradition really originates in "black" Egypt. Martin Bernal's *Black Athena* is controversial and certainly far from universally accepted. But it makes the argument that what today passes for Western culture, arises from black origins.

Samir Amin characterizes the Western viewpoint as "Eurocentrism" and delivers the following definition as if conceived by a Eurocentrist himself: "The European West is not only the world of material wealth and power, including military might; it is also the site of the triumph of the scientific spirit, rationality, and practical efficiency, just as it is the world of tolerance, diversity of opinions, respect for human rights and democracy, concern for equality—at least the equality of rights and opportunities—and social justice." This, of course, is optimistic self-definition. Amin also finds more pessimistic implications to Eurocentrism.

Edward Said's *Orientalism* deals extensively with the dilemma of East versus West: How can we Westerners look to the East (by which one can mean

Arab, Islamic, Hindu, Buddhist, and Asian cultures, and the Third World generally—to name those geographical locations and political, religious, and cultural arenas most often associated in the West with the East) in terms that are not bound up with suspicion, fear, ignorance, and the need for control? Professor Said's concept of Orientalism rests upon his analysis of how the West has created the Orient as an idea. He writes: "Therefore as much as the West itself, the Orient is an idea that has a history and a tradition of thought, imagery, and vocabulary that have given it reality and presence in and for the West." Conceptions held in the West about non-Western peoples and cultures are socially constructed. The West does not see the Orient as it is, in reality, or as it sees itself (a very different thing), but only in the West's own interested and suspicious terms.

One can say that this is simple human nature (but what is human nature?). Naturally we see others as different from ourselves, and therefore we inevitably distort what we see so as to create images out of the mechanics of our perceptions and the structures of our desires and fears. We are, after all, imperfect beings. True. Bias is natural, or at least common. But that's no reason not to study the power of bias, the effects of hate and distortion. The Nazi Holocaust arose in part from a process of demonizing and dehumanizing the "other." Conflicts in the Middle East involve distrust between Arab and Jew. The 1992 riots in Los Angeles had a racial impetus. Inkatha and the ANC; black and white; Serb and Croat; Protestant and Catholic—the list of oppositions is long. The fact that some nations are poor and that others are not; that some classes have fewer advantages than others; that enormous amounts of money are spent on weapons aimed at the other; that racism, sexism, and homophobia exist—these facts suggest that multiculturalism—understanding the dynamics of race, ethnicity, economics, and society—is a pressing if perplexing issue.

The "West" exists at least as an idea and a historical point of view. It is, as well, an artificial construct, both problematical and arbitrary. The "West" as idea results from a pattern of history that originates in Greece and Rome, moves through the Christian Middle Ages, Renaissance, Enlightenment, and into the European-Anglo culture and economy of the present day. In the view of multiculturalism, accepting the Western or white consciousness as representing a natural or real view of the world is distorting and potentially racist.

Which leads me back to the West's idea of the "other." Let's take the widely known statement by Descartes: "I think therefore I am." Mark Taylor's book *Altarity* situates the philosophical circumstance of otherness in Descartes' distinction between *res cogitans* and *res extensa*—the separation between the thinker and the world outside. The realm of the thinker is the "I," which indubitably exists, while other existences are doubtful. Descartes began from a position of skepticism. He doubted most truths. This, paradoxically, led him back to a certainty: that he doubts. Doubting is thinking. He

thinks, he exists. After Descartes, philosophy has concerned itself with the cogitator, the subject. Other things—be they natural objects, the Heavens, or people—are understood in terms of the mind of the perceiver. The power of cogitation is that of construction and projection. The subject invents, or at least composes, the object. Taylor writes that the other is an "aspect of mediate self-relation that is necessary for complete self-realization in transparent self-consciousness." I need the other to complete who I am. This situation creates at least two tensions: one is the distance or gulf between "I" and "thou"; the other is the use made by the "I" of the "thou." Mostly we are separated; then, when we come together we use one another. Manipulation follows estrangement. I can imagine Dr. Freud sagely nodding his head over this one. And yet I don't believe that we can logically prove that human relations are driven fundamentally by struggles over power. At the same time, to deny that power relations exist is, again in my opinion, hopelessly naive.

Art History and the Other: Modernism and Primitivism

An exhibition in the winter of 1984–1985 at New York's Museum of Modern Art called " 'Primitivism' in Twentieth-century Art: Affinity of the 'Tribal' and the Modern" has occasioned a spate of criticism, some of it hostile. Defining the relation between the great moderns of European art (Picasso in particular) and African tribal art bit into some very tender nerves.

But first, some matters of semantics. The use of the words "tribal" and "primitive" in quotation marks ("scare quotes") is meant to avoid the pejorative connotations of "primitivism," a term that has been widely used when discussing the origins of modern art. Because "primitivism" has historical associations with "lesser" and therefore "benighted" cultures, it now is used by ethnographers, anthropologists, and art historians with reluctance. Yet there is a long tradition to the name, and although not flattering, the customary use evokes the kinds of ideas—negative or not—that historians want to keep current, if only to critique them.

Art historians and others have used "primitive" often with equal parts of contempt and admiration. The primitive in art and culture can have the virtue of simplicity and naturalness, power and originality. This is the romantic use, and suggests that the West has become oversophisticated and inhumanly complicated. What one wants is a return to a more elemental and therefore better time: an escape to an arcadian or edenic isle—a trip to the Caribbean, for instance. However, this simple-minded Rousseauianism hasn't stood the test of time very well; it's hopelessly trivial.

The other more barbaric and cruder implications of the term "primitive" persist, however, perhaps because they haven't been examined very carefully. Primitivism is unavoidably and inherently caught up with the idea

of progress. Although the concept of progress (former President Reagan once made a living from telling people that progress is our most important product) has existed in the West since at least classical antiquity, its modern application begins in the early Enlightenment (late seventeenth, early eighteenth centuries), when the idea of "enlightened eudaemonism" took hold. Progress suggests that things will improve, every day in every way. But it is something of a cliché to point out that there are serious questions about progress in the West. Industrial and scientific progress has not necessarily removed inequality from society, nor has it liberated the human spirit. Those who are aggrieved by the failure of progress have suggested a return to the primitive. But the notion of primitivism alludes once again to progress, even if of an early stage. Primitive then becomes the undeveloped, naive, ignorant, remote, rudimentary, and savage. Not only are these adjectives deplorable, they are inaccurate and even fanciful.

Robert Goldwater attempted in 1938 to associate the primitivistic (as he called it) with modern art. He did this at a time when relatively few had tried to define what the West meant by the idea of primitive art; this makes his endeavor all the more noteworthy and significant for discussions of multiculturalism. He began his study with the observation—still common at the end of the twentieth century—that many see contemporary art as childish, simple, unsophisticated: "Any kid could paint that! Just give him a bucket of paint and a cheap brush from K-Mart and let him go for it!" I've heard such comments. Goldwater believes that this reference to an apparent lack of talent is associated in the public's mind with the idea of the primitive: the fresh, spontaneous, and undeveloped, sometimes mixed with the wild and savage. Because they assumed some model or another of progress, nineteenth-century anthropologists made the "natural" connection between primitive societies and the culture of children.

Goldwater asserts that there is an "affinity" (a tricky term, to be discussed subsequently) between the primitive and the modern, and so the project of his book is to study the attraction that the primitive has for the modern artist. He recognizes that primitivism (as practiced by European artists) is neither simple nor pure, that it calls upon many non-Western cultures as well as Western traditions, and that its agendas are manifold. Primitivism and the primitivistic concern the use made by European artists of the materials, moods, and styles of non-Western cultures. Goldwater's book is about Western art, not primitive art. The appropriation or employment of the primitive generally is not a matter of direct influence or deeply felt knowledge: "With the exception of a few of Gauguin's woodcuts, of some paintings of the *Blaue Reiter* group in Germany, and of the very limited production of Picasso's negroid period, there is little that is not allusion and suggestion rather than immediate borrowing."

Goldwater considers primitivism and modern art under four broadly conceived and flexible headings: "romantic," "emotional," "intellectual,"

and "subconscious." While insisting upon the point that primitivism is a tough issue to reduce to simple elements, Goldwater does come to a conclusion of sorts when he states that primitivism is based upon a common assumption about art and culture:

> This is the assumption that externals, whether those of a social or cultural group, of individual psychology, or of the physical world, are intricate and complicated and *as such not desirable.* It is the assumption that any reaching under the surface, if only it is carried far enough and proceeds according to the proper method, will reveal something "simple" and basic which because of its very fundamentality and simplicity, will be more emotionally compelling than the superficial variations of the surface; and finally that the qualities of simplicity and basicness are things to be valued in and for themselves: In other words, it is the assumption that the further one goes back—historically, psychologically, or aesthetically—the simpler things become; and that because they are simpler they are more profound, more important, and more valuable.

James Clifford and Marian Torgovnick take these and other implications of the primitive and subject them to a careful analysis in their reviews of the exhibition at Museum of Modern Art in 1984–1985.

If not precisely offended, Clifford is at least disquieted by the use of the term "affinity," which he sees as a designation of familial relationship. It is a kinship term, and as such signals an intimate connection between the tribal and the modern, some special relationship that goes beyond resemblance or likeness. Affinity means that modernism and tribalism share a universalizing, genetic, or essentializing tendency. They're brothers. Or sisters. But these so-called affinities are asserted rather than subjected to detailed, structural, philosophical investigation by the various writers who contributed to the catalogue of the show.

It is Clifford's position that the only common quality between the modern and the tribal is an avoidance of optical naturalism or realism; that both modernism and tribal (he's not happy with this term either) art are abstract and simplifying. Looking for other more specific commonalities misleads one into the popular but baseless assumption that there are archetypal human artistic modes of expression—and that modernism discovered them. This of course gives modernists (like Picasso, especially) power. Clifford objects that "Nowhere . . . does the exhibition or catalogue underline a more disquieting quality of modernism: its taste for appropriating or redeeming otherness, for constituting non-Western arts in its own image, for discovering universal, ahistorical 'human' capacities." The search for fundamental human experiences masks the darker tendency of Western art to appropriate the non-Western. Like so many buzzwords of contemporary theory, "appropriate" has become hackneyed through overuse. But its meaning is suitable just the same. It means to defraud, burglarize, and pilfer. To steal. As Clifford

concludes, ". . . the catalogue succeeds in demonstrating not any essential affinity between tribal and modern or even a coherent modernist attitude toward the primitive but rather the restless desire and power of the modern West to collect the world."

To see primitive art as informing modern art turns the non-Western tradition into something contingent and supplemental. Like the proverbial good wife standing behind every successful man, primitive or tribal art exists primarily in reflected glory, a satellite orbiting around a larger and more prominent body. To see primitive or tribal art as transcending its own cultures and contexts and speaking to us with a universal aesthetic voice minimizes or even denies the importance of its original meaning and purpose. Decontextualization in this sense has been seen as a kind of rape. One statement, in a catalogue accompanying an exhibition of African art (quoted by Clifford), has the type of egregious blather that can set one's teeth on edge: It says that these pieces have the capacity "to transcend the limitation of time and place, to speak to us across time and culture . . . ," and that this achievement "places them among the highest points of human achievement. It is as works of art that we regard them here and as a testament to the greatness of their creators." These empty pieties are more than bad writing; they trivialize the original African art by making it pay dues to Western notions of greatness and beauty.

On Quality

There are those who say that everything in life—love, death, beauty—everything—is political. But the idea of beauty or quality has to a large extent and for quite some time been taken for granted in Western culture. Once you've developed a good eye, so the story goes, have been civilized by good breeding, higher education, and, perhaps, a grand tour of the Continent and British Isles, you will have a sense of both what beauty is and the importance of quality. But polemicists for multiculturalism will point out that, in fact, beauty and quality are profoundly compromised terms that reveal the biases of the ruling class and act as weapons for excluding from the white, Western, and patriarchal (need I add heterosexual?) canon works by people of color and other artists from disenfranchised groups. But how can this be? Are there no standards for taste? Does the notion of "good art" exist only as a historical idea that no longer has any validity? Perhaps.

One critic writing in the *New York Times* says of "quality" that "there may be no more divisive word in the art world just now. Perhaps no word inspires more devotion among its supporters and more anger among its detractors. Perhaps no word expresses more deeply the present conflicts about art, standards, multiculturalism, and American culture in general" (Michael Brenson, "Is 'Quality' an Idea Whose Time Has Gone?" 22 July 1990, Arts and Leisure section, pp. 1, 27).

It's not so much the traditional philosophies of aesthetics and pleasing

form that are at issue in multiculturalism, but the ways in which quality has been used as a weapon of exclusion. Curators and gallery owners are often accused of having a pseudo level-playing-field and disinterested attitude: "I don't care about minority art; I care about quality. If it's good, we'll show it." Sounds fair, but many believe it isn't.

Perhaps no one has been more active, more effective, or more intelligent about promoting multicultural art than Lucy Lippard. So I'll let her speak for the idea of quality as a political hot potato and term of repression:

> Ethnocentrism in the arts is balanced on a notion of Quality that "transcends boundaries"—and is identifiable only by those in power. According to this lofty view, racism has nothing to do with art; Quality will prevail; so-called minorities just haven't got it yet. The notion of Quality has been the most effective bludgeon on the side of homogeneity in the modernist and postmodernist periods, despite twenty-five years of attempted revisionism. The conventional notion of good taste with which many of us were raised and educated was based on an illusion of social order that is no longer possible (or desirable) to believe in. We now look at art within the context of disorder—a far more difficult task than following institutionalized regulations. Time and again, artists of color and women determined to revise the notion of Quality into something more open, with more integrity, have been fended off from the mainstream strongholds by this garlic-and-cross strategy. Time and again I have been asked, after lecturing about this material, "But you can't really think this is Quality?" Such sheeplike fidelity to a single criterion for good art—and such ignorant resistance to the fact that criteria can differ hugely among classes, cultures, even genders—remains firmly embedded in educational and artistic circles, producing audiences who are afraid to think for themselves.

So it's not so much a matter of eliminating the concept of quality, but finding a broader understanding of it. More inclusive concepts of quality have been discussed by both Lippard and African-American artist Adrian Piper, as well as writer and critic Michael Brenson. The project of rewriting definitions of quality (to say nothing of beauty, a not entirely outmoded concept in our culture of cosmetics and lifestyles) will be enormous. It's not clear what direction this undertaking will follow, nor how widely accepted new definitions will be. *Webster's* says of quality that it is "any character or characteristic which may make an object good or bad, commendable or reprehensible; the degree of excellence which a thing possesses." One can hardly expect that there will be final agreement on what constitutes artistic quality; the debate should prove interesting precisely for this reason.

At the risk of stating the obvious, multiculturalism is about the inclusive, not the exclusive. Exclusive tastes, like exclusive clubs, are probably outmoded. We need not speak of the "other," but of "anotherness" as Lippard puts it. People may not find it entirely comfortable to think in embracing terms, but we are certainly capable of it.

As humans we are proficient (if not always honest) in self-scrutiny; we recognize the importance of personal identity and can hardly be unaware of the hybrid and curious mixture of things that make up individuality, temperament, and personality. These are some of the things that make me who I am (in no particular order): my species, genetic inheritance, biological structure; my family, friends, economic and social milieus; when and where I was born; how and where I was educated; my life experiences; my gender, health, physical attributes, age, ethnicity and culture, my sexual preference, what I read and see, my profession, my values, morals and ethics; my relation to nature, the infinite, and the sacred. And so forth.(One hardly looks for closure when discussing the elements of identity.) I cannot be sure what the precise measure of each ingredient is: How important is my whiteness? maleness? bourgeoisness? academicness? Swedish ancestry? To what extent do I decide the importance of these things, and how much am I at the mercy of how others define me? It seems reasonable to assert that I am neither entirely free of my identity, nor entirely its prisoner. I am both limited and motivated by it. I see myself in others; they see themselves in me. We struggle with one another, manipulate one another, avoid one another, love one another. Perhaps it's a jungle out there; maybe there's a fair measure of sweetness and light.

Lippard says that "all white people, no matter how well-meaning, are racist to some degree by virtue of living in a racist society." This of course is an assertion that can neither be proved nor disproved; but conceding its validity (and this doesn't mean that whites have a lock on racism), there's no reason why whites or any other cultural group can't be fair, open, and sensitive, can't recognize that rich if volatile mixture of peoples and aesthetic values that live and die on our planet. Multiculturalism is finally inevitable.

Consequences for Art History

It's no longer business as usual for the teaching and writing of art history. Even the focus of this text, which is Western, is too narrow and exclusive. Global perspectives are replacing the more parochial outlook of Western art history. The accepted structure of Western art, as it derives from Greek and Roman origins, is being challenged. Henry Louis Gates writes of "decentering" the Humanities, by which he means finding something more inclusive than the traditional, white, Eurocentric standard. Art historians operating from a multicultural perspective continue to question the accepted models of progress, development, and influence. The proportional representation of white, male artists in survey texts of art history will change. The balance between Western and non-Western arts and cultures will shift in these same texts. Definitions of quality, beauty, and significance will be mixed up and replaced. The new art history will probably not result in a melting pot of art's

histories and interests, or some stew of unrelated, even antagonistic styles and communities. What art historians will probably invent will be new ways of sorting out the vast, worldwide, historical data of art; and what will result will be a new construct of art history, one that is not necessarily more true, but one which reflects the claims of more voices and more cultures.

◆

Bibliography

AMIN, SAMIR, *Eurocentrism* (trans. Russell Moore). New York: Monthly Review Press, 1989.

ANDERSON, RICHARD L., *Calliope's Sisters: A Comparative Study of Philosophies of Art*. Englewood Cliffs, N. J.: Prentice Hall, 1990.

BERNAL, MARTIN, *Black Athena: The Afroasiatic Roots of Classical Civilization*. New Brunswick, N.J.: Rutgers University Press, 1987.

CLIFFORD, JAMES, *The Predicament of Culture: Twentieth-Century Ethnography, Literature, and Art*. Cambridge, Mass. and London: Harvard University Press, 1988.

GATES, HENRY LOUIS, *Loose Canons: Notes on the Culture Wars*. New York and Oxford: Oxford University Press, 1992.

LIPPARD, LUCY, *Mixed Blessings: New Art in a Multicultural America*. New York: Pantheon Books, 1990.

SAID, EDWARD W., *Orientalism*. New York: Vintage Books, 1979.

TAYLOR, MARK, *Altarity*. Chicago: University of Chicago Press, 1987.

TORGOVNICK, MARIANNA, *Gone Primitive: Savage Intellects, Modern Lives*. Chicago: University of Chicago Press, 1990.

Acknowledgments

Excerpt from *The Craftsman's Handbook: The Italian "Il Libro Dell'Arte"* by Cennino Cennini (translated by Daniel V. Thompson, Jr.). Reprinted by permission of Dover Publications.

Excerpt from *Idea: A Concept in Art History* by Erwin Panofsky (translated by Joseph J. S. Peake). Reprinted by permission of HarperCollins Publishers Inc.

Excerpt from "Of the Dignity of Man" by Pico della Mirandola (translated by E. Forbes) in *Journal of the History of Ideas* 3 (1942). Reprinted by permission.

Excerpts from *Complete Poems and Selected Letters of Michelangelo*. Translated by Creighton Gilbert. Princeton University Press. Reprinted by permission of Creighton Gilbert.

Excerpt from *Lives of the Painters* by Giorgio Vasari (translated by A. B. Hinds; edited by William Gaunt). Copyright © 1963 David Campbell Publishers Ltd. Published by Everymans Library. Reprinted with permission.

Excerpt from "Classicism and Academy" by Moshe Barasch in *Theories of Art from Plato to Winkelmann*. Reprinted by permission of New York University Press.

Excerpt from *Small World: An Academic Romance* by David Lodge. Copyright © 1984 David Lodge. Reprinted with the permission of Macmillan Publishing Company and Curtis Brown.

Excerpt form *Vicious Circles* by Maurice Blanchot (translated by P. Auster). Reprinted by permission of Station Hill Press.

Index